Artist's
Photo Reference
BIRDS

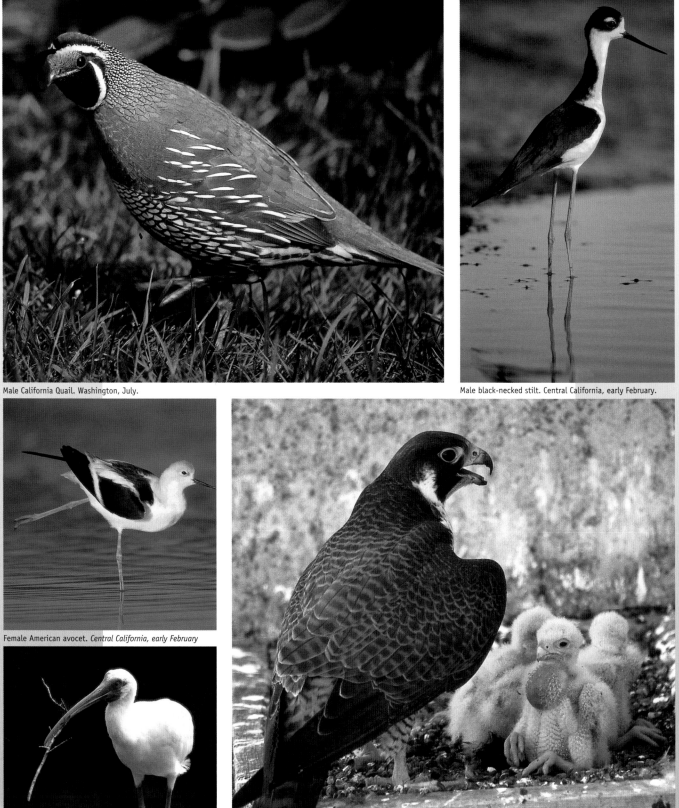

Male California Quail. Washington, July.

Male black-necked stilt. Central California, early February.

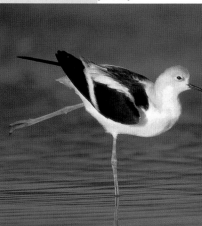

Female American avocet. *Central California, early February*

White Ibis. *S. Florida, late March*

Peregrine falcon adult and chicks. *Seattle, Washington, May*

Artist's
Photo Reference
BIRDS

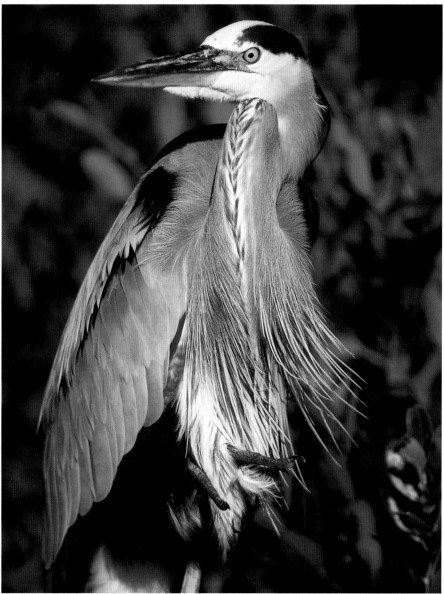

Great blue heron. *S. Florida, early April*

BART RULON

NORTH LIGHT BOOKS
Cincinnati, Ohio

About the Author

Born in 1968, Bart Rulon lives and works on Whidbey Island in Washington State's Puget Sound. He received a bachelor's degree from the University of Kentucky in a self-made Scientific Illustration major. He graduated with honors, and became a full-time artist, focusing on wildlife and landscape subjects, specializing in birds.

Rulon's works have been exhibited in many of the finest exhibitions, museums and galleries displaying wildlife and landscape art in the United States, Canada, Sweden, Japan and England. His paintings have been included in eight exhibitions with the Leigh Yawkey Woodson Art Museum including the "Birds in Art," "Wildlife: The Artist's View," and "Natural Wonders" exhibits. His work has been chosen for the Society of Animal Artists annual exhibition for all six years since he became a member. His paintings have been included in the Arts for the Parks Top 100 Exhibition and national tour four times, and in 1994 he won their "Bird Art Award." His paintings and sketches of birds are included in the permanent collection of the Leigh Yawkey Woodson Art Museum and the Massachusetts Audubon Society.

Bart's paintings have been featured on the cover and in the interior of *Bird Watcher's Digest*. His illustrations of seabirds appear in the field guide *All the Birds of North America* (HarperCollins). He is the author of *Painting Birds Step by Step* (North Light Books, 1996), and has been featured in two other North Light books, *Wildlife Painting Step by Step* (Patrick Seslar, 1995) and *The Best of Wildlife Art* (edited by Rachel Wolf, 1997).

Rulon's primary interest is in experiencing his subjects firsthand in the wild. He focuses on painting subjects and scenes he has experienced in the wild rather than trying to paint those he's never seen. It's that personal experience that inspires him to recreate an image, more than the act of painting itself.

Hobbies that occupy Bart's time when he's not painting include fishing, kayaking, basketball, soccer, weight lifting, bird-watching, camping and beach volleyball, to name a few.

Artist's Photo Reference: Birds. Copyright © 1999 by Bart Rulon. Manufactured in Singapore. All rights reserved. No part of this book may be reproduced in any form or by any electronic or mechanical means including information storage and retrieval systems without permission in writing from the publisher, except by a reviewer, who may quote brief passages in a review, or as a reference for painters and other artists in their original artwork. Published by North Light Books, an imprint of F&W Publications, Inc., 1507 Dana Avenue, Cincinnati, Ohio, 45207. (800) 289-0963. First edition.

Other fine North Light Books are available from your local bookstore, art supply store or direct from the publisher.
03 02 01 00 99 5 4 3 2 1

Library of Congress Cataloging in Publication Data

Rulon, Bart.
 Artist's photo reference: birds / Bart Rulon. -- 1st ed.
 p. cm.
 Includes bibliographical references and index.
 ISBN 0-89134-859-X (alk. paper)
 1. Birds in art. 2. Painting from photographs. I. Title.
ND1380.R77 1999
704.9'4328--dc21 98-27746
 CIP

Edited by Jennifer Lepore and Pamela Seyring
Production Edited by Michelle Kramer
Designed by Angela Lennert Wilcox

Dedication

To my mom, dad, and brother. The difficult part about living in Washington is that I miss you so much; but you are always in my heart no matter how far away.

Acknowledgments

There are many people to whom I would like to express my heartfelt thanks for helping me complete this book. First of all I want to thank my family: my dad, Art; mom, Althea; and brother, Barron, who have been the best family a guy could ever ask for, and who have always been there for me. To my aunt and uncle, Joyce and Tom Rulon, thank you for providing me with the most incredible opportunity an artist could have in starting his career.

I want to thank my great friends, travel buddies and fellow artists, Dave Sellers and Kalon Baughan, for being with me on many of the unforgettable adventures where I took many of these photographs. The great times we've had will live in my memory forever. Thanks to Chris Wood, Pam Gross and Sievert Rohwer at the Burke Museum for giving me access to the Burke's exceptional collection of bird study skins, and especially the spread wing collection. Thanks to Dennis Paulson for helping me with the accuracy of some of my bird information, and for the opportunity to use the Slater Museum's study skin and spread wing collections. Thanks to Bud Anderson of the Falcon Research Group for giving me advice about birds of prey, and for providing me with a fantastic opportunity to photograph and sketch Peregrine Falcons at their nest. It was a great experience. Thanks to Ruth and Charles Travers for letting Dave, Kalon and I stay at your cabin near Denali National Park in Alaska, where I photographed spruce grouse and ptarmigan. Thanks to Jon and Pam Herrell for allowing me to set up my blind to photograph your resident Steller's jays. Thanks to Charles Pilling for allowing me to photograph a few ducks from your collection to fill in some gaps in my photos.

Thank you to Sherry C. Nelson, MDA, for contributing your decorative artwork and time for this project. To John and Linda Kipling, for graciously continuing to let me use your computer ever since I wrote my last book.

I want to thank Rachel Wolf from North Light books for helping make this book a reality. Last but not least, thanks to my editor, Jennifer Lepore; you were a delight to work with, and thanks for your sense of humor in dealing with my typical problem of providing too much information and too many photographs for the book.

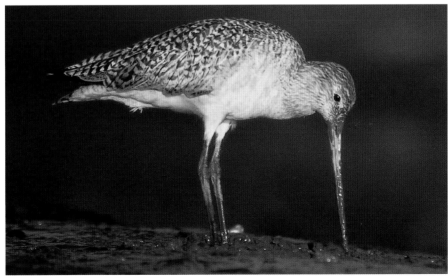

Marbled godwit. *Central California, early February*

Table of Contents

PART ONE WATER BIRDS

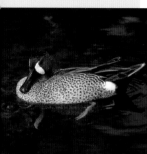

Male blue-winged teal. *Florida, late March*

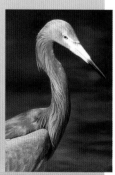

Reddish egret. *S. Florida, early April*

BLACK SKIMMER, ROYAL TERN AND WATERFOWL

HERONS AND EGRETS

SHOREBIRDS

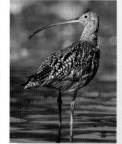

Long-billed curlew. *Central California, early February*

UNUSUAL WADERS

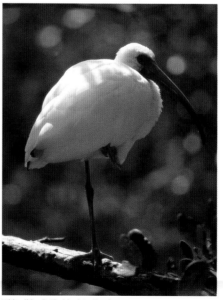

White ibis. *S. Florida, late March*

PART TWO LAND BIRDS

BIRDS OF PREY

STEP-BY-STEP DEMONSTRATION

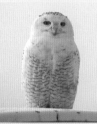

Snowy Owl. *Washington, late February*

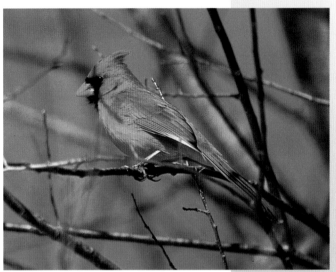

Male Cardinal. *Central Kentucky, late December*

BACKYARD BIRDS

STEP-BY-STEP DEMONSTRATION

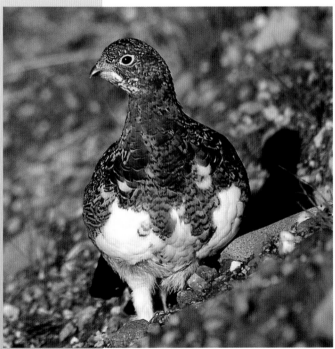

Willow ptarmigan. *Alaska, early September*

GROUND WALKERS

Introduction

The sound of three killer whales surfacing within twenty feet startled Dave Sellers, Kalon Baughan and me as we paddled along in our kayaks. We were in awe of being able to paddle alongside some of the most beautiful animals in the world. Traveling in the wild photographing, sketching and painting wildlife subjects is, for me, the most enjoyable part of being an artist, and having friends to travel with that have the same enthusiasm about fieldwork makes it even better.

The photographs and sketches representing my experiences in these trips have always served as inspiration for my paintings. With the improvement of my photography skills and a multitude of adventures under my belt, I noticed my work steadily improving. Having a library of my own references of wildlife photographs made all the difference. Although my photographs are often less than perfect, they give me a vital starting point to make a painting that sums up an experience.

Even if I stopped taking photographs today, I would never be able to use all the reference photographs I already have for my paintings. That is part of what sparked the idea for this book, which is intended to provide bird references from an artist's point of view. With all the species you'll find in the following pages, I have attempted to show the birds in a variety of situations, using different angles and poses, close-up photos for minute details and shots at a distance to show the bird together with its habitat. Unless otherwise noted, all my photographs are taken of wild birds, in the wild. This variety of photos should serve as a good form of reference for both bird painters and carvers, who often need more information to work from than they can find in their own files. And the four step-by-step demonstrations scattered throughout the book show you how to use reference photos to create beautiful bird paintings in various media.

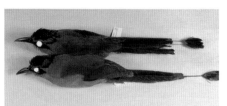

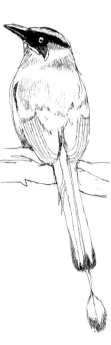

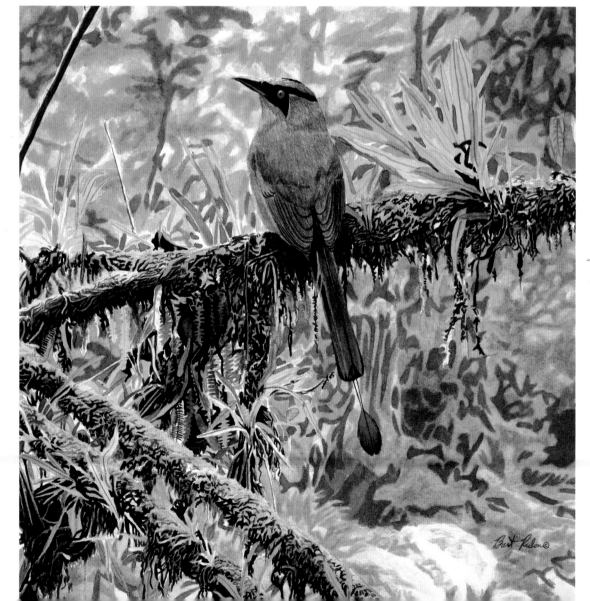

Blue-Crowned Motmot
BART RULON, Watercolor
13" X 12½" (33cm x 32cm)

How to Use This Book

This book was written by and for artists, not ornithologists, so if you find an error try to be forgiving. I have given my best effort to compiling accurate information about the birds without using too much technical jargon, so that readers unfamiliar with birds won't get lost in the details, but at the same time experienced bird artists will find useful information. As with any book where mounds of information are condensed into a few paragraphs, many things have to be omitted or generalized. I have tried to do this with the artist's best interest in mind.

In all cases, unless otherwise noted, the photographs, illustrations and information in this book have been executed by the author. When using the photographs, study the various views and details of the birds to create an original composition, or use the references to supplement your own photographs. For your information, I have listed the time of year and the state in which each photograph was taken. Although many of the species in this book range outside North America, I have generally only listed their distribution ranges within North America.

Refer to the anatomy section in the beginning of this book if you are unfamiliar with birds. There I have pointed out the body parts mentioned in the text and captions so you can visualize them. In some cases I have used terms that ornithologists would not use but novices would understand more readily.

At the end of each species description I have included information about the number of primary wing feathers, secondary and tertial wing feathers on the "trailing edge," and tail feathers for your reference. In many cases I have labeled the count as just "secondary feathers on the trailing edge" for those species where I was unable to tell if the last feather or feathers on the inside of the wing's trailing edge were secondaries or tertials. Each species has a definite number of wing and tail feathers, and should normally have them all except when feathers have molted out and have not been replaced yet. I gathered the information by actually counting feathers from spread wings and specimens at the Burke museum and cross-referencing my information with published counts. These counts were done for the specific purpose of an artist's reference, and are therefore not scientific. For instance, some species have one extra, extremely small primary feather that you normally would not see and which I did not include in the primary feather count.

Upperwing

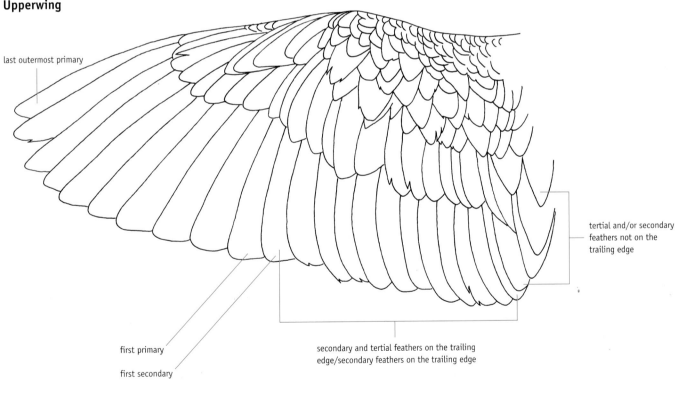

last outermost primary

first primary

first secondary

secondary and tertial feathers on the trailing edge/secondary feathers on the trailing edge

tertial and/or secondary feathers not on the trailing edge

Bird Anatomy

Knowing the external structure of a bird will be very important as you use this book. Become familiar with this terminology as it is used in bird field guides and books and by experts and amateurs in the field of ornithology. Knowing the different parts and how they relate to each other is an important step in recreating a bird accurately in your art.

Varied Thrush (Female)

forehead

crown

upper mandible

lore

eyebrow/eye stripe

cheek/ear patch

lower mandible

nape

chin

back/mantle

throat

scapulars

shoulder

median wing coverts

breast

wing bars

greater wing coverts

secondaries

primaries

side

rump

abdomen/belly

uppertail coverts

flank

tail feathers or rectrices

tarsus/leg

toe nail/claw

toes

heel

undertail coverts

hallux/hind toe

Upperwing

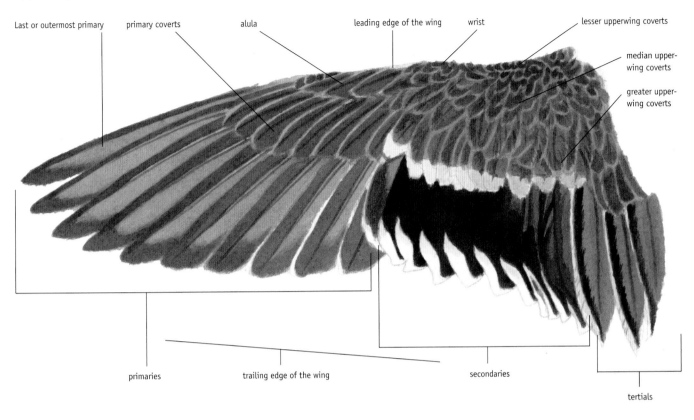

Last or outermost primary

primary coverts

alula

leading edge of the wing

wrist

lesser upperwing coverts

median upper-wing coverts

greater upper-wing coverts

primaries

trailing edge of the wing

secondaries

tertials

Underwing

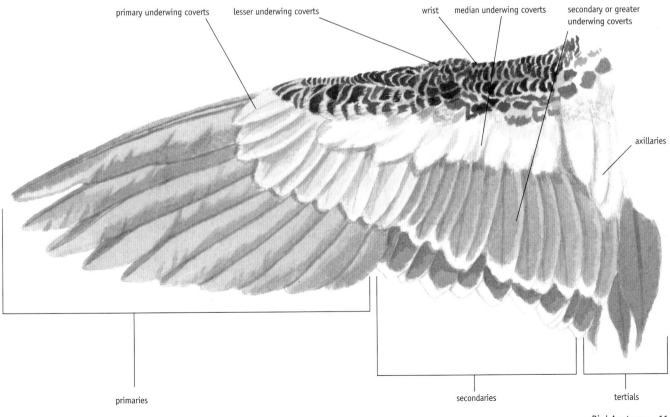

primary underwing coverts

lesser underwing coverts

wrist

median underwing coverts

secondary or greater underwing coverts

axillaries

primaries

secondaries

tertials

Glossary

Form—Some bird species have more than one color type within that species that exhibit different colors or different markings not related to age, sex or seasonal variations. Form is a term used to describe these recognizably different color variations. Also called morph or phase.

Immature plumage—Describes a bird that has not reached full adult plumage yet. Normally immature plumage should refer to a young bird in between juvenile and adult stages, but people sometimes refer to immature birds as any bird that hasn't reached adulthood yet.

Juvenile plumage—Describes the first full set of contour feathers acquired by a young bird immediately after its natal down is lost. In birds that are not covered with down at birth, juvenile plumage is their first set of contour feathers. Juvenile plumage is usually lost in a molt during the first late summer or fall after birth.

Molt—The process by which a bird partially or completely sheds feathers and grows new ones to replace them.

Morph—See Form

Speculum—An often iridescent colored patch on the secondary wing feathers of a duck.

Kildeer at Crockett's Lake
BART RULON, Acrylic, 9" X 12" (23cm X 30cm)
Collection of Mr. and Mrs. Robert Rasmussen

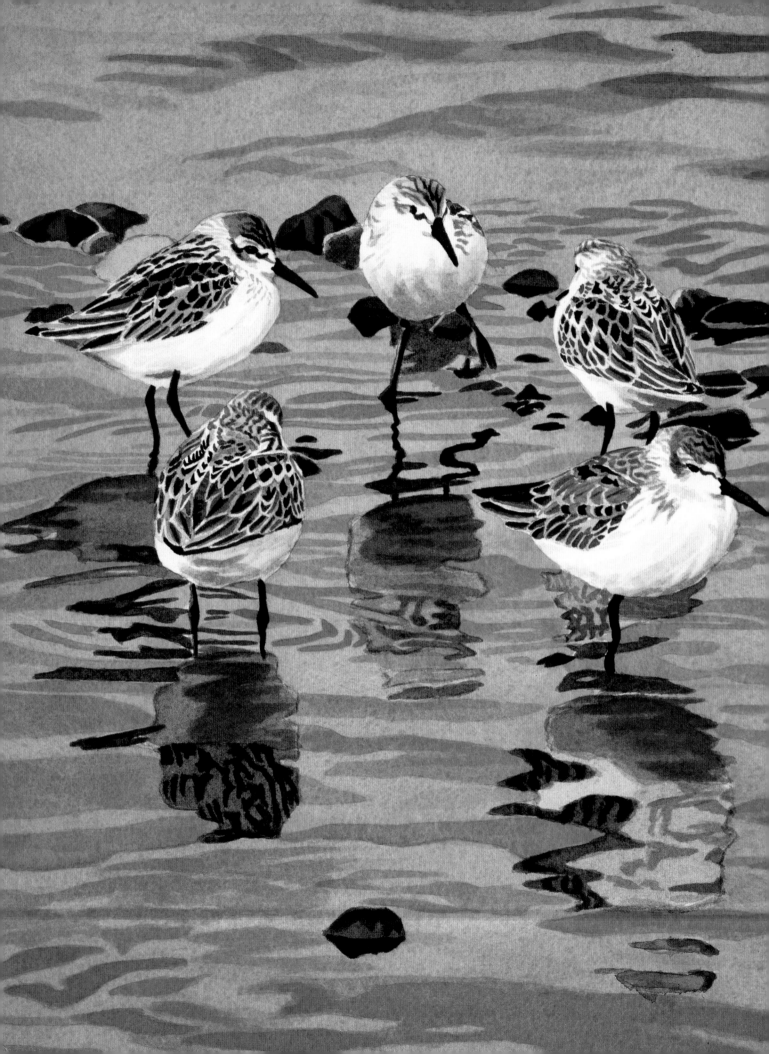

PART ONE
WATER BIRDS

Although you can find many water birds on dry land, most of them seldom stray far from wetlands. And each group of birds has its own way of utilizing their wetland habitat. This section takes you through the Black Skimmer and Royal Tern species, as well as various species of Waterfowl, Herons and Egrets and Shorebirds.

Western Sandpipers BART RULON Watercolor 16" x 20" (41cm x 51cm) Collection of the Massachusetts Audubon Society

BLACK SKIMMER, ROYAL TERN AND WATERFOWL

These birds differ from the rest of the waterbirds covered in part one because they are not wading birds. Except when hunting, skimmers and terns spend most of their time near the water instead of in it. And although many species of waterfowl spend time feeding on land, they spend the majority of their time directly on or near water.

You may notice that each species of duck is limited to one page. Since the ducks shown in this book frequently appear in general and specialized publications, I have limited images of them, and emphasize the spread-wing images for each duck species as a useful artistic reference.

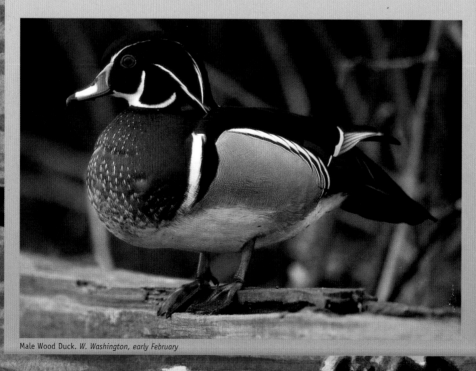

Male Wood Duck. W. Washington, early February

Black Skimmer

Skimmers feed in salt water and rest on the beaches of the Atlantic coast, Gulf coast and southern part of the Pacific coast, in southern California and Mexico. However, they are sometimes found inland around fresh water, following large rivers and creeks in search of food.

Black skimmers are the only birds that have lower beaks longer than their upper beaks. Their beaks are laterally compressed. The skimmer feeds by flying along the water's surface with its lower bill slicing through the water. When the bird's beak hits a fish, it quickly snaps shut on the prey. When skim-mers are fishing like this their wing-beats normally don't go under the plane of their body—that way their wings don't hit the water.

These birds have a distinctive black, white and orange design. The upperparts are black, the underparts are white and the bill is orange at the base and black on the tip. The male and female look alike except the female is smaller than the male. Black skimmers have ten primary feathers, eighteen secondary feathers on the trailing edge and twelve tail feathers.

A Winter plumage skimmers have a brownish black back and a white collar around the neck. A highlight from the sun keeps the eye from getting lost in the surrounding feathers. *S. Florida, early April*

B Summer plumage birds have a dark blackish back and the hind neck which turns black. At rest, skimmers' wings extend far beyond the length of their tails. *S. Florida, early April*

C A typical flock of skimmers intermingling with other beach-going birds—in this case laughing gulls and a royal tern. From the front, the skimmer's beak is laterally flattened. *S. Florida, early April*

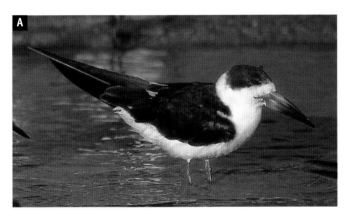

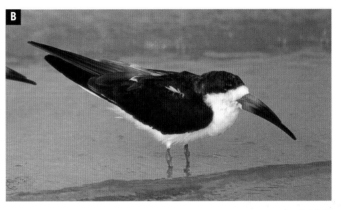

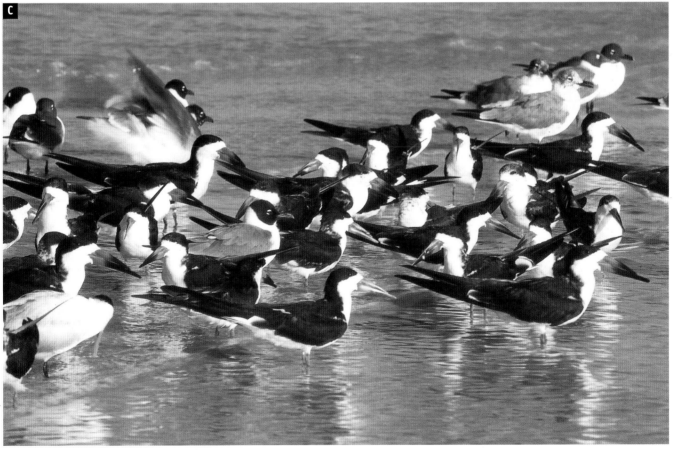

Black Skimmer

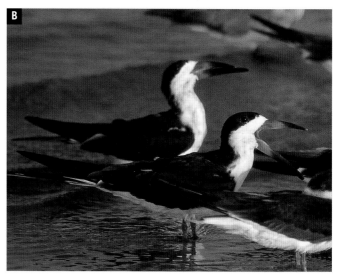

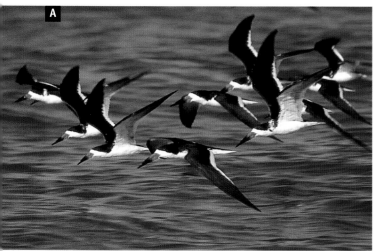

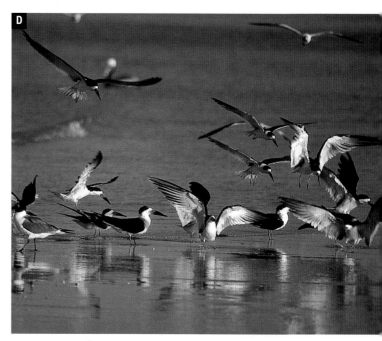

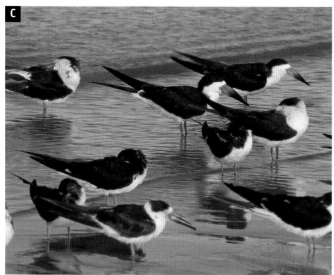

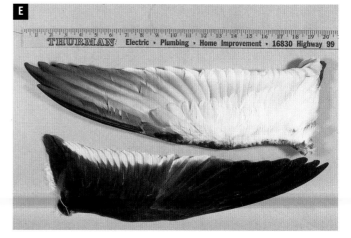

A With this view of black skimmers in flight you can see the skimmer's long, narrow, pointed wings. The skimmer's tail is white with black running down the middle. *S. Florida, early April*

B The upper beak is much shorter than the lower beak; notice the gap when the beak is closed. The nostril is lower on the beak than on most birds. *S. Florida, early April*

C Note the positions of several of these sleeping birds. *S. Florida, early April*

D Heads down, tails fanned, feet out and wings flapping furiously just before landing. *S. Florida, early April*

E Underwing (top), upperwing (bottom).

Royal Tern

You can find royal terns on the sandy beaches of the Atlantic coast (mid to southern), the Gulf coast and the southern Pacific coast in California and Mexico. They are often seen in large flocks on the beach.

They feed by flying about fifty feet above salt water, looking for small fish. Once spotted, the terns hover above their prey and dive into the water, capturing fish with their beaks.

The royal tern has two different plumages, one for winter and a very elegant one for breeding. In adult plumage the tern has a white body, light gray back and wings and a bright orange bill. In breeding plumage during the spring and early summer, the adult has a full black cap ending in line with the eyes. In nonbreeding plumage the black cap is broken up by a white forehead. Royal terns have ten primary feathers, twenty secondary feathers on the trailing edge, and twelve tail feathers.

A In winter the full black back of the head graduates into black streaks and into white on the forehead. *S. Florida, early April*

B This royal tern is molting from winter into summer plumage. *S. Florida, early April*

C In summer, terns' distinct black caps and sharp orange bills make them great subjects. *S. Florida, early April*

D This tern's untucked wings show the wing's white leading edge. Terns appear eyeless when there is not a strong highlight in the eye. *S. Florida, early April*

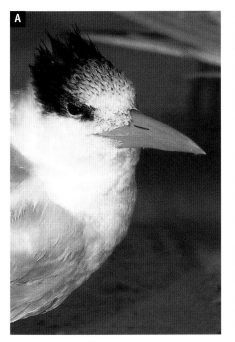

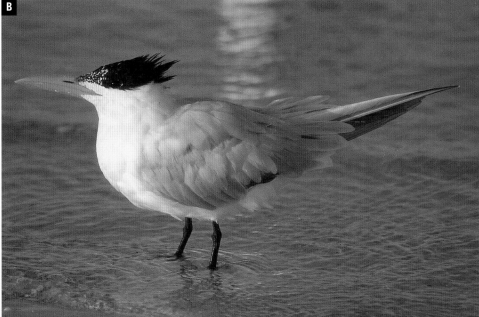

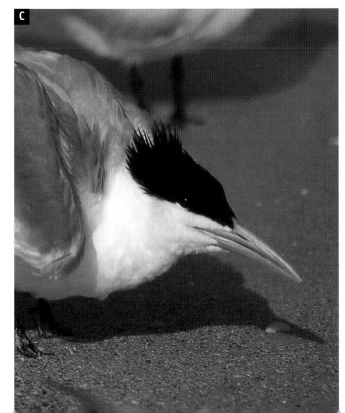

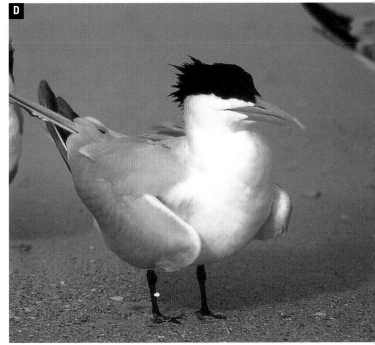

Royal Tern

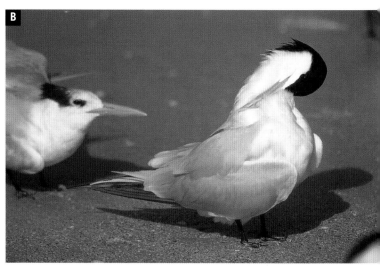

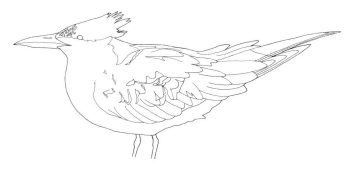

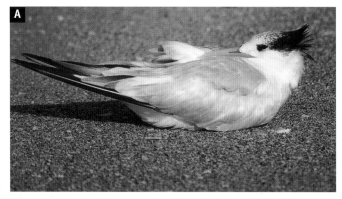

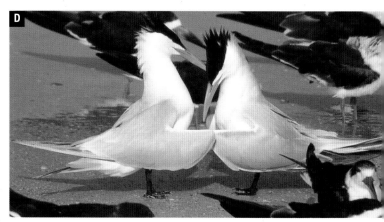

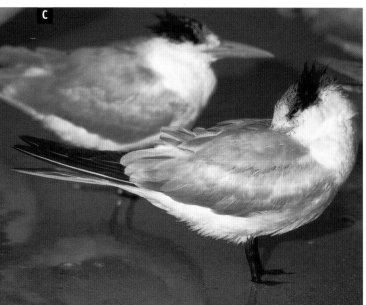

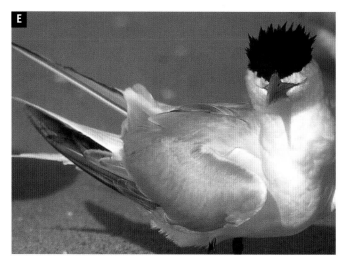

A This tern's crest looks very prominent as it tucks its bill into its back feathers. *S. Florida, early April*

B Like most birds, terns often twist themselves into unusual positions while preening. *S. Florida, early April*

C This resting bird's bill is almost completely covered up. The projected length of the folded wings and the tail is equal. *S. Florida, early April*

D In a mating display, terns hold their heads proudly bowed, chest out and wings lowered. *S. Florida, early April*

E This tern in summer plumage gives a good look at the thickness of the head and bill. *S. Florida, early April*

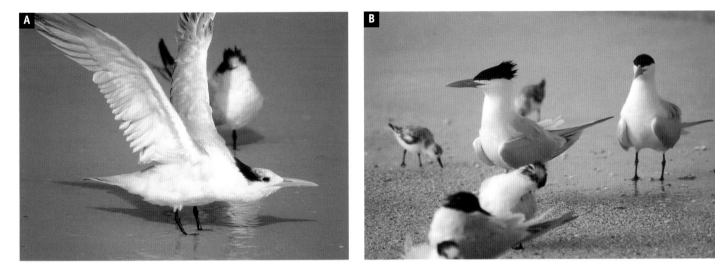

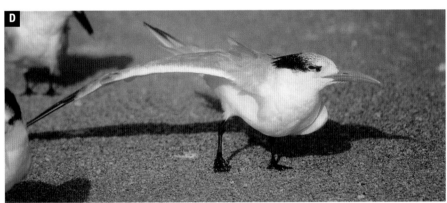

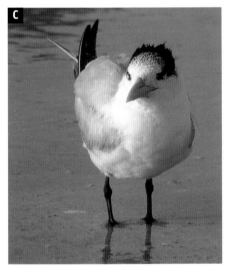

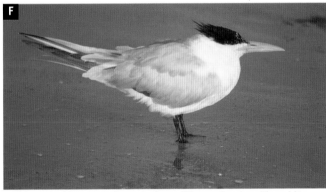

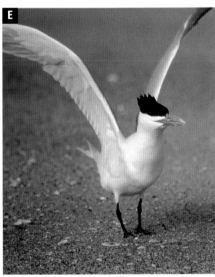

A This stretching tern shows a view of the underwing. The white feather edges are subtle. *S. Florida, early April*

B These terns are holding their wings untucked and lowered. The tern on the left is in a classic tern pose with crest held high. *S. Florida, early April*

C The wings can tuck in under the white breast feathers. *S. Florida, early April*

D This stretching tern shows the curvature of the wing and black webbed feet. *S. Florida, early April*

E A summer plumage bird ready for takeoff. *S. Florida, early April*

F A tern's white, forked tail tips show below the folded primary wing feathers. *S. Florida, early April*

Snow Goose

Snow geese are often seen in tremendously large flocks during winter and migration times. They winter in fresh and saltwater marshes and in shallow saltwater bays, often feeding in nearby grassy pastures and grainfields. They range over most of North America and are common in national and state wildlife refuges. Their nesting and summer grounds are in Arctic North America.

The most common form of snow goose has a white body and black wing tips, but there is a "blue form" that was once referred to as a separate species. The blue form of snow goose is most abundant on the Gulf coast in winter. It has a white head with a dark lower neck, belly, secondary feathers, primary feathers and back. In all forms of the snow goose, the male and female look the same. Snow geese have ten primary feathers, eighteen secondary and tertial feathers on the trailing edge and sixteen tail feathers.

A The tertials and wing coverts drape down at an angle in the rear part of the goose. *W. Washington, late February*

B Snow geese have a blackish "grinning patch" between the upper and lower beak. They often have a rusty color on their face near the bill. *W. Washington, mid-January*

C Here is part of a typical flock of adult and immature snow geese feeding in a grassy field. *W. Washington, mid-January*

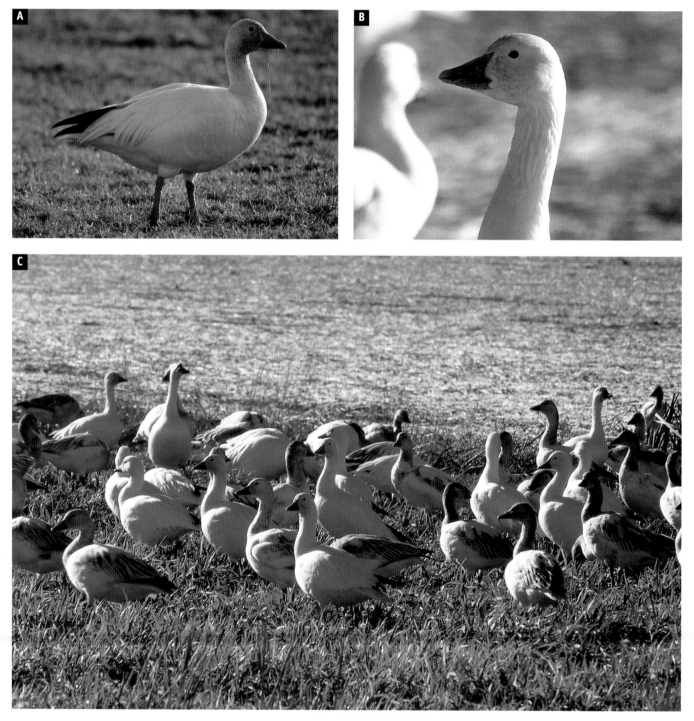

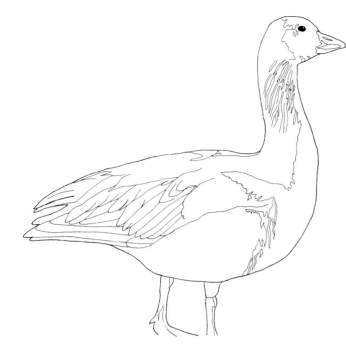

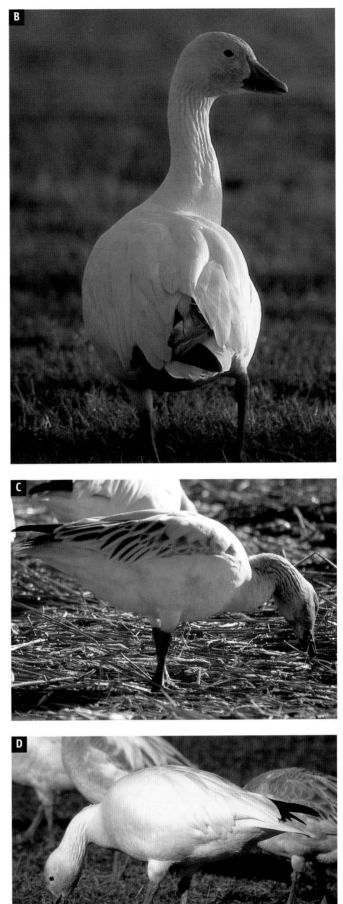

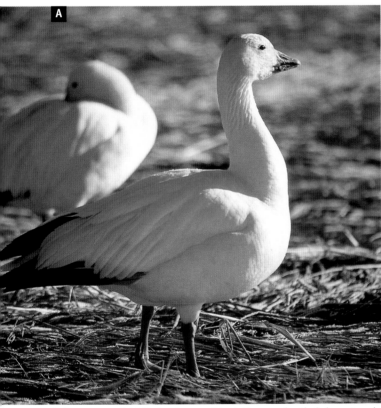

A Snow geese fold their wings and tuck them under their breast and side feathers. The white snow goose looks very colorful in the right lighting. *W. Washington, mid-January*

B A view from the back shows the crossed primary wing feathers, and how the feathers lie from side to side. *W. Washington, mid-January*

C Immature birds have black feet and an overall duskier color than adults. *W. Washington, mid-January*

D This adult shows a typical feeding posture. *W. Washington, late February*

Snow Goose

A In certain parts of the country, especially in state and federal wildlife refuges, snow geese gather in huge numbers during migration and wintering times. *Sacramento National Wildlife Refuge, California, mid-December*

B Three adults at different stages in flight. *W. Washington, late February*

C Coming in for a landing with lowered heads, fanned tails, legs hanging down and feet opened wide to catch maximum air resistance. *W. Washington, late February*

D When geese are a few feet away from landing, they lower their heads and vertically position their bodies. *W. Washington, late February*

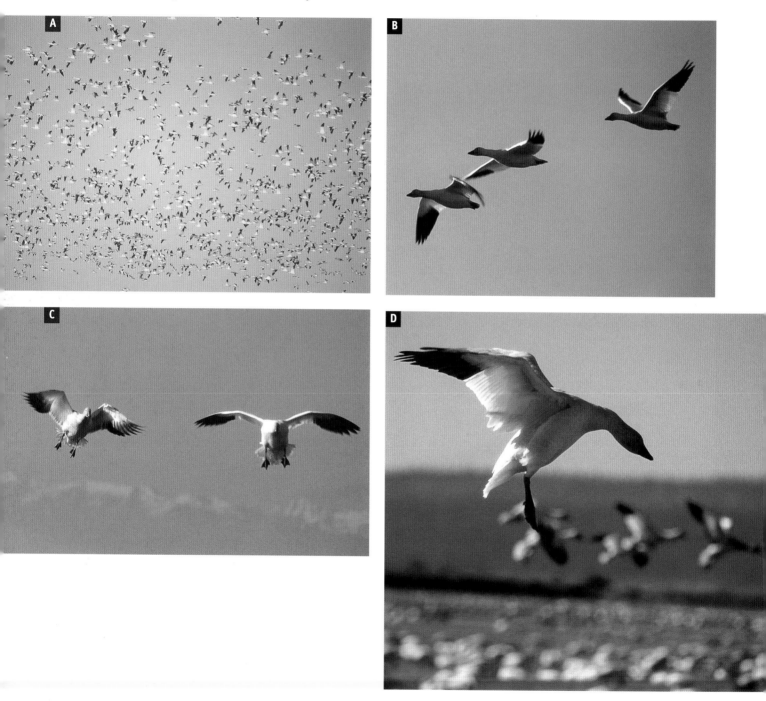

A This immature goose shows the division between the white back and the brown wing feathers outlined with white. *W. Washington, late February*

B Snow geese have distinct vertical "feather lines" on their necks. A shadow helps define the shape of the long upperwing coverts. *W. Washington, late February*

C A goose pauses to exercise its wings giving a view of the black primary feathers. *W. Washington, late February*

D Adult upperwing. This adult has not molted out all his gray immature primary covert feathers yet.

E Adult underwing.

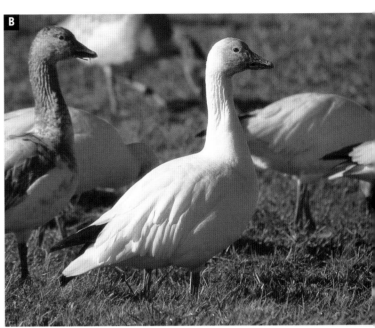

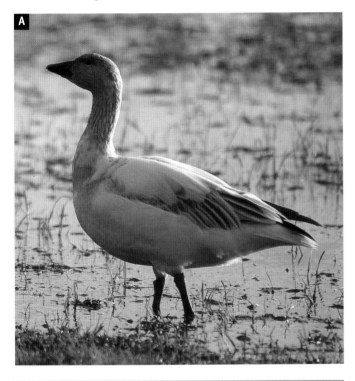

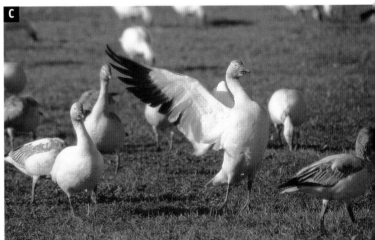

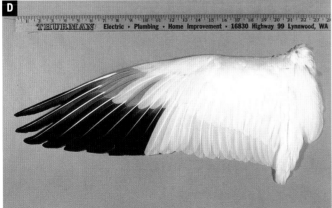

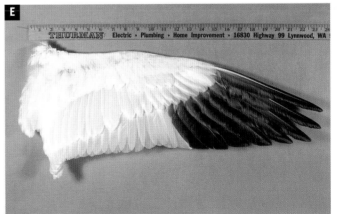

Barrow's Goldeneye

Barrow's goldeneyes are diving ducks that have a larger range in western North America than in the east. In the west they range from Alaska down through Canada and into Washington, Oregon, California, Montana and Idaho. In the east they range from Newfoundland and Quebec down into some of the New England states. They spend their summers on lakes, rivers and ponds often near woodlands, but most winter in coastal areas. Goldeneyes dive under the water for their food which consists of aquatic insects, crustaceans, mollusks, small fish and some aquatic plants. Barrow's goldeneyes have ten primary feathers, thirteen secondary and tertial feathers on the trailing edge and sixteen tail feathers.

A Male goldeneye (right). *W. Washington, early February*

B Female goldeneye (left). *W. Washington, early February*

C Male upperwing. Several of the secondaries are all white and the greater coverts, in front of those white secondaries, have white feather ends. This normally forms a solid block of white rather than the black trimmings on the greater coverts as shown here.

D Male underwing.

E Female upperwing.

F Female underwing.

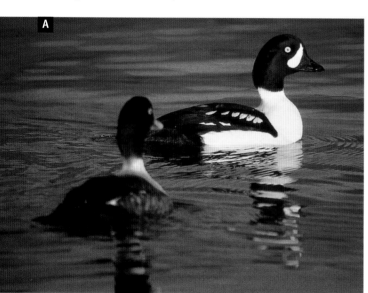

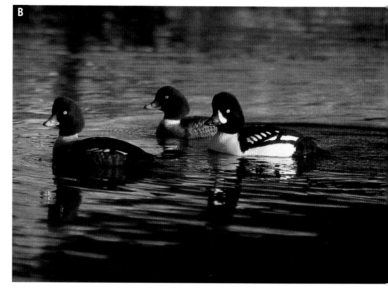

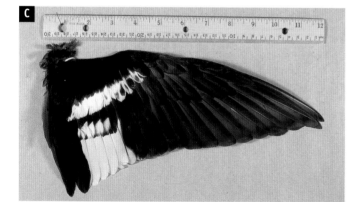

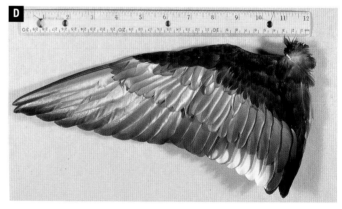

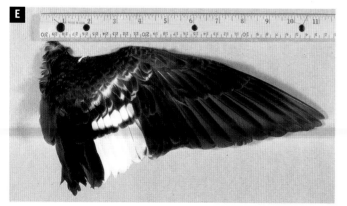

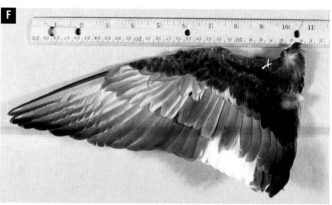

Blue-Winged Teal

Blue-winged teal range over most of North America except in some of the upper reaches of Canada and Alaska. They are uncommon on the West Coast. These dabbling ducks are found on the fresh water of ponds, lakes and marshes, but will also use protected saltwater areas. They feed mostly by skimming the water's surface but will also tip up their tails and submerge their heads when feeding on aquatic vegetation, seeds, mollusks, crustaceans and aquatic insects. Blue-winged teal have ten primary feathers, thirteen secondary and tertial feathers on the trailing edge and fourteen tail feathers.

A Male. *S. Florida, late March*

B Female. *S. Florida, late March*

C Male upperwing.

D Male underwing.

E Female upperwing.

F Female underwing.

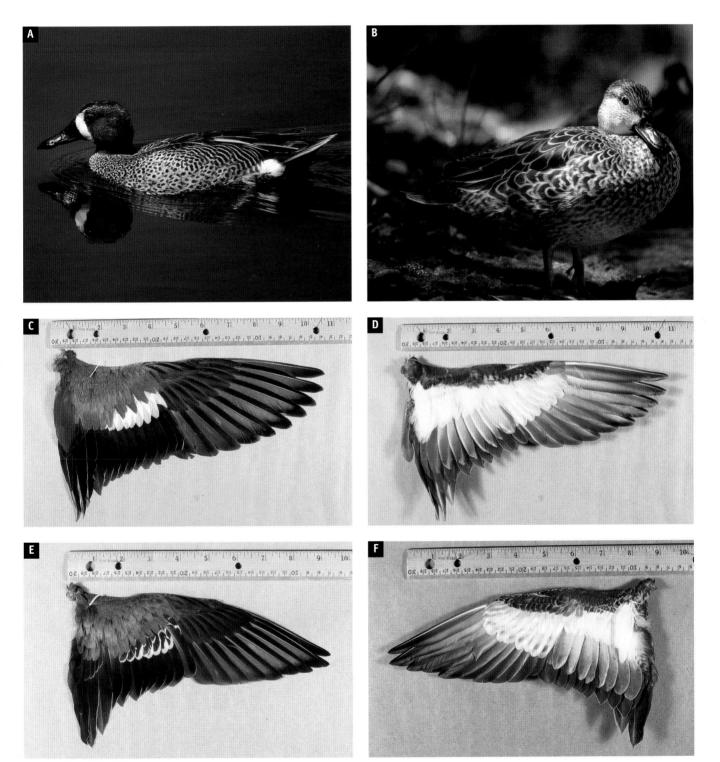

Greater Scaup

In the winter, greater scaup range from Alaska down to California in the west, from Quebec down to South Carolina in the east, and throughout the Great Lakes region. During the summer they range from Alaska across the upper provinces of Canada and around the south end of Hudson Bay. In the summer these diving ducks spend their time on tundra lakes, but in winter they prefer saltwater habitats. Scaup dive under the water to eat aquatic plants, mollusks and crustaceans. Greater scaup have ten primary feathers, fourteen secondary and tertial feathers on the trailing edge and fourteen tail feathers.

A Male. *W. Washington, early February*

B Female. *W. Washington, early February*

C Male upperwing.

D Male underwing.

E Female upperwing. The coverts on her innerwing have only a few tiny gray patterns scattered about.

F Female underwing.

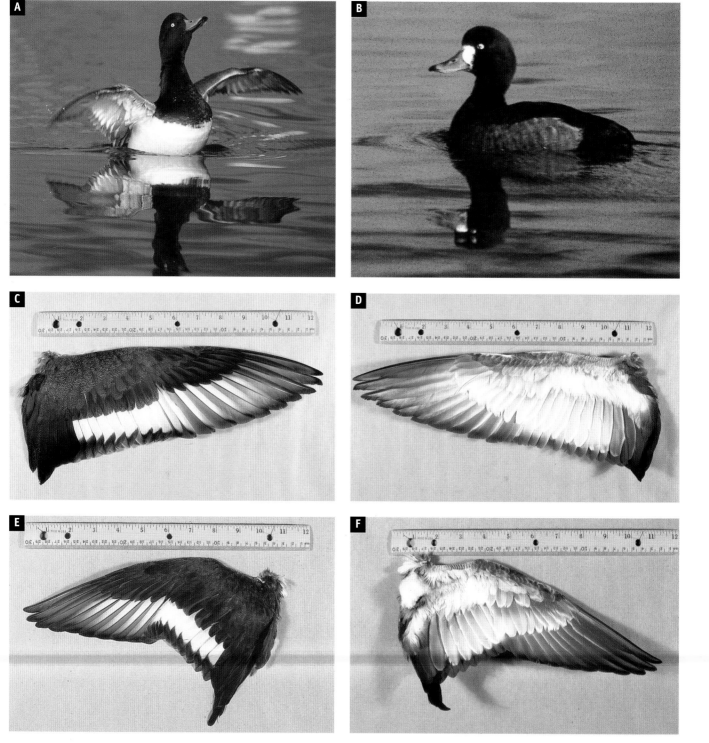

Green-Winged Teal

Green-winged teal are North America's smallest dabbling ducks. They range over most of North America except for some of the upper reaches of Canada. They are common in freshwater lakes, ponds and marshes and in protected saltwater marshes. They feed mostly on aquatic vegetation and other small aquatic life, and may also visit grainfields. Green-winged teal have ten primary feathers, thirteen to fourteen secondary and tertial feathers on the trailing edge and sixteen tail feathers.

A Green-winged teal, like this male with his eyes closed, are very small ducks. The primary feathers on the right side of this teal have been removed. *Captive bird*

B Female. It looks like the primary feathers on the left side have been removed on this teal. *Captive bird*

C Male upperwing.

D Male underwing.

E Female upperwing.

F Female underwing.

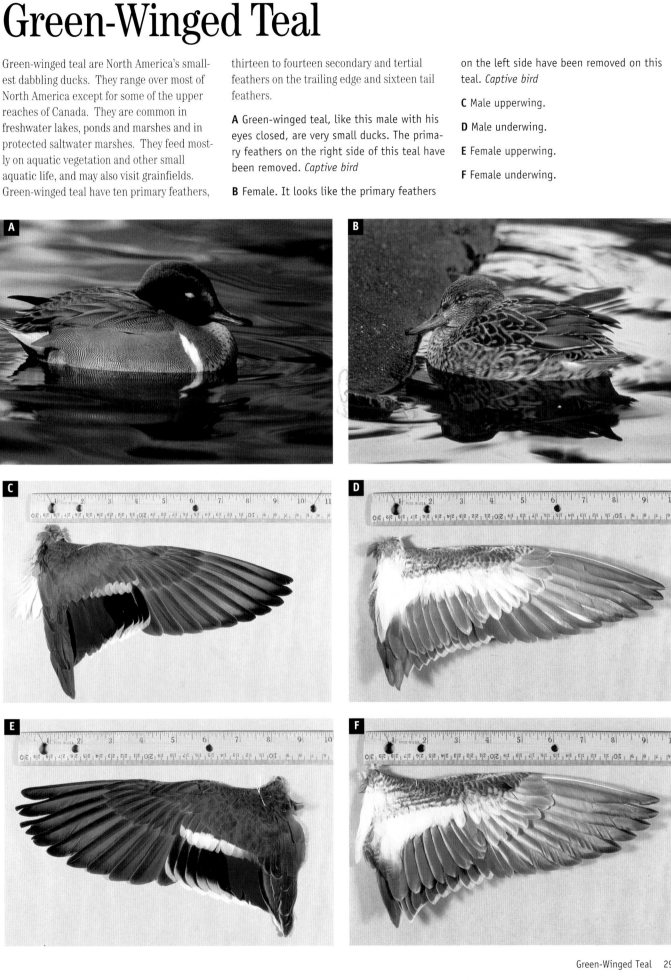

Harlequin Duck

Harlequin ducks are more numerous in the West than the East. These diving ducks range from Alaska down through western Canada and into Washington, Oregon, Idaho, Montana, California and Wyoming in the west. In the east they range from Baffin Island, Canada, Newfoundland and Quebec down into the New England states. They nest and summer on mountain streams and rivers and spend their winters on rocky coasts. In the summer they eat aquatic insects by diving in swift water, and in winter, on salt water, they dive to feed on mollusks, crustaceans, sea worms and some small fish. Harlequin ducks have ten primary feathers, twelve to thirteen secondary and tertial feathers on the trailing edge and fourteen tail feathers.

A Male. *Captive bird*

B Female (right) with chicks. This is a typical summer habitat of swift-moving mountain streams and rivers where the young are raised. *Alaska, August*

C Male upperwing (top) and underwing (bottom).

D Female upperwing (top) and underwing (bottom).

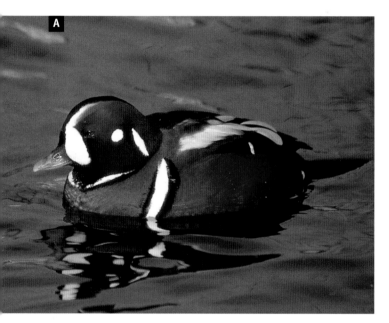

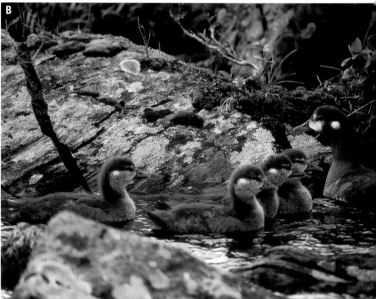

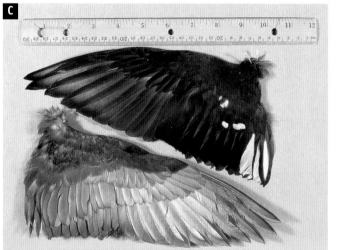

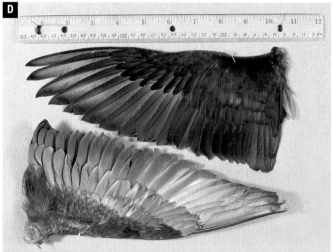

Mallard

Mallards range across most of North America except in the upper reaches of Canada. These most recognizable, dabbling ducks eat vegetation on land and in the water, and will also eat aquatic insects and small aquatic animals. They are primarily shallow-water feeders, but feed frequently in farm fields on waste wheat, oats, corn and barley. Mallards have ten primary feathers, thirteen secondary and tertial feathers on the trailing edge and twenty tail feathers.

A Male. The blue speculum of the wing often shows a little above the side feathers. *E. Washington, late December*

B Female. *E. Washington, late December*

C Male upperwing.

D Male underwing.

E Female upperwing. The lesser and median upperwing coverts of the female are edged with light brown. Notice the subtle difference in the tertials between the male and female.

F Female underwing.

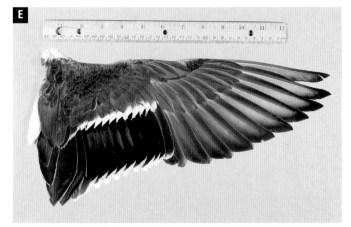

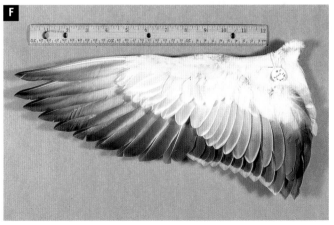

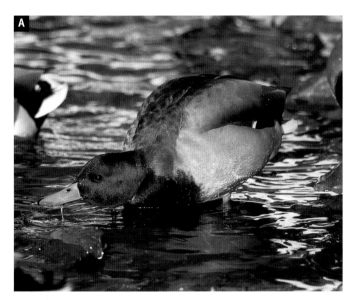

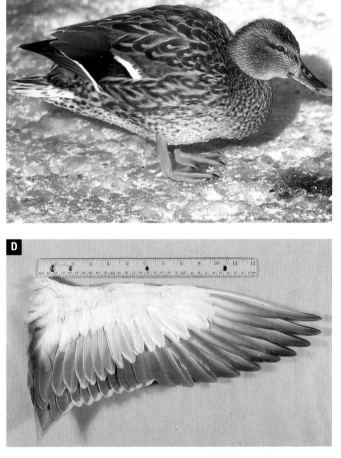

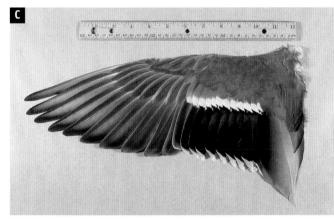

Pintail

Pintails range over most of North America except some areas in the eastern United States. These dabbling ducks are more abundant in the west than the east. Pintails feed in shallow water on aquatic vegetation, seeds and roots, but may also feed on small aquatic animals and insects and in fields of waste grains and corn. Pintails have ten primary feathers, thirteen secondary and tertial feathers on the trailing edge and sixteen tail feathers.

A Male. The primary feathers on the right side have been removed. *Captive bird*

B Female. The primary feathers on the left side have been removed. *Captive bird*

C Male upperwing.

D Male underwing.

E Female upperwing.

F Female underwing.

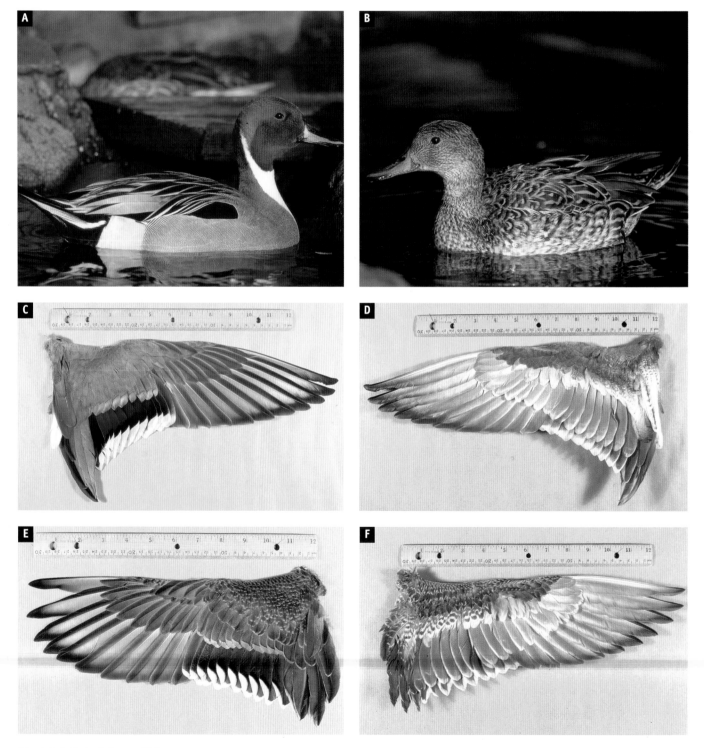

Wood Duck

Wood ducks are common in the eastern and western United States and range up into Canada in some areas, but they are absent from many of the plains states. They are especially common in small bodies of water like ponds, streams and rivers with accompanying woodlands. They nest in tree cavities. Wood ducks feed mostly on aquatic plants, but also eat small aquatic animals and insects; venture into woodlands to eat acorns, nuts, and fruits; or feed in cornfields. Wood ducks have ten primary feathers, twelve to thirteen secondary and tertial feathers on the trailing edge and fourteen tail feathers.

A The male wood duck is one of North America's most colorful ducks. *W. Washington, early February*

B Female. *W. Washington, early February*

C Male upperwing.

D Male underwing.

E Female upperwing.

F Female underwing.

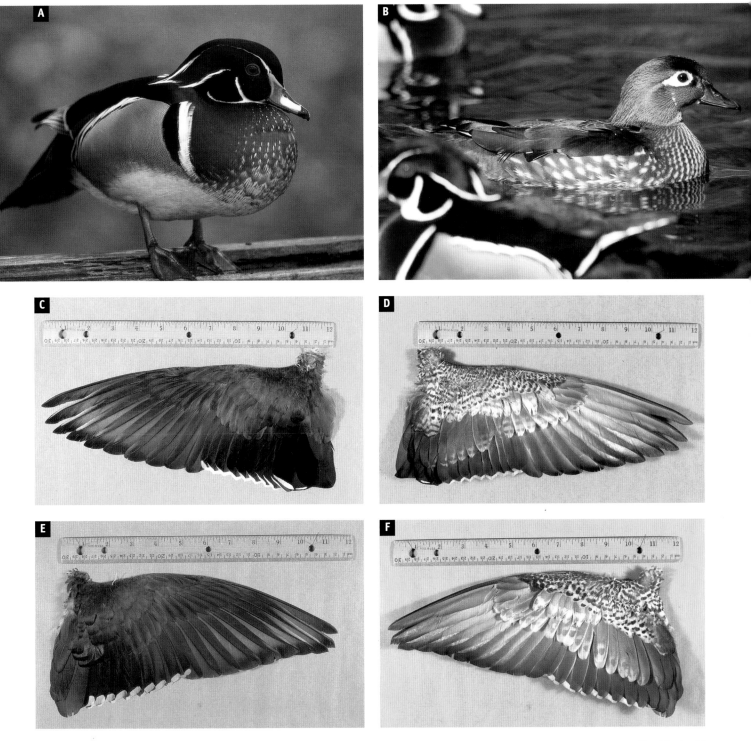

DEMONSTRATION

by Bart Rulon

Barrow's Goldeneye in Acrylic

Materials

Palette:

Winsor & Newton Acrylics—
Titanium White
Raw Sienna
Raw Umber
Burnt Sienna
Brilliant Yellow
Ultramarine Blue
Ivory Black

Grumbacher Acrylics—
Cadmium-Barium Yellow Light

Liquitex Acrylics—
Scarlet Red (Cadmium Red Light Hue)

Brushes:

flat no. 12
round no. 00, no. 2, no. 4

Other:

Gessoed Masonite panel

I approach a duck stamp design very differently from the way I paint one of my normal paintings. Duck stamps usually feature a male/female pair captured in a "perfect pose" with the ducks pictured very large in the frame. In choosing one of my photographs to work from I decide to go with part of one that shows a pair of Barrow's goldeneyes in a classic duck stamp pose. This photograph already has most of the elements in it that make for a good duck stamp design: warm early morning lighting, ducks in a good composition shown in regal poses, and a soft background of water that makes the ducks pop out and become noticed. With all these elements already in place in my photograph, very little has to be changed for my painting.

Reference photo

1. Composition

The biggest question is how large the ducks should be in the composition. Make enlarged and reduced photocopies of your initial sketch for comparison within your image size. Narrow this down to four different sizes and redraw them with the painting edges drawn in. I choose a sketch with the birds a little smaller so I can include all their reflections in the composition.

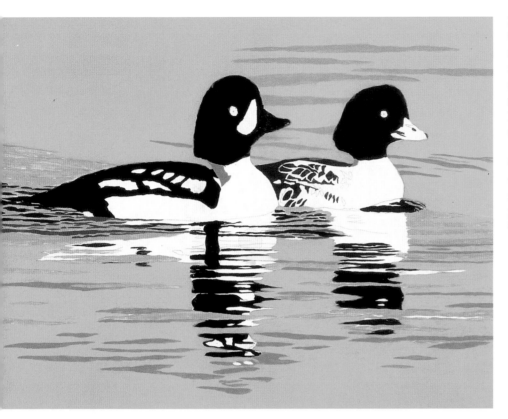

2. Begin Painting

On the gessoed Masonite panel, block in the darks of the birds' heads and backs and the reflection of those areas. For the male, use a mixture of Ultramarine Blue and Ivory Black, and for the female, a mixture of Burnt Sienna, Raw Umber, Ultramarine Blue, Ivory Black and Titanium White.

Use a mix of Raw Sienna, Scarlet Red, Titanium White and Burnt Sienna to paint the water with a no. 12 flat brush. Use a no. 4 round brush to paint blue where the water reflects the sky, with a mix of Ultramarine Blue, Titanium White and a touch of Scarlet Red.

3. Details

Refine the water by going back and forth with light and dark mixtures, painting streaks as indicated in the reference photo. Begin the eyes with a base of Cadmium-Barium Yellow Light/Brilliant Yellow/Titanium White mix, adding a base of Ivory Black for the pupil. Add feathers to the goldeneyes with a no. 2 round brush using a mixture of Ultramarine Blue, Scarlet Red and Titanium White on the male and mixes of the previous colors used on the female head and back. Where the feathers are lightest and most colorful, paint pure white first and then glaze over that with the purple mix.

For white areas on the male, accent the pure white with a warmer mixture of Raw Sienna and white to help indicate the warm, early-morning sun. Add hints of a light blue mixture to the shadow side of the white markings, and add feather details on the black back of the male with a subtle mixture of Raw Umber, Ivory Black and Titanium White just slightly lighter than the base color. Continue the details on the female's back using her same color mixes in varying degrees.

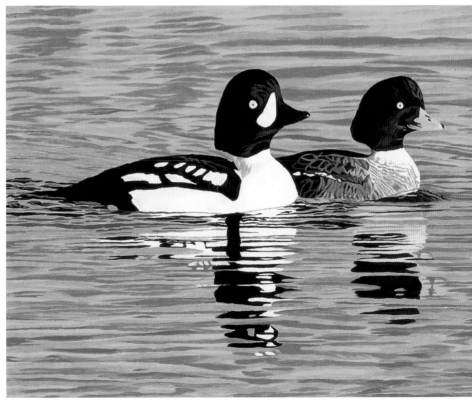

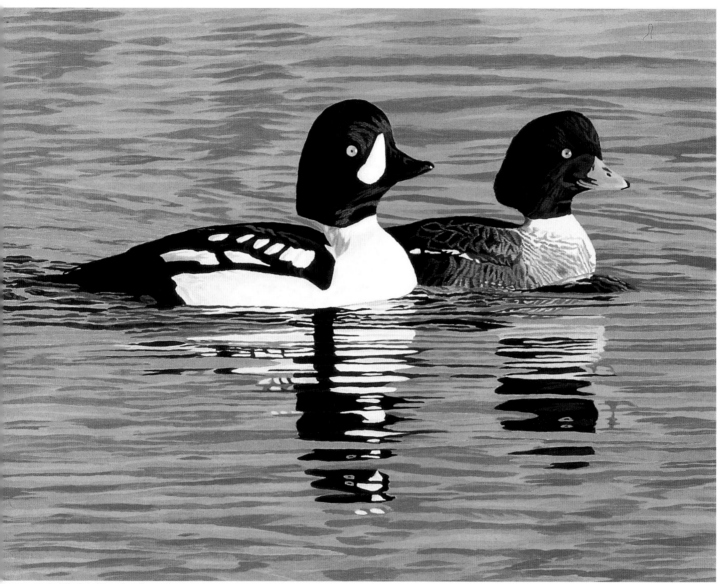

4. Finish the Ducks

Finish the eyes with a no. 00 round brush by adding a mixture of
Cadmium-Barium Yellow Light, Brilliant Yellow, Ultramarine Blue and
Scarlet Red to indicate a slight shadow in the middle of each side. Then
add a bright white highlight to the leading edge of each eye.

Refine feather details on the female by selectively adding rows of
small dark streaks with a no. 00 round brush to give a feathered look to
the edges. Add subtle feather details on the dark tail and rump of the
male with a no. 2 round brush and a mixture of Raw Umber, Ivory Black
and Titanium White. Give shape to the male's beak by adding subtle
shading and highlights with a mixture of Ultramarine Blue, Scarlet Red,
Ivory Black and Titanium White. Brighten the sunlit highlights on the
male's head using the same technique as before of underpainting with
white and glazing over this with a more colorful mixture of Ultramarine
Blue, Scarlet Red and Titanium White.

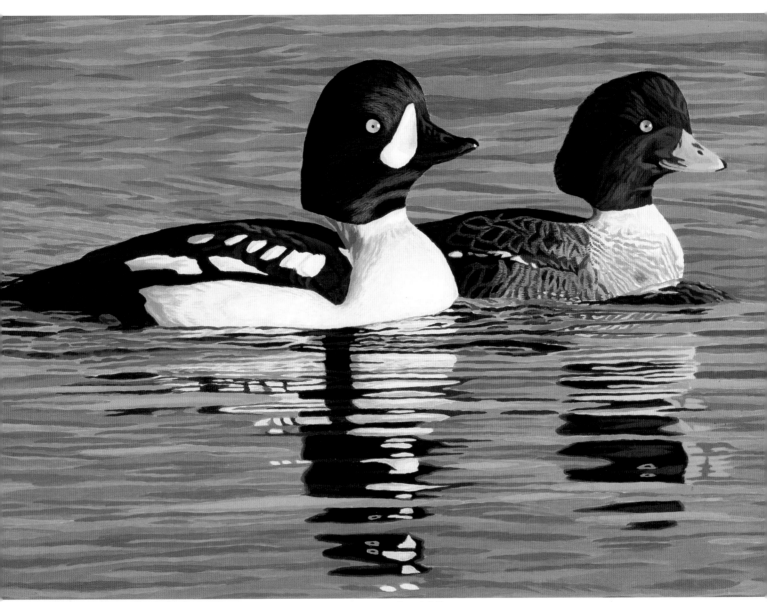

5. Reevaluate the Painting

After setting your painting aside for a few days without looking at it, pull it out and compare it to your reference photo. The colors in the water on my painting don't match those in the photograph. The colors in the photo are deeper and more reddish. So, I repaint the background water with the same mixtures of paint used before, but with less Titanium White and more Scarlet Red and Burnt Sienna.

The white breast and sides of the male need more shading to give the bird a more realistic shape even though the photograph does not show it. Since the photo doesn't help, use the direction of the sun as a guide, adding various value mixes of Scarlet Red, Ultramarine Blue and Titanium White to the spots that would be somewhat shaded from the sun. Painting a mixture of Titanium White, Raw Sienna and Scarlet Red adjacent to those shadows indicates the warmth of the early morning sun. This same process can be applied to the white crescent-shaped patch on the head of the male.

Barrow's Goldeneyes
BART RULON, Acrylic,
9" x 12" (23cm x 30cm)

HERONS AND EGRETS

Herons and egrets are usually associated with the water's edge, both fresh and saltwater. They exhibit the same general body shape and proportions, with a spear-like beak, long neck and long legs.

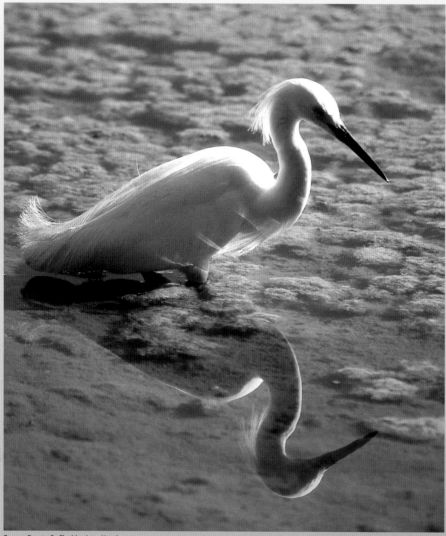

Snowy Egret. *S. Florida, late March*

Great Blue Heron

The great blue heron is the largest and most widespread heron in North America. It is common in most areas of the United States, ranging into Canada and Alaska to the north. "Great blues" usually nest in groups in trees, but will also nest on the ground or on rock ledges. You often see these herons in fields or at the edge of fresh or saltwater bodies, stalking slowly for prey. Just before striking forward for a meal the heron usually stands perfectly still and watches its prey. These herons eat a large variety of prey including fish, frogs, lizards, mice, various insects and more.

The male and female heron look the same, but the male averages a little larger. Birds in breeding plumage have plume feathers (long pointy feathers) on their backs and necks. Nonbreeding plumage birds lack plumes. The great blue heron has ten primary feathers, fifteen secondary feathers on the trailing edge and twelve tail feathers.

A A classically posed adult in full breeding plumage. *S. Florida, early April*

B The long legs and toes of herons are covered with protective scales. The middle toe is the longest. *S. Florida, early April*

C Study the shape of the head and beak and the angle of the eyes on this immature heron. *W. Washington, late March*

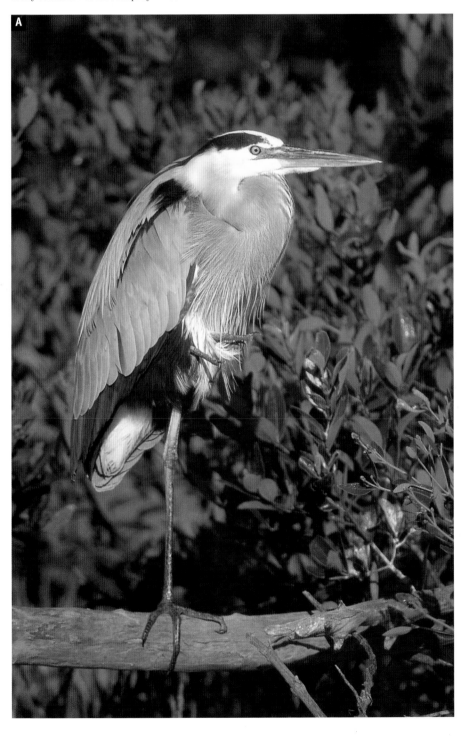

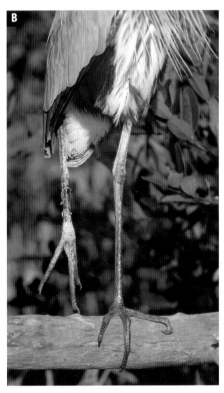

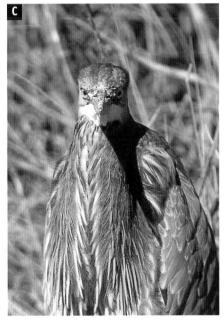

Great Blue Heron

A Note the reddish brown upper leg feathers on this adult bird. *S. Florida, early April*

B This view of an immature heron gives you an idea of the shape of the back, the layering of the wing feathers and feather splits. *W. Washington, late February*

C The front edge of an adult's neck is white with dark streaks. *S. Florida, early April*

D Notice the long plume feathers on the back of this adult in breeding plumage. *S. Florida, late March*

E This immature bird is starting to develop the neck and head plumes of an adult. *W. Washington, late January*

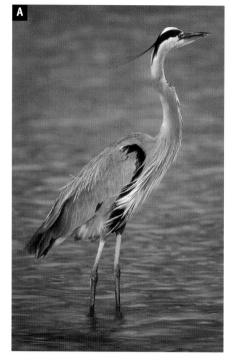

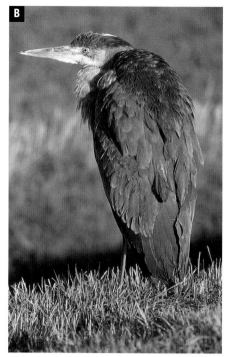

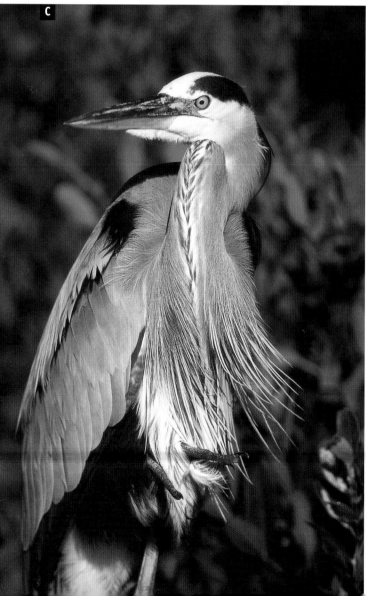

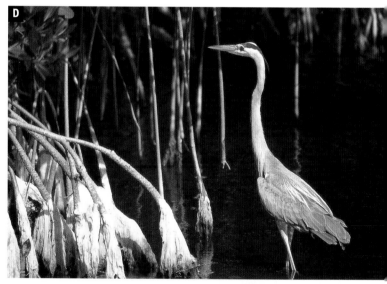

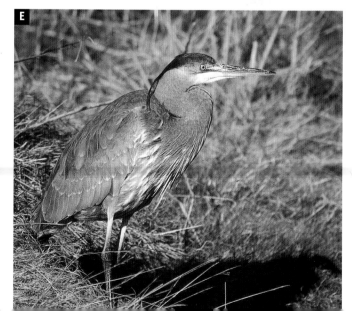

Great Egret

This large white egret is common over much of the United States, both on the coast and in the interior. Great egrets are most often in saltwater or freshwater marshes, streams, ponds, mudflats, mangrove swamps and fields. They usually nest in trees, often in large colonies with other egrets and similar species such as herons and wood storks.

These egrets eat a variety of prey including fish, amphibians, insects and mice. They will hunt alone or in large groups of other great egrets, other egret species, herons and wading birds.

Great egrets are primarily white, with an orange-yellow bill and black legs. The male and female look the same, but the male averages a little larger. In breeding plumage, long plumes are present on the backs and necks of the birds, with the plumes on the back often trailing off beyond the tail. On breeding birds the lore (area between the eye and bill) is green. The great egret has ten primary feathers, thirteen secondary feathers on the trailing edge and twelve tail feathers.

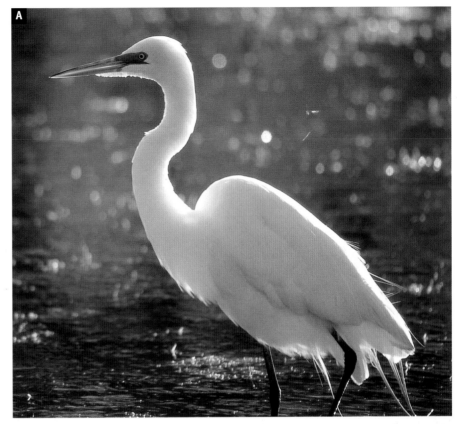

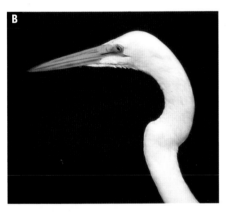

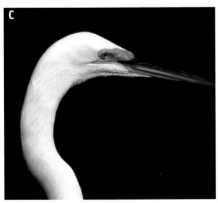

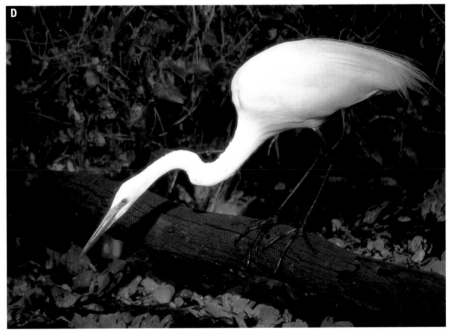

A A backlit egret is a great subject. *S. Florida, early April*

B Egrets have lores without any feathers. *S. Florida, late March*

C In the height of breeding season the lore changes from its normal yellow to green. *S. Florida, late March*

D The moment before the strike shows a good look at those long toes. *Corkscrew Swamp, Florida, late March*

Great Egret

A This head-on view gives you a look at the bill pointing straight on and the subtle layering of feathers on the neck. *Central California, mid-December*

B This egret is shown in its typical Florida habitat, on the edge of the mangroves. Great egrets don't hunt from a vertical branch or root like this as much as smaller herons and egrets do. *S. Florida, late March*

C and D Early morning light softens and warms up the egret's plumage. *S. Florida, late March*

E In softer light it's easier to see the subtle feather details. *Corkscrew Swamp, Florida, late March*

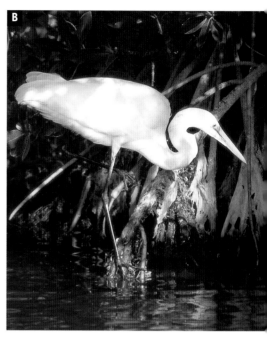

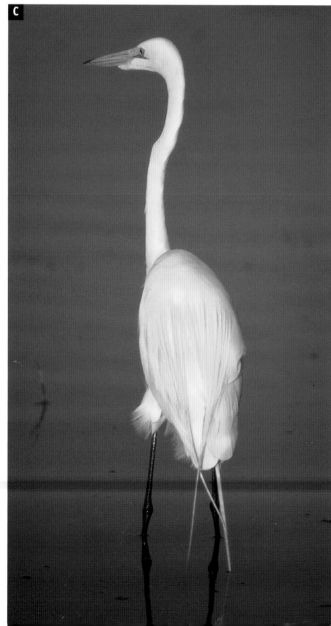

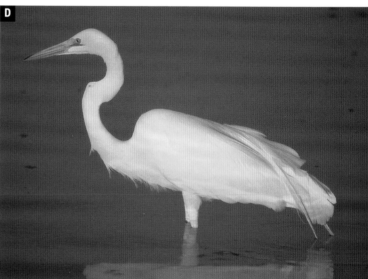

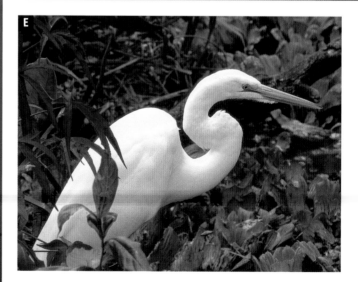

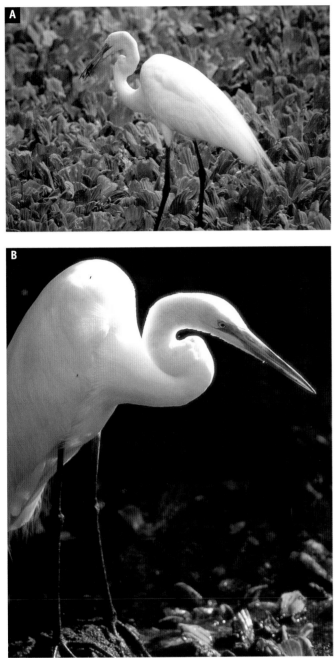

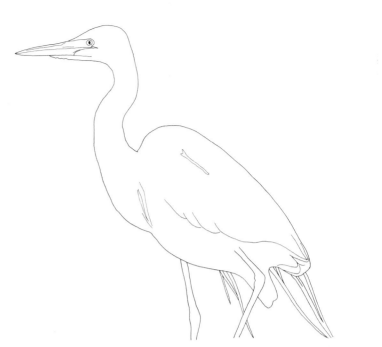

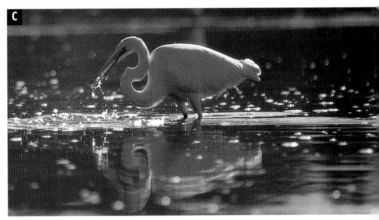

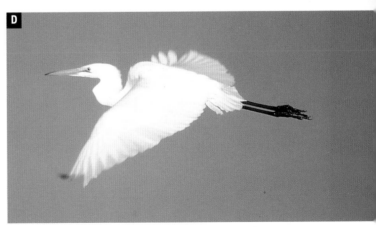

A A successful hunt yields a crayfish. *Corkscrew Swamp, Florida, late March*

B Notice how hunchbacked this egret looks in this dramatic pose. *Corkscrew Swamp, Florida, late March*

C Egrets' long legs enable them to hunt deeper in the water than shorebirds. *Central California, mid-December*

D A great egret in the middle of a downstroke shows slightly bent primary tips, the usual flying position with the neck in a tight S-curve, and legs trailing straight behind. *Central California, mid-December*

Combine Several Photos to Create a Painting

Inspiration and Ideas

Watching the interaction of snowy egrets, great egrets and one great blue heron from my kayak gives me an idea for a painting. I find a picture that shows these birds in a pleasing composition.

Composition and Lighting Considerations

I decide to add another snowy egret, and move the two snowy egrets in the middle of the group back and change their poses. I also want to add a great blue heron and change the background to create a scene similar to the one I witnessed from my kayak.

I gather photos of various birds taken in the same area and work out ideas for a better composition. It is essential to keep lighting consistent throughout the painting. To avoid having to "make up" the lighting and shadows on the added birds, I pick photos taken during the same time as my main reference picture or photos with similar lighting angles.

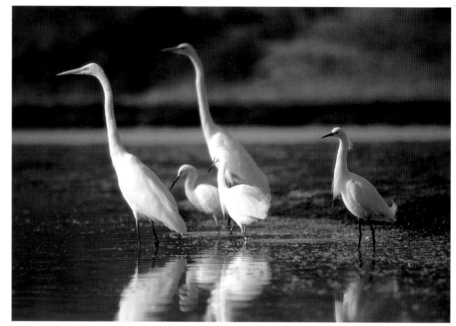

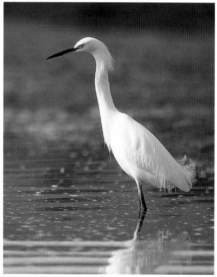

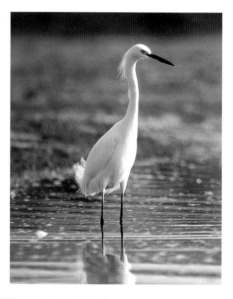

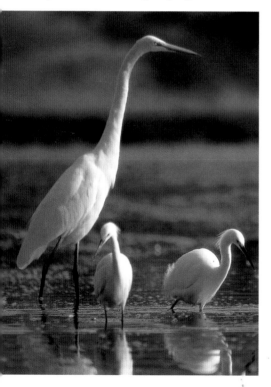

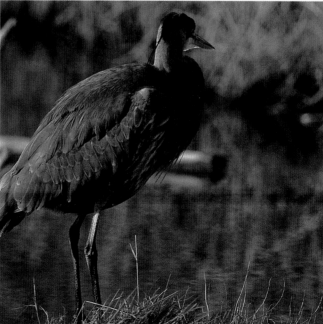

Habitat and Size Considerations

Habitat is the most difficult thing to change. I pick habitat photos with the sun coming from the same general direction as my main reference picture. These photos are taken within a couple hundred yards of where I saw the egrets. The new habitat adds better color and more contrast to the scene. Fortunately my habitat reference photos include black-necked stilts which I can use as a size comparison to determine how large the egrets and heron should be drawn in their new scene.

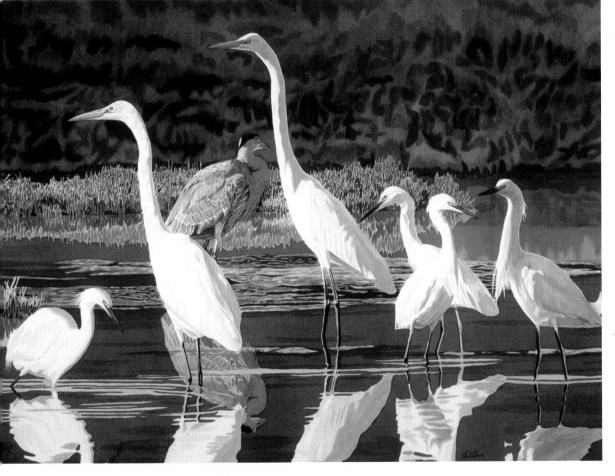

Great Egret, Snowy Egrets, and a Great Blue Heron
BART RULON, Watercolor
29" x 41" (74cm x 104cm)

Green Heron

This small heron ranges over most of the United States and southward. Green herons prefer streams, ponds, lakes and mangrove swamps. They seem to like places with some cover nearby like trees or bushes.

They hunt in classic heron fashion by striking from a still position or stalking slowly up to prey before striking. Sometimes they hunt by scraping the muddy bottom with one foot, looking for prey to move from the disturbance. They hunt from the water's edge or from tree branches near the water's surface where they sometimes lunge their whole body into the water after a fish. These herons eat many small prey in and near the water, like fish, minnows, insects, amphibians, crayfish and even mice.

Males and females look the same, but in breeding plumage the male's yellow legs turn orange. Green herons have ten primary feathers, eleven secondary feathers on the trailing edge and twelve tail feathers.

A The green heron has a groove running horizontally along the upper beak. *Corkscrew Swamp, Florida, late March*

B This photo shows the beak and head thickness from the top and how the toes are held when lifted up to walk. *Everglades National Park, Florida, late March*

C The greenish-blue back and wings give this heron its name. *Everglades National Park, Florida, late March*

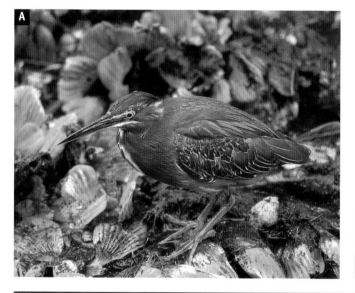

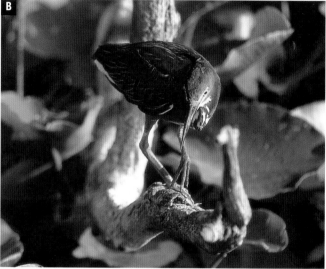

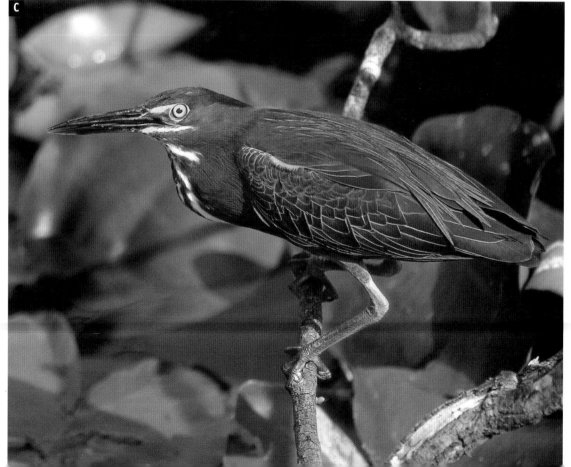

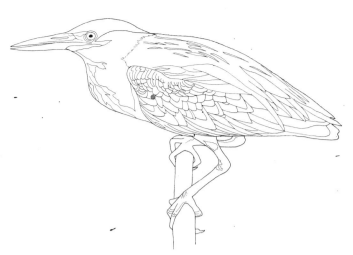

A Typical habitat. *Everglades National Park, Florida, late March*

B This heron, perched on mangrove roots, sports duller yellow legs than that of the male in high breeding plumage. *Southern Florida, late March*

C The front of a green heron's maroon neck is streaked with white. *Everglades National Park, Florida, late March*

D Upperwing.

E Underwing.

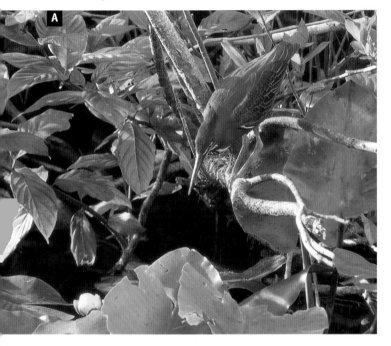

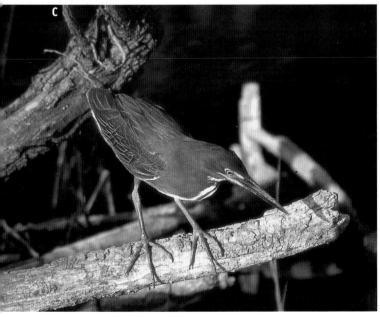

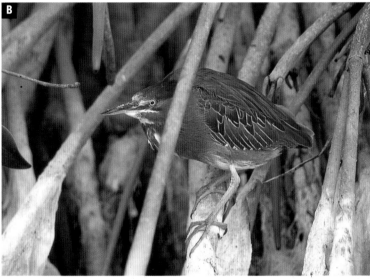

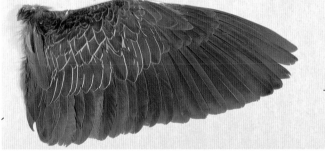

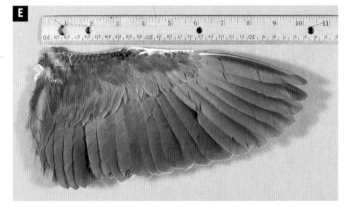

Little Blue Heron

Little blue herons range from New England down the eastern coastal states, through Mexico and beyond. They also range into some of the interior southeastern states, and in breeding season can be found much farther north into Canada in the east, Minnesota in the middle United States and California in the west.

Little blue herons are generally very slow and methodical hunters. They often feed in the company of tricolored herons. They do not normally wade out as deeply as other herons; they hunt from shore, from a branch or in the shallow water. They prefer fresh water but can be found in salt water. These herons eat the same prey as most other herons and frequent ponds, lakes and marshes.

A little blue heron has a slate blue-gray body with a purple neck and head. The beak and lore are bluish and the legs and feet are dark. Male and female birds look alike. Immature birds start with an all white body except for bluish wing tips, grayish beak and lore and greenish-yellow legs and feet. In the first spring of its life an immature little blue heron begins to molt its feathers into adult plumage. During this molting phase the young bird is white blotched with bluish feathers.

Little blue herons have ten primary feathers, twelve secondary feathers on the trailing edge and twelve tail feathers.

A Immature bird. *Corkscrew Swamp, Florida, late March*

B A view of the head looking forward. Notice the shape of the eye and where the forehead meets the beak. *S. Florida, early April*

C Notice the brilliant blue at the base of this heron's bill and lore, and the head feathers displaced by the wind. *S. Florida, early April*

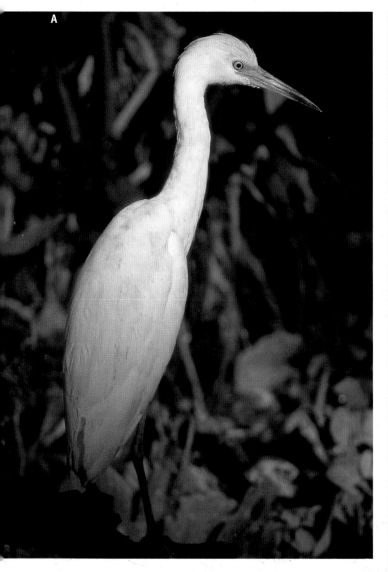

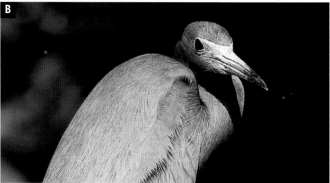

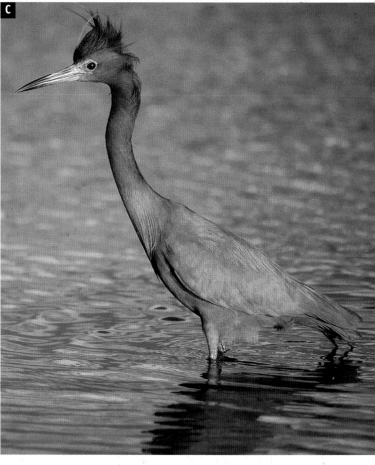

A Notice the direction of the neck feathers and the pointed covert feathers on the wing. *S. Florida, early April*

B Notice the long plume feathers on the back of the head and the fine, skinny upper back feathers. *S. Florida, late March*

C Typical habitat at the water's edge. *S. Florida, late March*

D Note the long plumes trailing from the back into the water and from the head. *S. Florida, early April*

E When the little blue heron scratches its head the crest is usually raised. *S. Florida, late March*

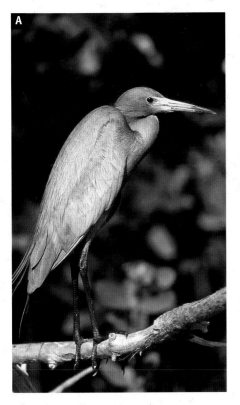

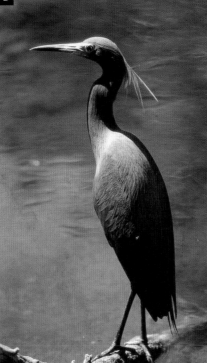

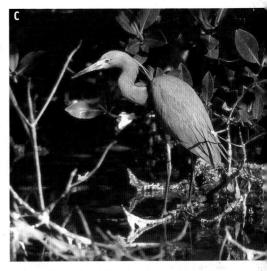

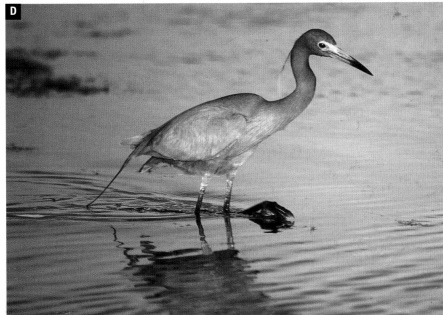

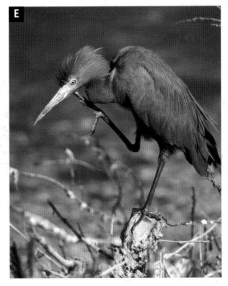

Reddish Egret

This beautiful and uncommon egret is a coastal species found in the United States mostly in southern Florida, the Gulf coast of Texas and Louisiana, and, rarely, in southern California. Reddish egrets range south into Mexico and nest in Baja, California. They prefer an open saltwater habitat.

They feed on small fish and other small aquatic animals, usually feeding alone or in small flocks of two to four birds. They often feed by dancing around quickly with their wings spread, chasing fish. Sometimes they will hunt in the shadow of their own spread wings, and stir up the water's bottom with their feet to find food.

Adult reddish egrets come in two colors. The most common is the dark form, and less common is the white form. The dark-form birds have a rufous colored (reddish brown) neck with a blue-gray body, and the white-form birds have an all white body. In both color forms the bill is fleshy pink with a black tip. Reddish egrets have ten primary feathers, twelve secondary feathers on the trailing edge and twelve tail feathers.

A This bird is following kids catching live minnows for fishing bait. The free meal is welcomed. *S. Florida, early April*

B Notice the long plume feathers of the neck. *S. Florida, early April*

C This white-form egret, rare outside Florida in the United States, is hunting in the tidal shallows. *S. Florida, late March*

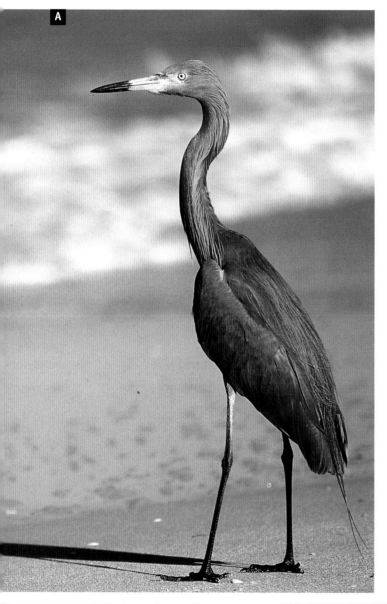

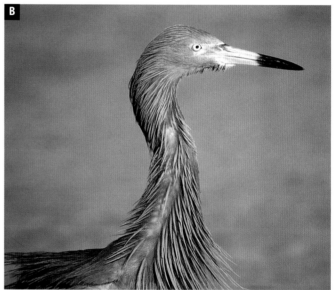

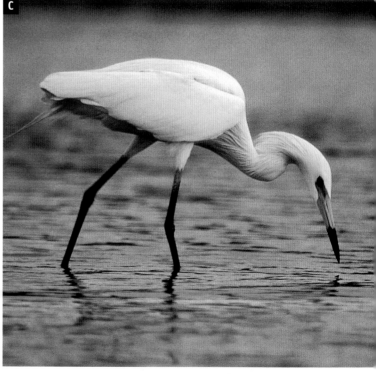

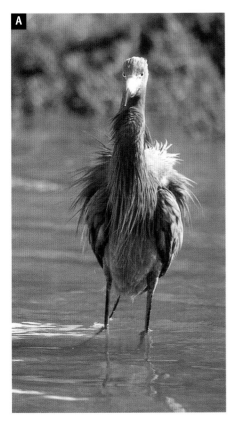

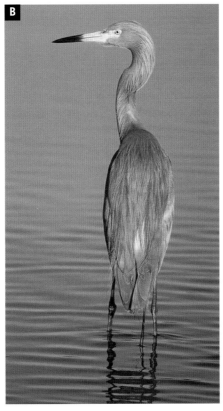

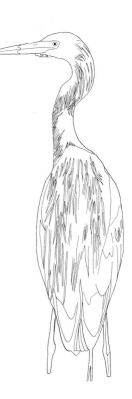

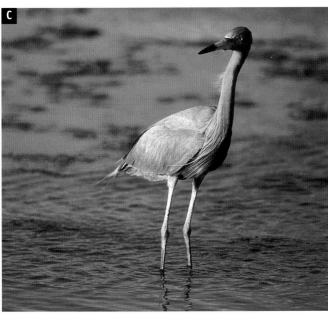

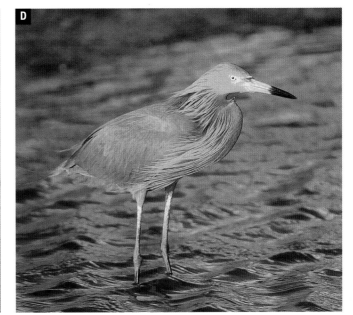

A The eyes are angled slightly downward. *S. Florida, early April*

B Study the elegant plume feathers on this bird's back. *S. Florida, early April*

C A strong shadow, and a beam of light catching this egret's eye are important to consider in bringing this bird to life in art. *S. Florida, early April*

D The evening light warms up this entire bird, making the grayish back slightly browner and the neck rustier. *S. Florida, early April*

E This bird is resting in the mangroves. *S. Florida, late March*

Snowy Egret

This beautiful white egret is common in the southern United States, especially on the Atlantic, Pacific and Gulf coasts. They are very common in salt water and fairly common around fresh water. They frequent marshes, ponds, mud flats, mangroves, beaches and sometimes fields. Snowy egrets can be seen singly or in large groups, often mixing with other wading birds.

These egrets prey mostly on aquatic life as the other egrets do, and they frequently use the technique of stirring up the bottom with one foot to spook out prey. They may also chase wildly after prey with wings raised and flapping, stabbing repeatedly in the water with their bills. These egrets will also wait motionless watching for prey.

Male and female egrets both have all-white bodies, black legs, black bills and yellow feet. In adult breeding plumage, their lores and feet turn reddish, and they develop beautiful plume feathers on their backs, the back of their heads and on their necks. These plumes look very dramatic when the egrets ruff up their feathers. Immature snowy egrets differ from adults in that they have a yellow line running up the back of their legs from their yellow feet. Snowy egrets have ten primary feathers, eleven secondary feathers on the trailing edge and twelve tail feathers.

A This adult is starting to get some red pigment in the lore area for breeding. *Central California, early February*

B Study the head and beak details in this close-up shot. *Central California, early February*

C This photo shows the shape of the head, eyes and beak from the front. *Central California, early February*

D This photo shows the shape of the head and neck as the bird looks away. *Central California, early October*

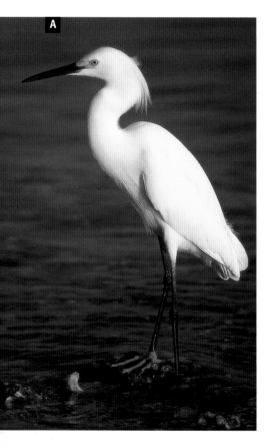

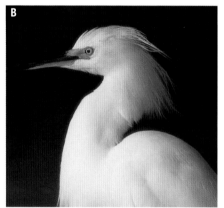

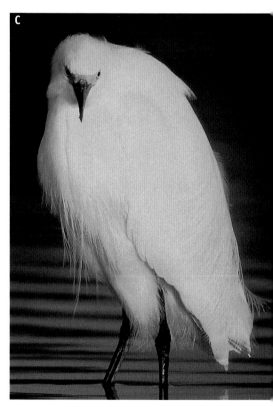

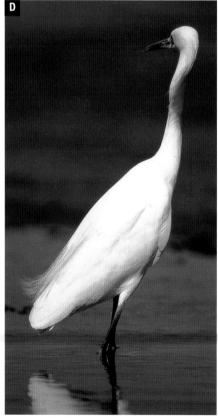

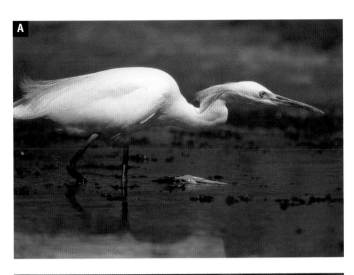

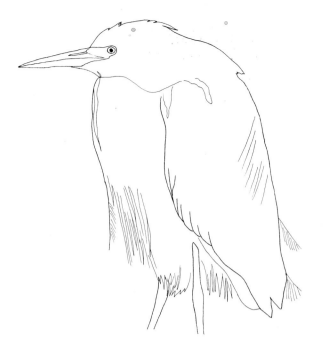

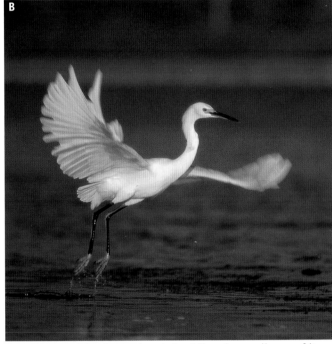

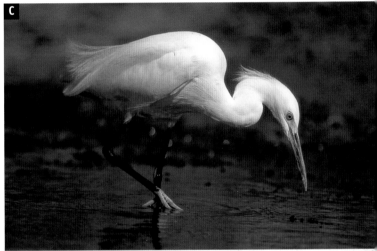

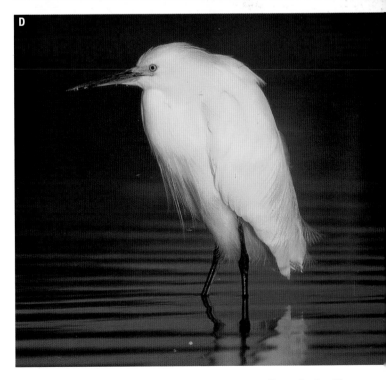

A An egret, stalking low and ready to strike, gives a glimpse of its yellow feet. *Central California, early October*

B Snowy egrets dash about running and sometimes flying after prey. *Central California, early October*

C Snowy egrets often feed by disturbing the bottom with one foot to spook prey into sight. *Central California, early October*

D The late evening light warms and softens the egret's features. *Central California, early February*

Snowy Egret

A In the height of the breeding season the lores and feet turn from yellow to a reddish hue. *S. Florida, early April*

B This photo shows how the egret's legs bend while walking. The yellow up the back of the legs shows that this is an immature bird. *Central California, early February*

C A graceful preening pose as this snowy egret works on its back and wing feathers. *Central California, early February*

D Adults have completely yellow feet but no yellow running up the back of their legs. *S. Florida, late March*

E The ruffed-up plume feathers here are very striking. Notice how well the shadows help define the form of the egret's body. *S. Florida, late March*

F Snowy egrets frequent marshy forest habitat as well as open water shallows. *Corkscrew Swamp, Florida, late March*

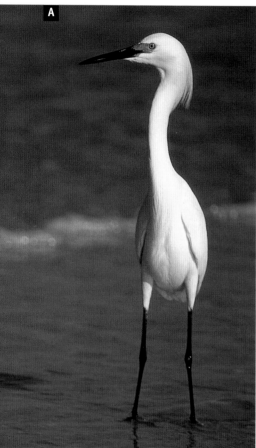

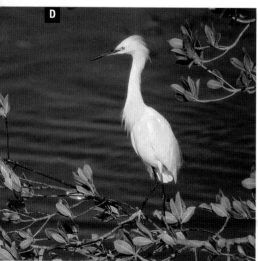

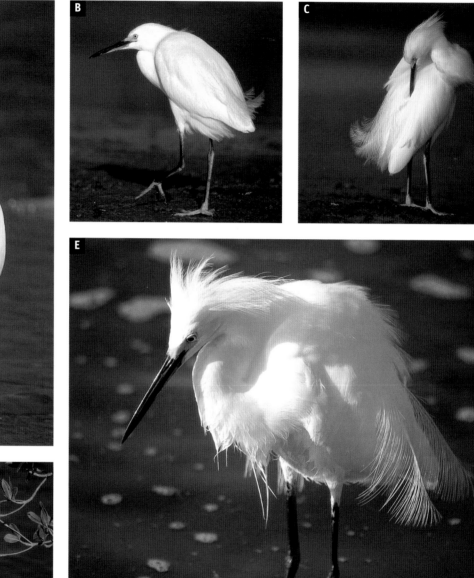

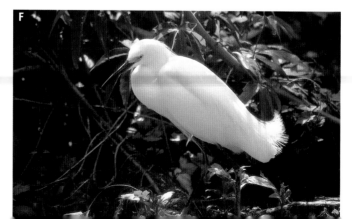

Tricolored Heron

This medium-sized heron lurks around saltwater habitats such as mangrove trees and saltwater shallows, but sometimes near fresh water. Tricolored herons are found on the Atlantic and Gulf coasts, and on the Pacific coast in southern California and southward.

These herons feed in and around water, rarely on land. They eat mostly fish and other aquatic life and will employ the same methods that the other egrets and herons employ, like hunting by standing still, running after prey and disturbing the bottom with their feet. They often venture out in deep water up to their bellies.

Male and female tricolored herons have the same plumage. They seem to have a very skinny neck and long bill compared to other members of this family. Tricolored herons have ten primary feathers, thirteen secondary feathers on the trailing edge and twelve tail feathers.

A These herons frequent the shorelines in search of prey. *S. Florida, late March*

B The flow of plume feathers on the back is very elegant. *S. Florida, early April*

C Notice the brilliant turquoise bill and lore and reddish legs and feet of this adult heron in breeding plumage. *S. Florida, early April*

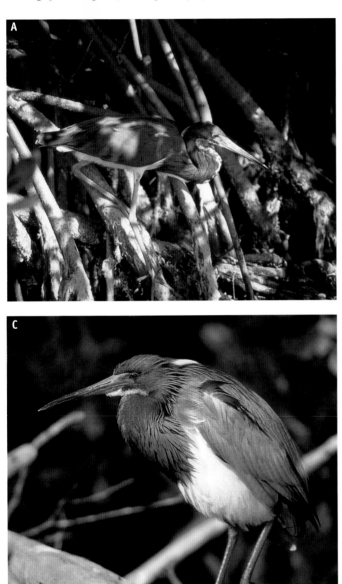

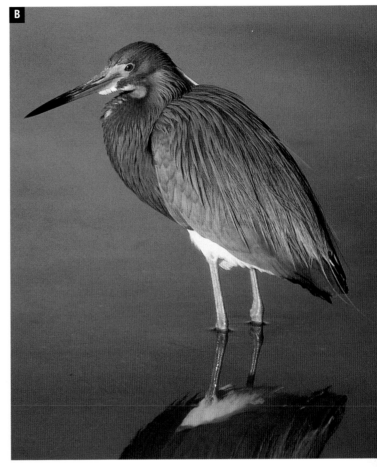

Tricolored Heron

A This heron is actively hunting in deeper water. Notice the deep colors of the bill and eye. *S. Florida, early April*

B Pay special attention to the bends in the neck here. One of the heron's legs is folded into the lower belly feathers. *S. Florida, early April*

C This tricolored heron is in a classic frozen pose right before striking forward to catch a meal. Pay attention to the angle of the eye as it concentrates on the hunt. *S. Florida, late March*

D Tricolored herons have a two-toned back with blue plumes on the upper back and yellow plumes on the lower half. Notice the long claw on the rear toe. *S. Florida, early April*

E A good view from the top of the head, and with the feathers ruffed up its easier to map them out. *S. Florida, early April*

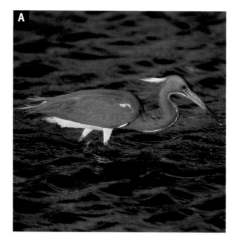

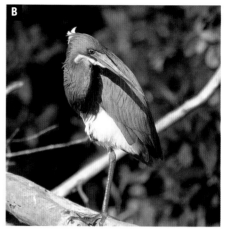

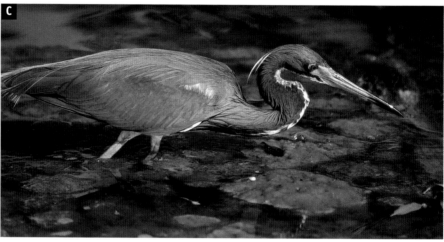

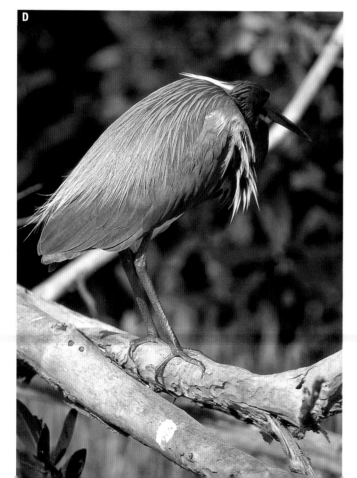

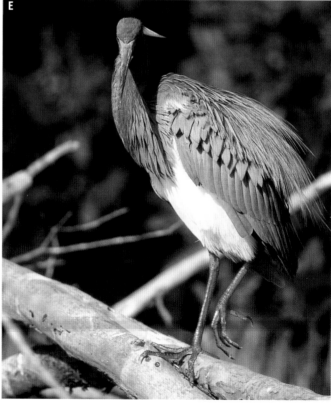

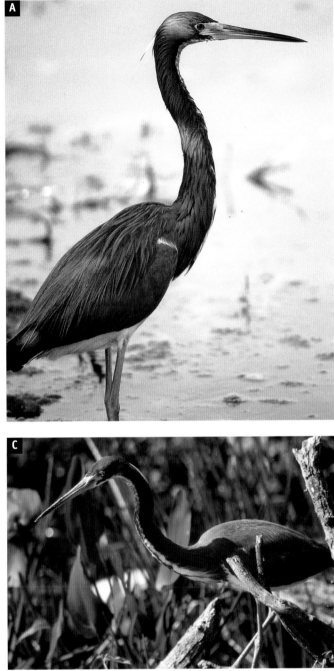

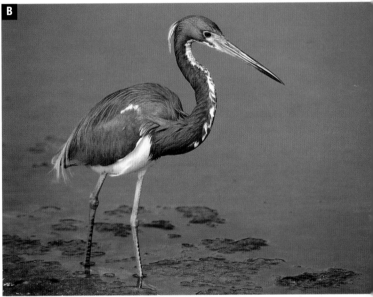

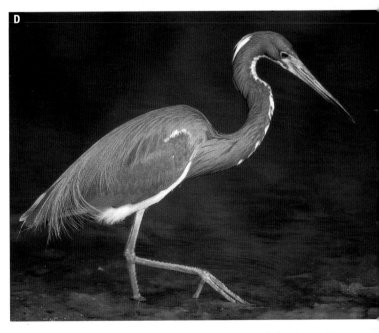

A The tricolored heron has an extremely long and skinny neck and bill proportionately compared to other herons and egrets. *S. Florida, late March*

B Tricolored herons have necks streaked with white on the leading edge. *S. Florida, late March*

C This bird appears to be molting from immature plumage into adult plumage. Notice the lighter-colored eye typical of immature birds. *Everglades National Park, Florida, late March*

D This photo gives a good view of the leg and feet details as well as a many-colored bill. *S. Florida, late March*

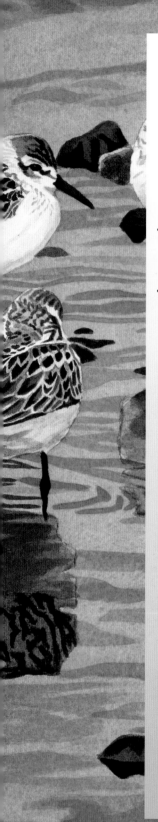
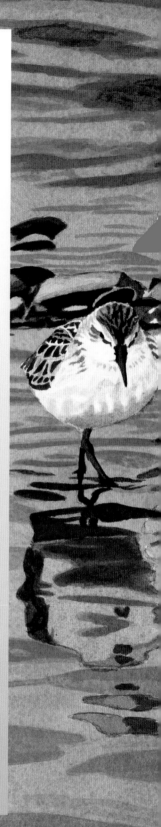

SHOREBIRDS

The shorebirds covered in part one frequent the shorelines of fresh water, salt water or both. These shorebirds come in a wide range of sizes, shapes and overall appearances, with beaks made for specific feeding habits accounting for much of the difference in appearance.

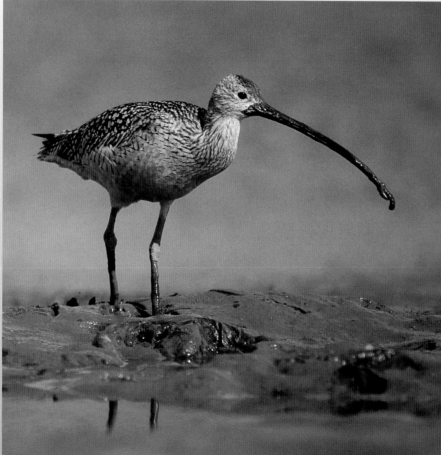

Long-billed curlew. *Central California, early February*

American Avocet

Avocets inhabit much of the United States and southward, but are absent from some of the northeastern United States. You see them in the spring and summer on shallow ponds, prairie potholes and freshwater marshes near where they nest. Avocets winter on coastal marshes and mudflats.

Avocets feed in the water on crustaceans, beetles, aquatic insects, seeds of aquatic plants, larvae and other small aquatic life by walking slowly, sweeping their bills back and forth under the water, stirring up prey. They often stop and raise their heads to swallow their prey, and will sometimes plunge their whole head under the water in search of food. They also feed in the mud, and often feed in large groups, sharing their shoreline habitat with other species such as black-necked stilts. When traveling from one shallow area to another, avocets look like long-necked ducks, swimming in water up to their bellies.

This graceful shorebird wears a different plumage for winter and summer. Their backs and wings are black and white, but in the winter their necks and heads are gray and in the spring and summer they are a rusty, orange color. Avocets have an upturned bill, and the male's bill is longer and straighter than the female's bill which turns up more at the tip. Avocets have ten primary feathers, sixteen secondary and tertial feathers on the trailing edge and twelve tail feathers.

A A male avocet's beak is straighter and longer than a female's beak. *Central Montana, late June*

B Two feeding avocets actively swing their bills from side to side in the water, picking up food from the mud's surface. *Central California, early February*

C The female kneels down as one of her chicks nestles into her belly feathers for warmth (notice the extra leg). *Central Montana, late June*

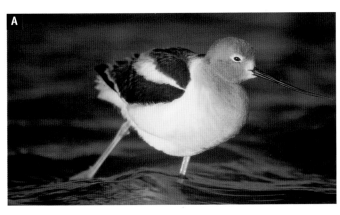

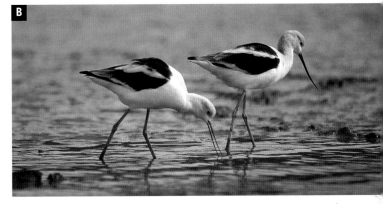

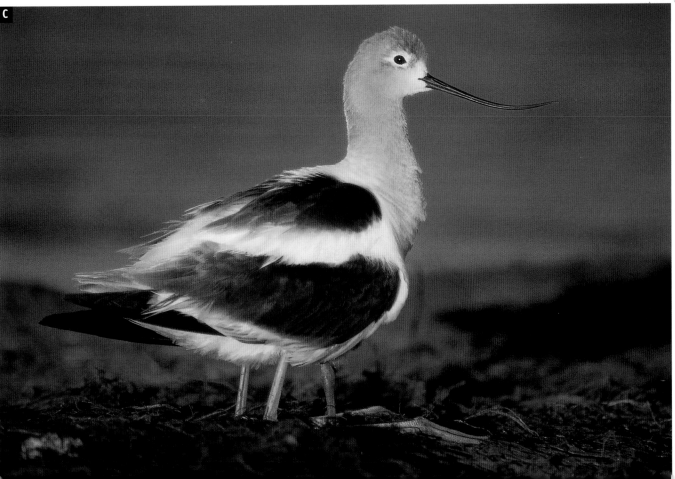

American Avocet

A Avocet's black primaries and partially black primary underwing coverts give the wing its black-tipped appearance in flight. *Central California, mid-December*

B The black feathers on the top of the back are back feathers, but the white wedge shape that comes next is part of the folded wing, the upperwing coverts. Notice the small, slightly raised hind toe on each leg. *Central California, mid-December*

C Winter avocets of both sexes have grayish necks. *Central California, early February*

D Avocets' summer plumage differs from their winter plumage by having orange necks and heads. Notice the white ring of feathers around the eye and the white feathers at the base of the beak. *Central Montana, late June*

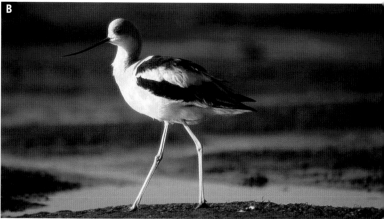

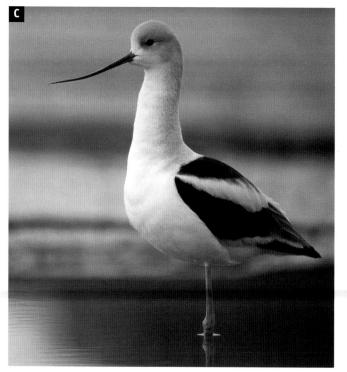

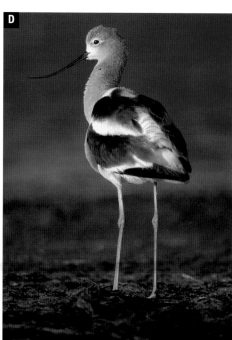

A Taking a stretch, this female starting to unfold her wing gives a better look at how the wing is folded. *Central California, early February*

B Both winter and summer plumage avocets have grey legs. *Central California, early February*

C The small avocet chick can feed for itself with a parent nearby to offer protection. *Central Montana, late June*

D A view of the head facing forward shows the round features of the face above and below the eye. *Central California, mid-December*

E Typical resting pose. *Central Montana, late June*

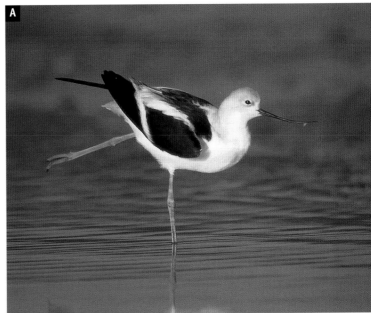

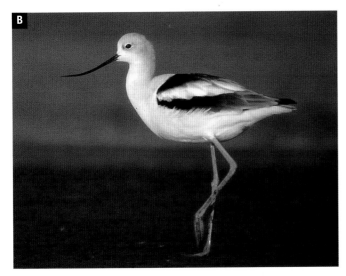

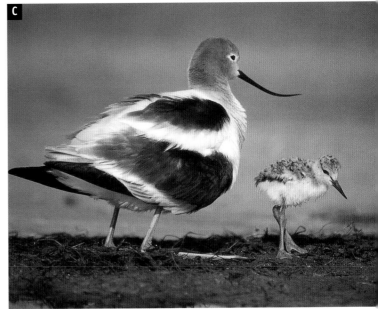

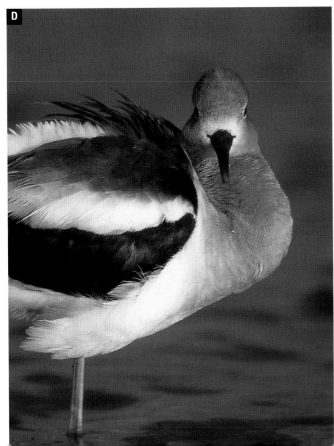

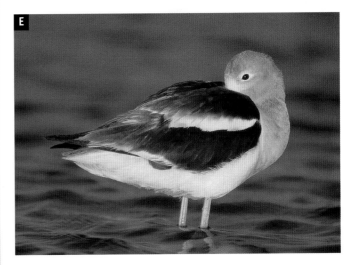

Black-Necked Stilt

The elegant black-necked stilt is found on the Atlantic coast (most common in Florida), Gulf coast, Pacific coast and inland, mostly in the western United States and southward. Stilts prefer fresh water, flooded fields and alkaline lakes, but they also like brackish ponds and marshes.

Stilts eat insects, aquatic bugs and beetles, flies, larvae, crustaceans, some seeds of aquatic plants, and more. They feed in the water and at the water's edge in the mud by actively walking and running around picking up food from the surface. Stilts are often seen with avocets.

Stilts have a striking black-and-white appearance with glossy black upperparts and white underparts, black bills and long pink to reddish legs. The female's back is a slightly duller and browner color than the male's jet black back. Black-necked stilts have only three toes. They have ten primary feathers, sixteen secondary and tertial feathers on the trailing edge and twelve tail feathers.

A Male stilts have glossy black backs. *Central California, early February*

B This is a good reference for walking posture. *Central California, early February*

C Female stilts have brownish backs. *Central California, early February*

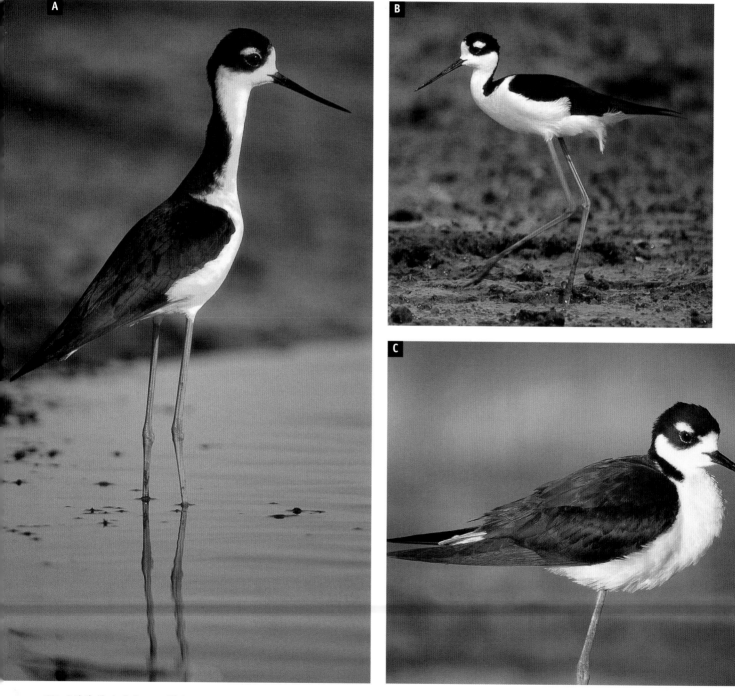

A Stilts have straight or very slightly upturned bills. They have only three toes: They lack a hind toe. *Central California, early February*

B There are two highlights in the eye; the strongest is from the sun and the second one is from the reflection off the water. *Central California, early February*

C A typical feeding pose, at the water's edge. *Central California, early February*

D Notice the reflection from the water on the belly in this photo. *Central California, early February*

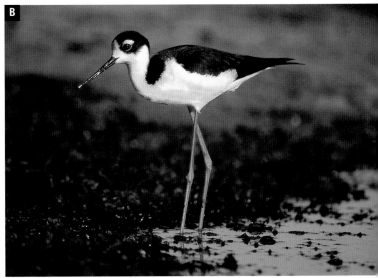

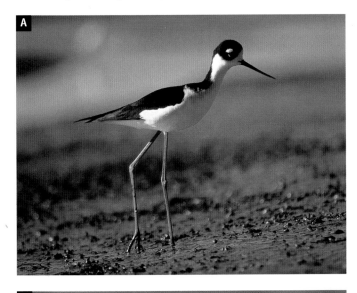

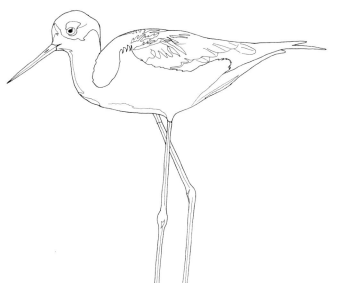

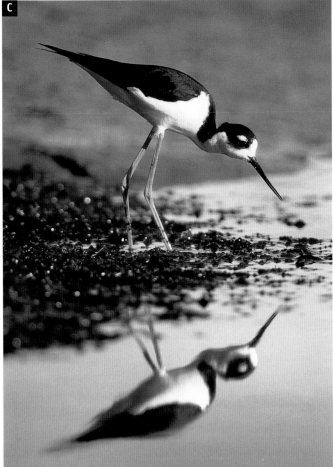

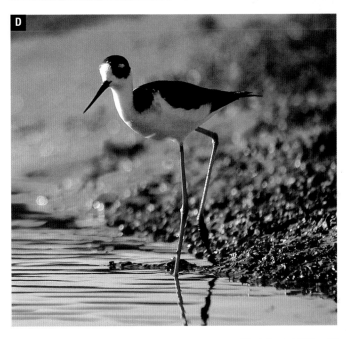

Black Oystercatcher

You find these large noisy shorebirds only on the Pacific coast of North America, ranging from the Aleutians in Alaska all the way down to Baja California. They appear singly or in small groups on rocky coastlines, rocky islands or neighboring beaches.

Oystercatchers usually feed as the tide is sinking and at low tide when rock clinging shellfish such as mussels and limpets are exposed. Their bills are laterally compressed so that they can be slipped into the shells of partially opened shellfish. Oystercatchers feed on rocky areas and probe in the mud and sand for invertebrates; they also eat marine worms.

Male and female oystercatchers look the same, sporting brownish black bodies; black heads, necks and breasts; pinkish legs; red bills; and yellow eyes with orange eye rings. Immature birds have a duller, more brownish body and a duskier beak. Oystercatchers have ten primary feathers, seventeen secondary and tertial feathers on the trailing edge and twelve tail feathers.

A Oystercatchers frequent the rocky shores and tidal pools of the Pacific northwest. *W. Washington, mid-May*

B The oystercatcher's bill is flattened side to side at the middle to end which makes it easier to stab the bill into partially opened shellfish. *W. Washington, mid-May*

C The details of the light-colored feet are easy to see here. Oystercatchers have only three toes. Notice the contrasting black toenails. *W. Washington, mid-May*

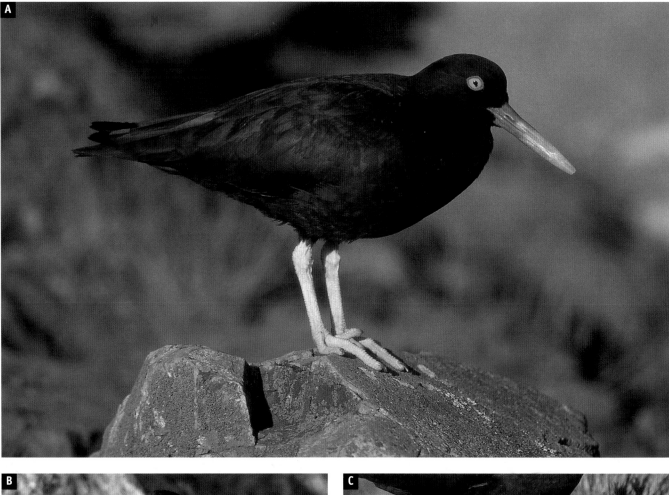

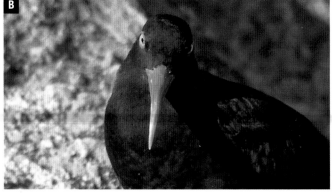

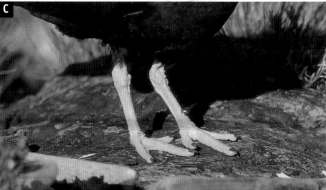

A A view from the front shows how plump this shorebird's body is. *W. Washington, mid-May*

B Many oystercatchers have a yellowish tip to their beaks. *W. Washington, mid-May*

C In this resting pose you can see the feather division between the back and the folded wing. *W. Washington, mid-May*

D This view shows a walking pose. Notice no hind toe. *W. Washington, mid-May*

E Oystercatchers run side by side with their heads and bills pointed downward calling loudly, and sometimes raise their heads up high in courtship and defense displays. *W. Washington, mid-May*

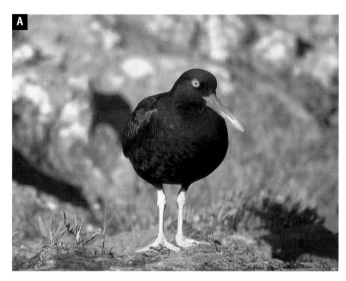

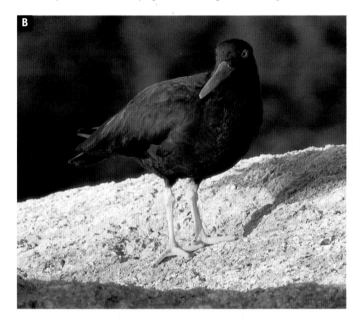

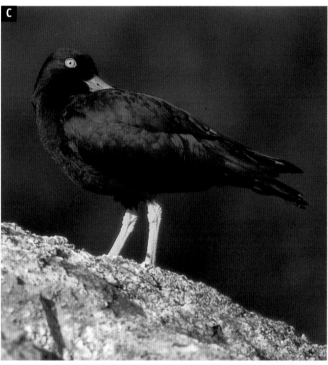

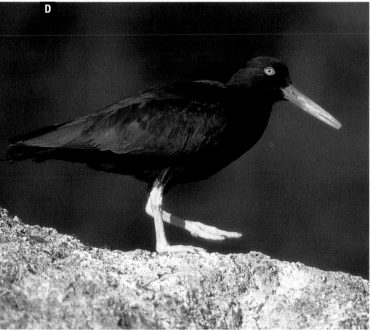

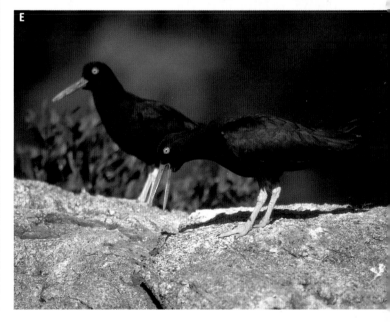

Black Oystercatchers in Acrylic

Materials

Palette:

Winsor & Newton Acrylics—Titanium White, Raw Sienna, Raw Umber, Burnt Sienna, Ultramarine Blue, Ivory Black, Burnt Umber

Grumbacher Acrylics—Cadmium-Barium Yellow Light

Liquitex Acrylics—Scarlet Red (Cadmium Red Light Hue)

Brushes:

flat no. 12
Filbert no. 2
round no. 1, no. 2, no. 3

Other:

Gessoed Masonite panel

I saw my first black oystercatchers on a rocky point, but I only had a glimpse of them before they flew off. I photographed the exact spot where I saw the birds for future reference. A few years later, after having several opportunities to photograph other black oystercatchers, I decided it was time for a painting using my original scene. Follow the steps to create your own painting, using a combination of reference photos, and practice fitting your birds into a habitat.

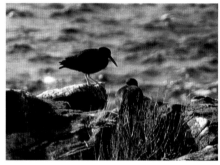

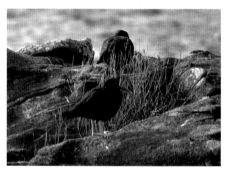

1. Choose Reference Photos

I chose these photographs of oystercatchers partly because of their poses and partly because they show the birds in a lighting situation and direction similar to the habitat reference photo. The birds in the photo at top will need warmer colors and stronger lighting.

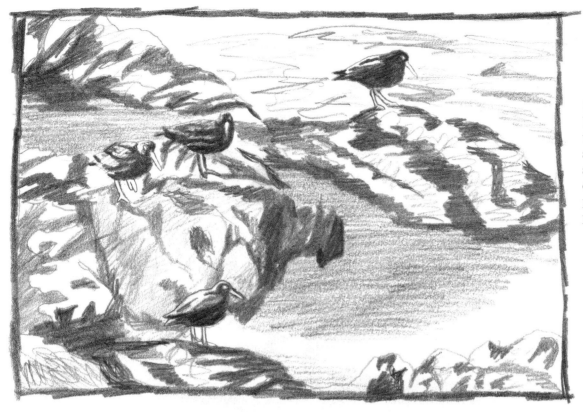

2. Composition

Using all the photographs, draw a small thumbnail sketch of a possible composition, incorporating bits of each photo.

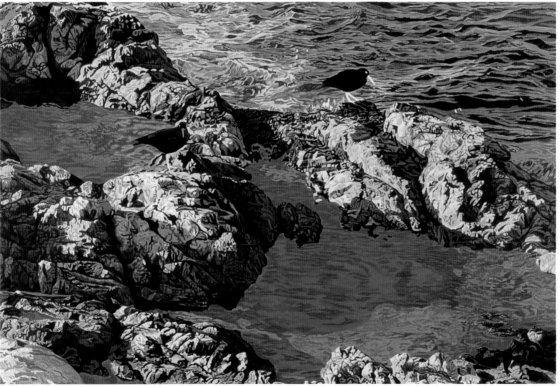

3. Begin to Paint

Block in all areas of the painting with their medium color values using the flat no. 12 and the no. 2 filbert brushes. Covering the entire surface of the painting quickly helps you judge the correct color balance and values from the beginning.

Next, add the darkest darks and lightest lights for the rocks and water using the no. 3 round and no. 2 filbert brushes. These extremes help you find your spot when you're trying to refer back to your reference photos. Use an Ivory Black/Raw Umber mix for dark rocks, Raw Sienna/Titanium White for sunlit rocks. Use an Ultramarine Blue/Scarlet Red/Titanium White/Ivory Black/Raw Umber mix for the darker water, Ultramarine Blue/Scarlet Red/Titanium White for the lighter water areas, adding Cadmium-Barium Yellow Light and Burnt Sienna as necessary where the sun shines through the water to the ocean floor.

From that point work back and forth, blending in between those two extremes.

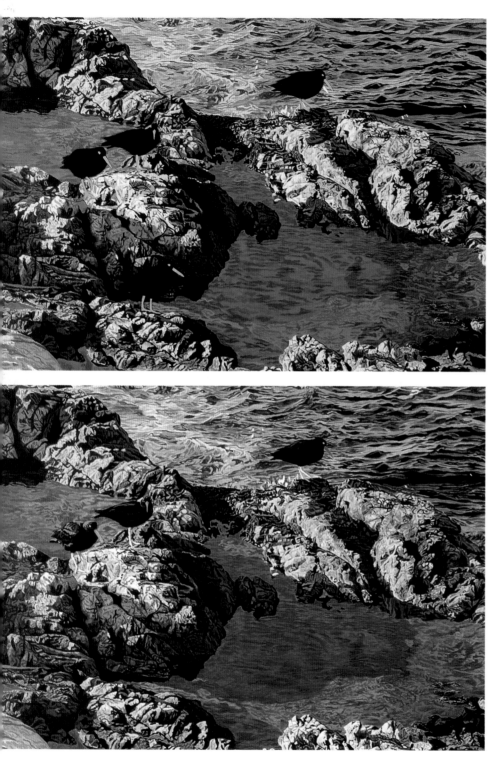

4. Fine-Tune the Composition

Usually I plan the placement of my birds before starting a painting, but in this case I add the birds after the landscape is almost finished. Work out the best size for the birds by making cutouts of them. These cutouts are the basic black and orange of the oystercatchers painted in quickly on Mylar. After determining the correct sizes for the birds, place the Mylar cutouts in different spots to help fine-tune the composition.

5. Add Details

Following the position of the Mylar cutouts, block in three of the oystercatchers' bodies with black using the no. 2 filbert and no. 3 round, then rough in the feathers on their backs with a brown mixture of Raw Sienna, Burnt Sienna, Raw Umber and Titanium White. The mixture for the head is bluer, using a mix of Ultramarine Blue, Cadmium Red Light and Titanium White using the no. 2 round brush. The feathers on the head are much smaller than on the back and are less distinct. As a result they look more like velvet. With the no. 1 round brush, start out the beaks and eyes by underpainting them in white, then glaze just enough red over the white underpainting so the white shows through the transparent layer, intensifying the color.

Using the no. 2 filbert and no. 3 round, warm up the background rocks and work on the calm foreground ponds, unifying the shadow side of the water to the side in the sun.

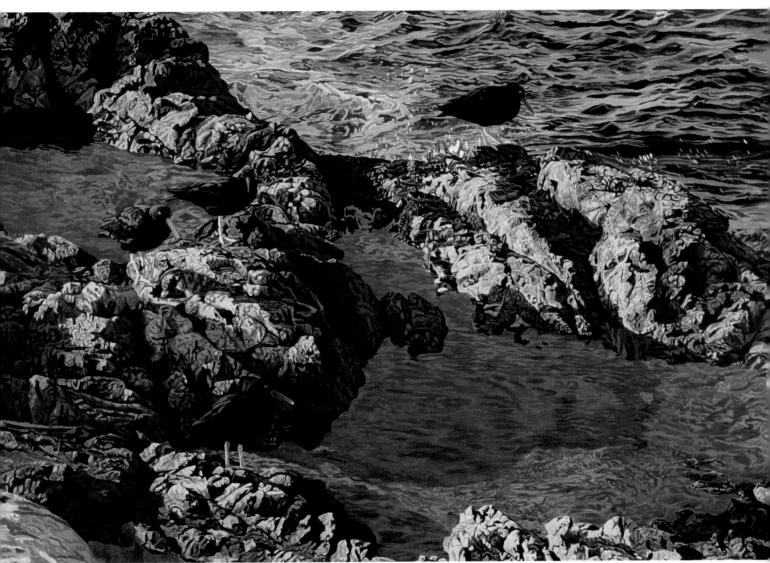

6. Final Touches

Finish the background by painting splashes of water with thin strokes of Titanium White, using the no. 1 round brush.

After blocking in the final bird and adding initial details, the next step on the birds is to work in values lighter and darker than the initial middle-value feathers, using the no. 1, no. 2 and no. 3 round brushes. On the shadow side of the birds some of the mixtures for the lighter areas are barely a shade lighter than the black underpainting.

The last step for the left-most oystercatcher is to cast a shadow from it onto the rocks. Make several sketches in paint on Mylar to see how a shadow from the bird might land on the rocks, taking into consideration the shapes in the rocks and the direction of the sun. Once you come up with one that looks believable, paint it in with a mix of Ultramarine Blue/Scarlet Red/Raw Sienna/Raw Umber/Ivory Black/Titanium White. Paint a warm glaze of Ivory Black/Raw Sienna/Burnt Umber/Burnt Sienna/Titanium White on the belly of this oystercatcher to indicate light reflected from the sunlit rocks onto the belly of the bird.

My First Oystercatchers
BART RULON
Acrylic
20" X 30" (51cm x 76cm)
Collection of Nancy Spencer

Long-Billed Dowitcher

Two species of dowitchers are present in North America, the long-billed dowitcher and the short-billed dowitcher. Long-billed dowitchers spend their springs and summers nesting on the northern slope of Alaska and Canada. Their winter range is continuous along the coastline states from Washington all the way around to South Carolina, and down into Mexico. During migration and winter, long-billed dowitchers prefer to use freshwater or brackish water habitats while their cousins, the short-billed dowitchers, prefer salt water, but they both will use either fresh or salt water and are often seen together.

Dowitchers feed on tidal mudflats, and the edges of ponds and marshes. They probe in the mud and shallow water with a rapid stabbing motion similar to that of a sewing machine and they sometimes immerse their entire head under the water probing for food. They feed mostly on insects, insect larvae, aquatic insects, mollusks, crustaceans, worms and some plant food including seeds.

Long-billed and short-billed dowitchers are similar and can be difficult to separate in the field, especially for birds in winter plumage. They cannot be separated by length of the bill like you might think by their names. One of the few sure ways to distinguish between these two species is to note their different calls. The call of the long-billed dowitcher is a high-pitched "keek" and the call of the short-billed dowitcher is a mellow "tu tu tu." Male and female dowitchers look the same in both species except that the females average a little larger in both cases. Winter plumage birds are brownish with lighter underparts and lightly barred sides, while summer plumage birds are more colorful, having orange-patterned upperwing coverts. They have ten primary feathers, thirteen secondary and tertial feathers on the trailing edge and twelve tail feathers.

A Winter plumage bird. *Central California, mid-December*

B These birds have four toes, but the hind toe is much smaller than the front three. *Central California, mid-December*

C Juvenile birds tend to have crisp, relatively unworn feather edges compared to adults. *W. Washington, mid-October*

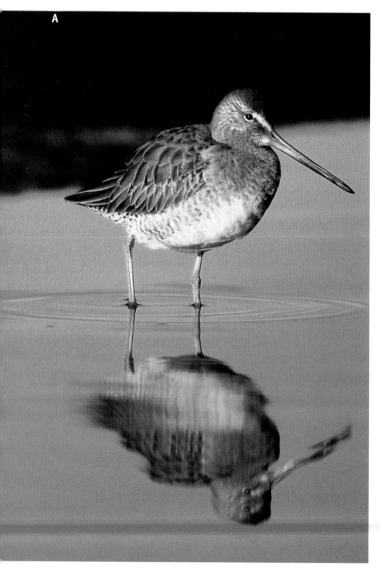

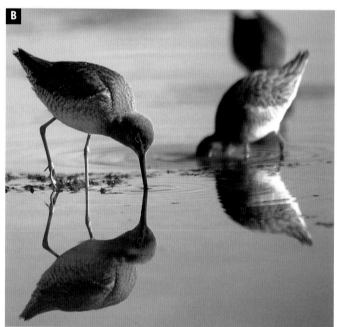

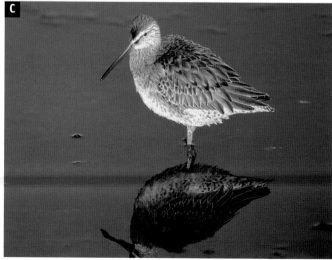

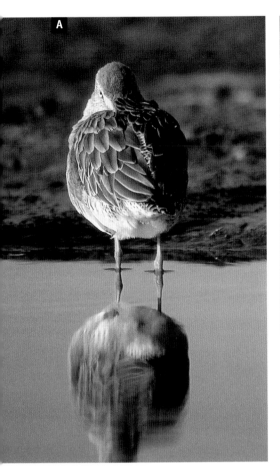

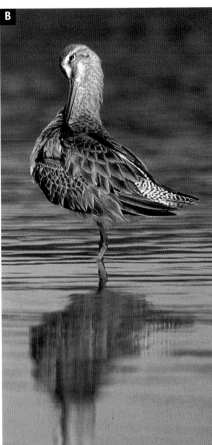

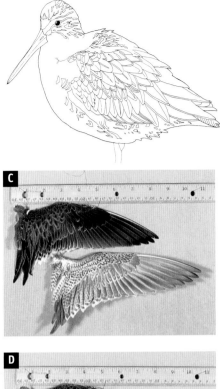

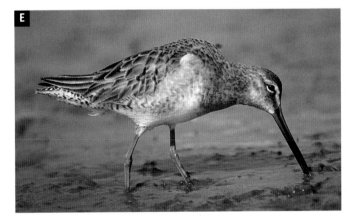

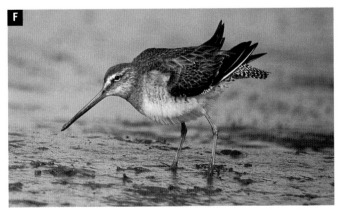

A This photo gives a good idea of the body shape and layout of the back and wing feathers. Dowitchers will often sleep with one leg pulled up into their belly feathers. *Central California, mid-December*

B This preening pose gives a glimpse of the white lower back underneath the folded wings. *Central California, early February*

C Immature upperwing (top) and underwing (bottom) from October.

D Immature upperwing (top) from October, and adult upperwing (bottom) from June.

E This feeding shot shows how the long-billed dowitcher probes in the mud with its long bill in search of food. *Central California, early February*

F This is a great view of the wing unfolding and the barred black-and-white tail. On average, long-billed dowitchers have tails with black bars wider than the white bars. *Central California, early February*

Long-Billed Curlew

You find this large shorebird in the west to mid United States from the southern part of Canada southward into Mexico and beyond. In the summer, curlews spend their time inland in wet and dry grasslands where they feed on insects, seeds, frogs, snails and other pond life. In winter they are mostly near the coast on mudflats, salt marshes and beaches or on nearby lakes, ponds and fields. I've seen curlews probing around in unusual twisted positions as they turn their heads from side to side or even upside down to catch their prey deep in the mud. Often after one of these exhaustive probings, the curlew comically pulls out its long bill covered with mud. In winter you can see curlews singly or in loosely gathered small flocks, sometimes with other large shorebirds such as marbled godwits.

Long-billed curlews have long down-curved bills. The males and females are alike except that the females average much larger in size, and both sexes have, generally, the same plumage year round. Juvenile birds have a much shorter down-curved bill than adults. Long-billed curlews have ten primary feathers, seventeen secondary and tertial feathers on the trailing edge and twelve tail feathers.

A Notice the ladder-like patterns of the back feathers and the adjacent lighter brown triangular-patterned upperwing coverts. *Central California, early February*

B This frontal view gives a good look at the shape of the head and the two dark rows of feathers on the crown. *Central California, early February*

C Curlews spend their winters mostly on the coast feeding on the shallow tidal mudflats and vegetated borders. *Central California, mid-December*

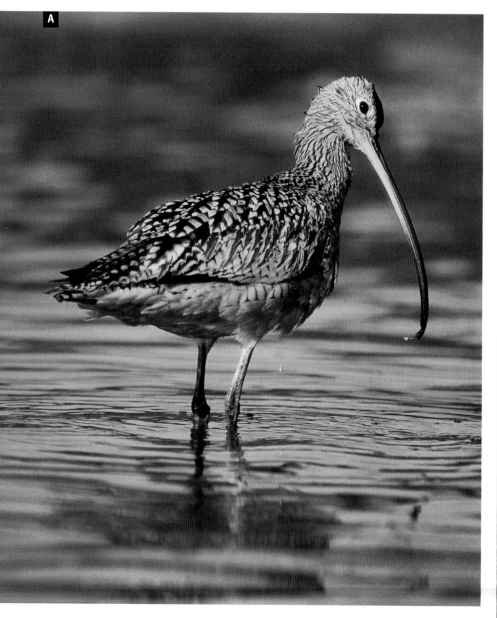

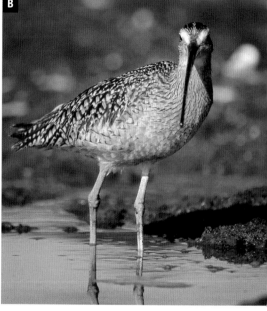

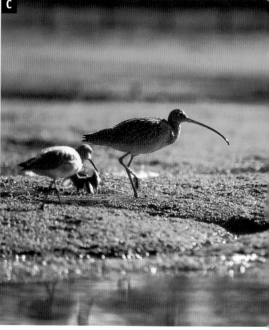

A A curlew twists its head digging deep for food. *Central California, early February*

B After submerging its bill completely in the mud, this curlew comes up with mud in its face. *Central California, early February*

C This bird probes as far down as possible with that extremely long bill. *Central California, early February*

D Curlews often roughhouse with crabs to remove their claws for easier eating. *Central California, early February*

E Probing for food, this curlew shows the rows of patterns on its back. *Central California, early February*

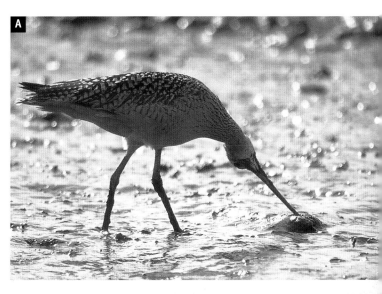

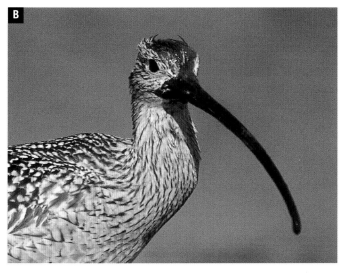

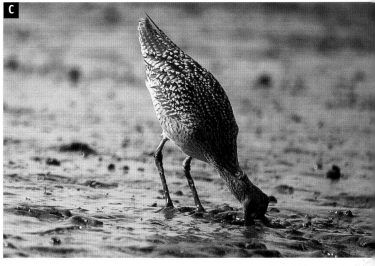

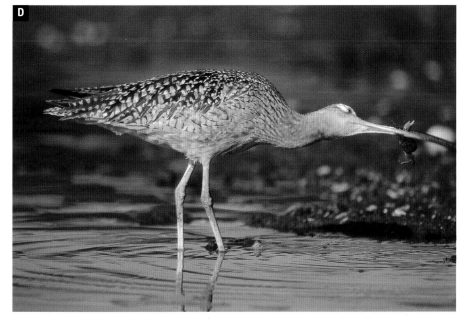

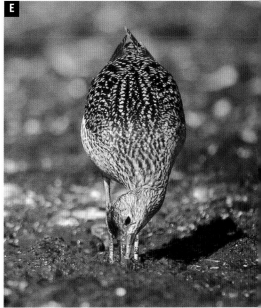

Long-Billed Curlew

A The fine barring on the neck leads way to perpendicular barring on the sides or flanks. *Central California, early February*

B From the back, notice how the streaking on the side of the head and neck converge with that of the back of the head and neck. *Central California, early February*

C The neck streaking gradually lessens as it passes the breast. Clean of mud, the curlew's bill is pink at the base and dark at the teardrop-shaped tip. *Central California, early February*

D Notice the warmer color of this individual bathed in early evening sun. *Central California, early February*

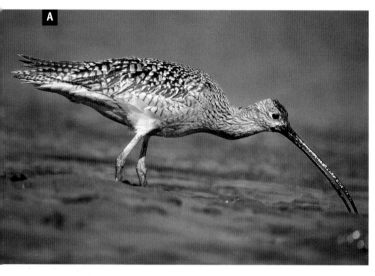

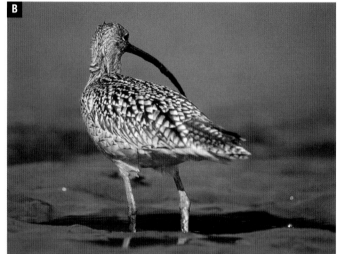

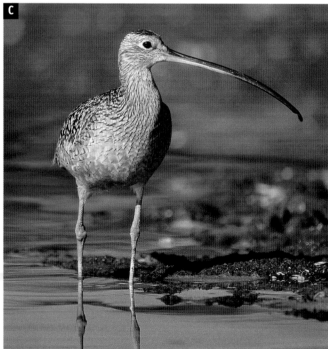

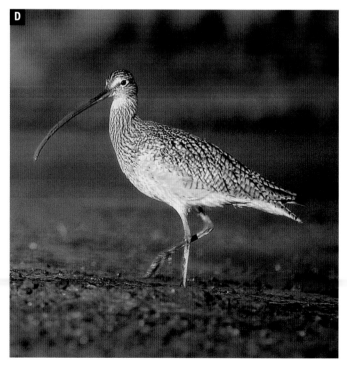

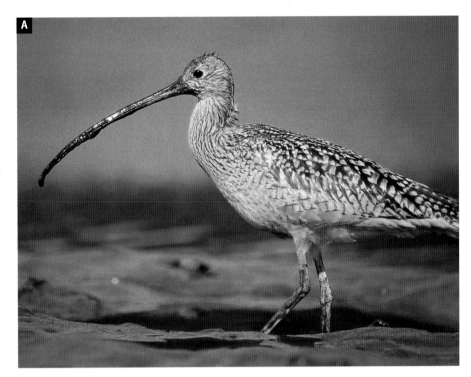

A The long down-curved bill comes up from feeding covered with mud. *Central California, early February*

B Like the typical sleeping shorebird, when the curlew rests in a tucked position, even its long bill can be hidden from view. *Central California, early February*

C While preening, this bird reveals the lighter ladder-like patterns of the uppertail coverts. *Central California, early February*

D Upperwing.

E Underwing.

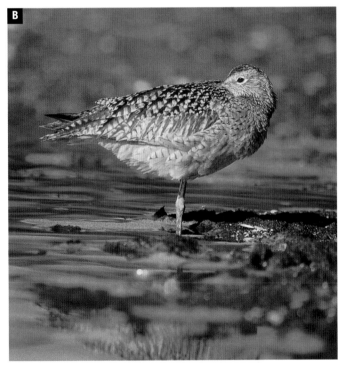

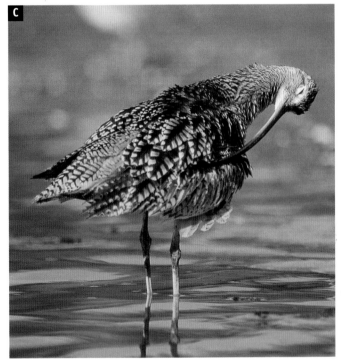

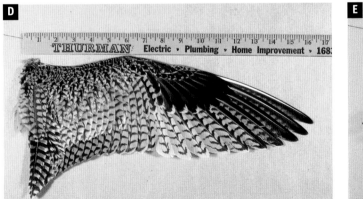

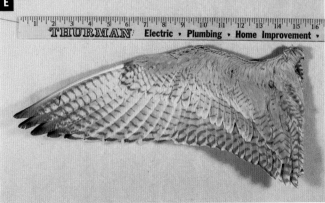

Marbled Godwit

You can find these brown shorebirds during different parts of the year over much of North America, south of southern Alaska and Canada, although they are more abundant in the west than the east. They spend their summers mostly in grassy areas near prairie potholes, lakes and ponds. During winter they spend their time on the coasts; the Pacific coast where they are abundant, the Gulf coast where they are common, and Atlantic coast where they are rarer. Godwits' preference for salt water in the winter leads them to tidal mudflats, bays and saltwater marshes where they often feed in large flocks.

On tidal flats, godwits feed by probing their bills in the mud for crustaceans, worms and mollusks. In fields they eat insects, seeds and some plant life. During winter, spring and fall migration on the Pacific coast they feed in groups, often in mixed flocks with other shorebird species such as willets, long-billed curlews and avocets.

The marbled godwit has a slightly upturned bill, pink at the base and black on the tip. The male and female look the same except that females average larger in size. The marbled godwit's summer and winter plumage are similar, except that the summer plumage has more fine barring on the neck and belly and a warmer rustier color of brown on the belly. Marbled godwits have ten primary feathers, fifteen secondary and tertial feathers on the trailing edge and twelve tail feathers.

A Godwits have a warm Raw Sienna color and beautiful barring on the back and wings. *Central California, early February*

B All marbled godwits have slightly upturned bills with a pink base and black tip. *Central California, mid-December*

C Summer plumage birds have more barring and streaking on their necks and breasts than in winter. *Central Montana, late June*

D Notice the small hind toe. *Central California, mid-December*

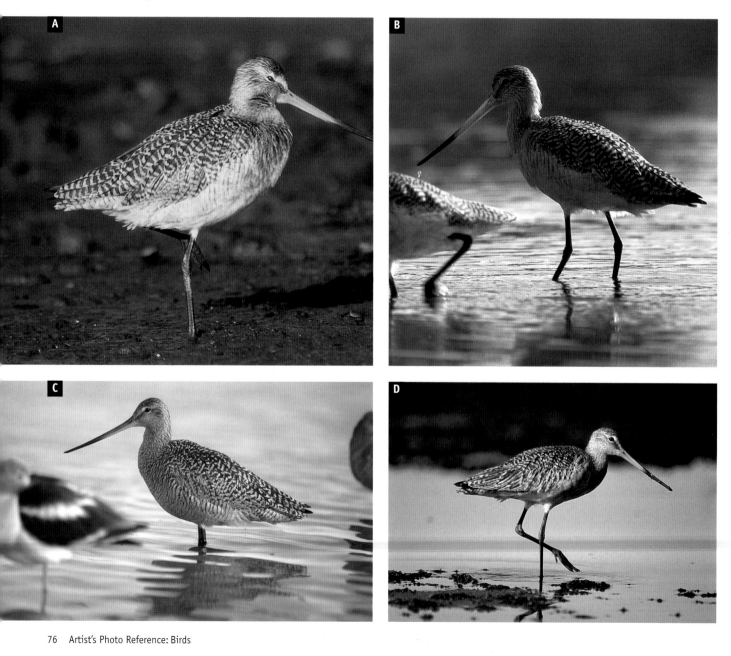

A A view from the back shows heavy barring and a few ruffed-up feathers. *Central California, mid-December*

B The other wing feathers almost cover up all the primary tips. *Central California, early February*

C In the mud, godwits use their long bills to probe deep down for food, leaving them with mud-covered bills and faces. *Central California, early February*

D Like other shorebirds, godwits will extend one foot out underneath while stretching a wing out. Notice the cinnamon color of the wing with distinctly dark primary coverts. *Central California, early February*

E Upperwing.

F Underwing.

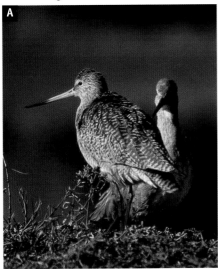

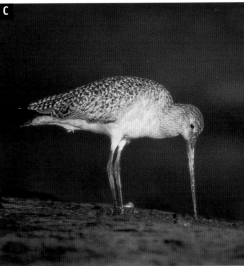

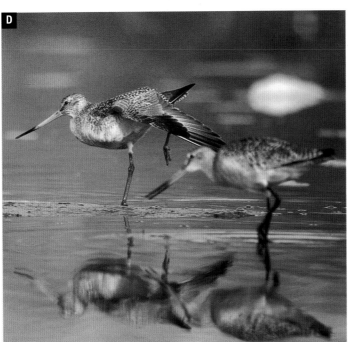

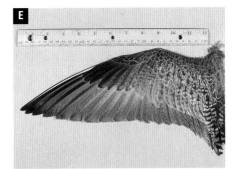

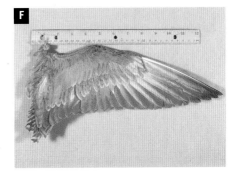

UNUSUAL WADERS

I have grouped white ibis and roseate spoonbills together because of their unusual and brightly colored appearance. They are members of the same family of birds, and often feed and rest together in their wetland habitat.

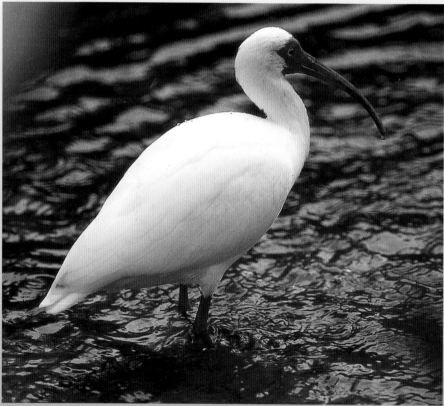

Adult white ibis. *S. Florida, late March*

Roseate Spoonbill

This unusual yet beautiful bird has a limited range in the United States. Spoonbills are mostly seen in Florida and along the Gulf coast (especially in Texas), but also range southward into Mexico and beyond. They frequent salt water as well as fresh water, including mangroves, ponds, brackish pools, marshes, tidal sloughs and beach lagoons.

Spoonbills swing their slightly opened spoon-shaped bill from side to side in shallow water and mud feed by feel for crustaceans, fish, mollusks and other aquatic life. They often feed, rest and roost in large to medium-sized flocks. They frequently retreat to rest in mangrove trees during midday in Florida. Spoonbills sometimes intermix with other wading species such as white ibis while feeding. Typically, before a flock of birds decides to take flight, I've seen some of the individuals repeatedly point their spoonbills up into the air as if to say, "Let's go."

Roseate spoonbills' plumage is the same in males as it is in females. Birds with lighter pink and no red on the wings are immature birds. They gradually get pinker as they approach adulthood. These immature birds have white feathers on their heads which are eventually lost when they reach adulthood, where they give way to a bald head with light greenish skin. Roseate spoonbills have ten primary feathers, fifteen secondary feathers on the trailing edge and twelve tail feathers.

A Notice the dark grooves on the bill of this adult bird in full breeding plumage. *S. Florida, early April*

B Spoonbills often feed, rest and roost together in flocks. *S. Florida, late March*

C Notice the small pouch-like area under the bill. *S. Florida, early April*

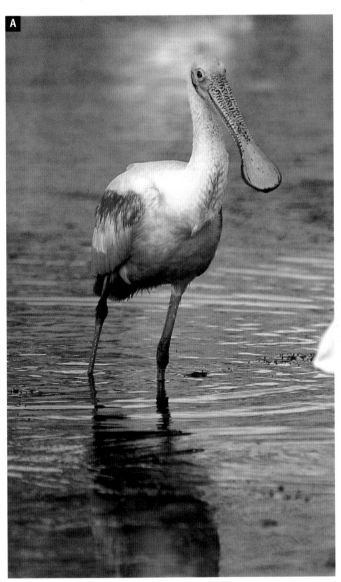

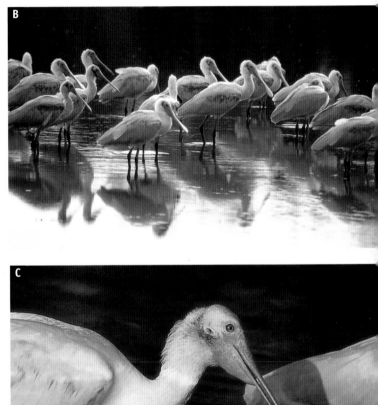

Roseate Spoonbill

A Take a good look at the tail and at the spoonbill's feet which are partially webbed toward the inside between the toes. *S. Florida, early April*

B Notice the exposed ear and dark patch dividing the green head skin from the feathered neck. *S. Florida, early April*

C Immature bird. Notice the eye is more of an orange color than on adult's. *S. Florida, early April*

D Adult bird. *S. Florida, early April*

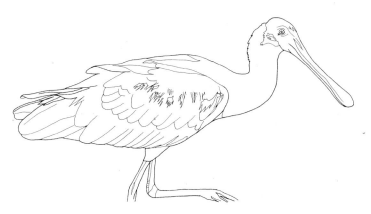

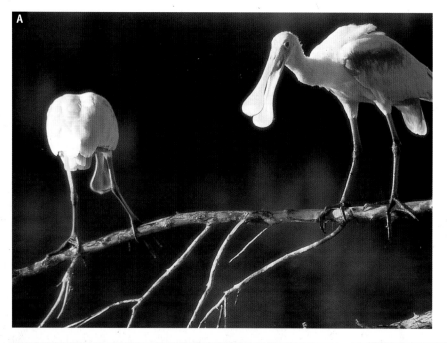

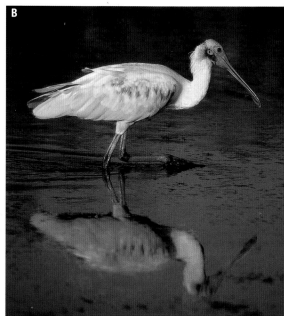

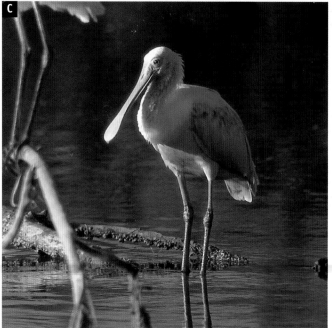

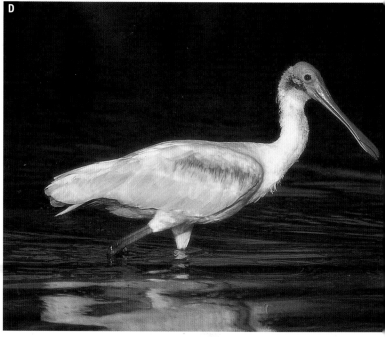

A This flock of spoonbills is shown in typical mangrove and shallow water habitat. *S. Florida, late March*

B Spoonbills' beaks are truly spoon-shaped. The nostrils are found on the top of the flattened bills. *S. Florida, early April*

C Often before a flock of birds decides to take flight, several birds raise their bills and point them up to the sky. *S. Florida, early April*

D Spoonbills sweep their opened bills back and forth through the water feeling for prey rather than looking for it. *S. Florida, early April*

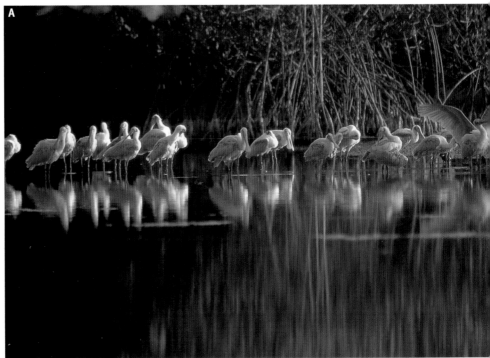

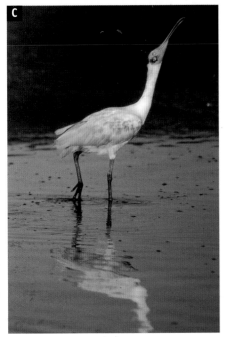

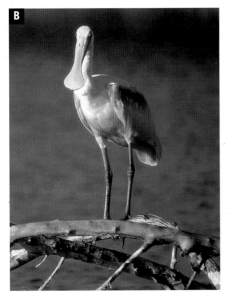

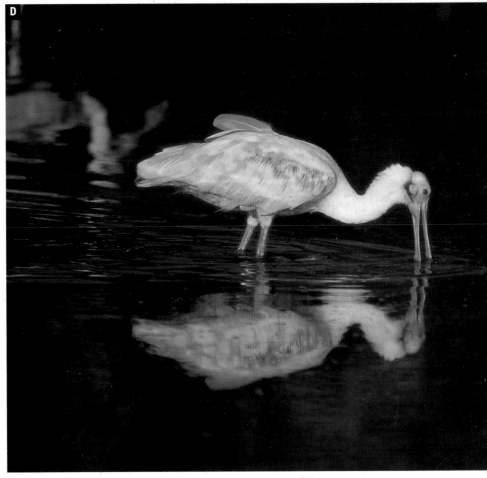

Roseate Spoonbill

A Notice the yellow patch on the side of this adult in full breeding plumage. *S. Florida, early April*

B Feeding spoonbill. *S. Florida, late March*

C The folded wings reach the same length as the tail. *S. Florida, early April*

D Upperwing.

E Underwing.

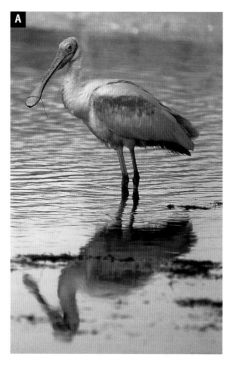

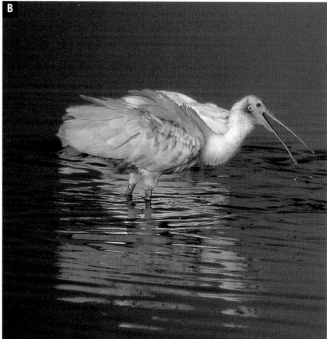

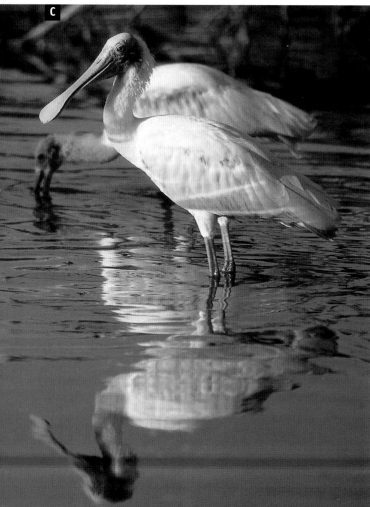

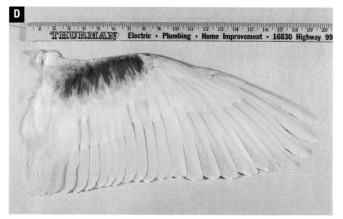

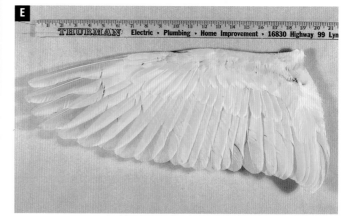

White Ibis

The beautiful white-and-red white ibis range all over Florida and up the Atlantic coast as far as Virginia and across the Gulf coast into Mexico, where they are found on both coasts, including Baja California and southward. Usually they are near the coasts but they will frequent freshwater as well as salt water. You can find them in mangroves, swamps, tidal marshes and coastal lagoons or shallow fresh water and brackish ponds.

Ibis feed in the water or at the water's edge, and sometimes in the grass. They feed by probing in the mud for crustaceans, small crabs, aquatic beetles, small fish and other tiny aquatic life. In Florida I see white ibis in large and small groups feeding in the water or resting in the trees together. While feeding they often intermix with other species of waders such as roseate spoonbills, egrets and herons.

White ibis in adult plumage have an all-white body with pink legs, bill and face. In breeding plumage the ibis's legs, bill and facial skin turn from pink to a striking deep scarlet red color and the bill's tip turns black. Immature ibis have a brown back and wings with a brownish white body and dull pink legs and bill. As the young bird nears adulthood, white feathers gradually molt into the brown starting with the back and wing coverts.

Immature birds have less bare facial skin than adults. White ibis have ten primary feathers, thirteen secondary feathers on the trailing edge and twelve tail feathers.

A The ibis's pinkish red feet are webbed slightly in between the toes and they have a black nail at the end of each toe. *S. Florida, late March*

B Ibis often feed wading in large groups with other birds such as these snowy egrets. *S. Florida, early April*

C Immature bird. *S. Florida, late March*

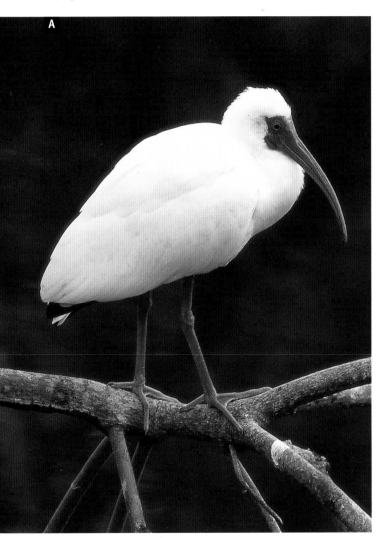

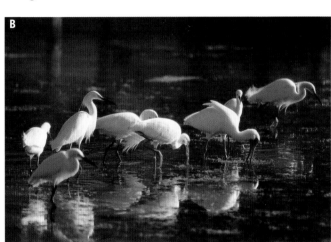

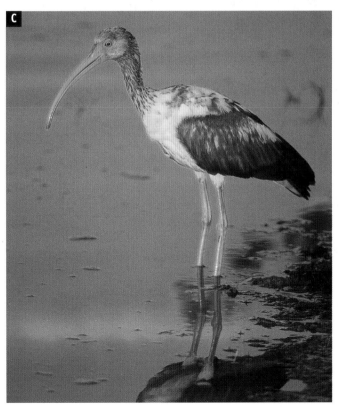

White Ibis

A This preening photo gives you a chance to study the texture of an ibis's red featherless face. *S. Florida, late March*

B This typical sleeping pose shows the feather edges better in an overcast situation. *S. Florida, late March*

C This photo shows the shape of an ibis from the front. *S. Florida, late March*

D Ibis feed wading in the water and sometimes walking around in the mud. *S. Florida, late March*

E This ibis has found a mussel. *S. Florida, late March*

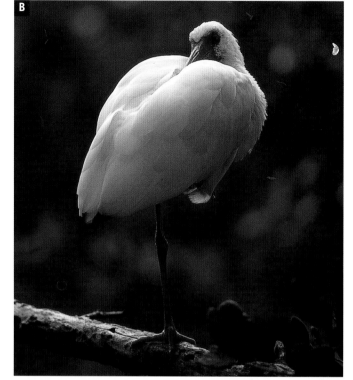

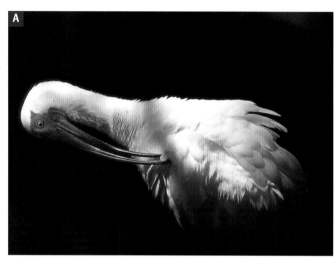

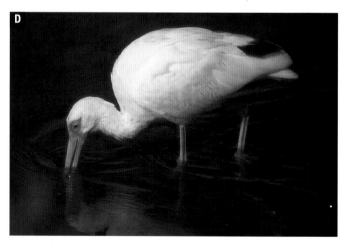

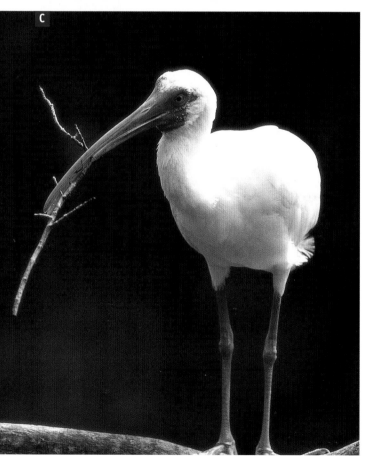

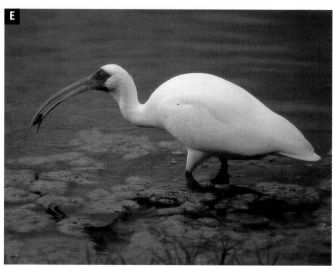

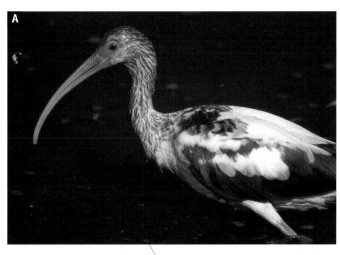

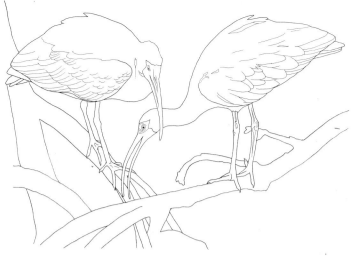

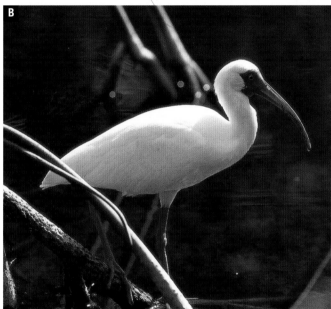

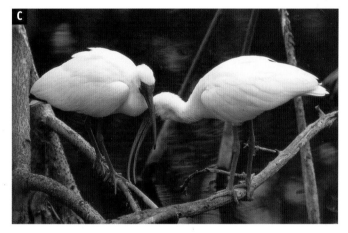

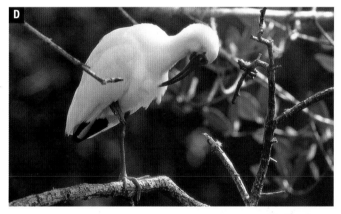

A This immature bird is nearing adulthood as it has molted into many white adult feathers on the back and wing. *S. Florida, late March*

B Backlighting can really make the beak glow and the bird stand out from a dark backdrop. *S. Florida, late March*

C The ibis on the left is closer to breeding plumage than the one on the right. *S. Florida, late March*

D The small black wing tips are normally completely hidden under the other wing feathers, but in this view from beneath you can see them. *S. Florida, late March*

E A view from the front shows the placement of the nostrils on the top of the beak and the point of white feathers in between the eyes. *S. Florida, late March*

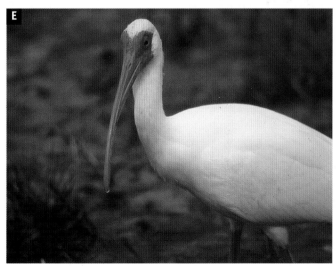

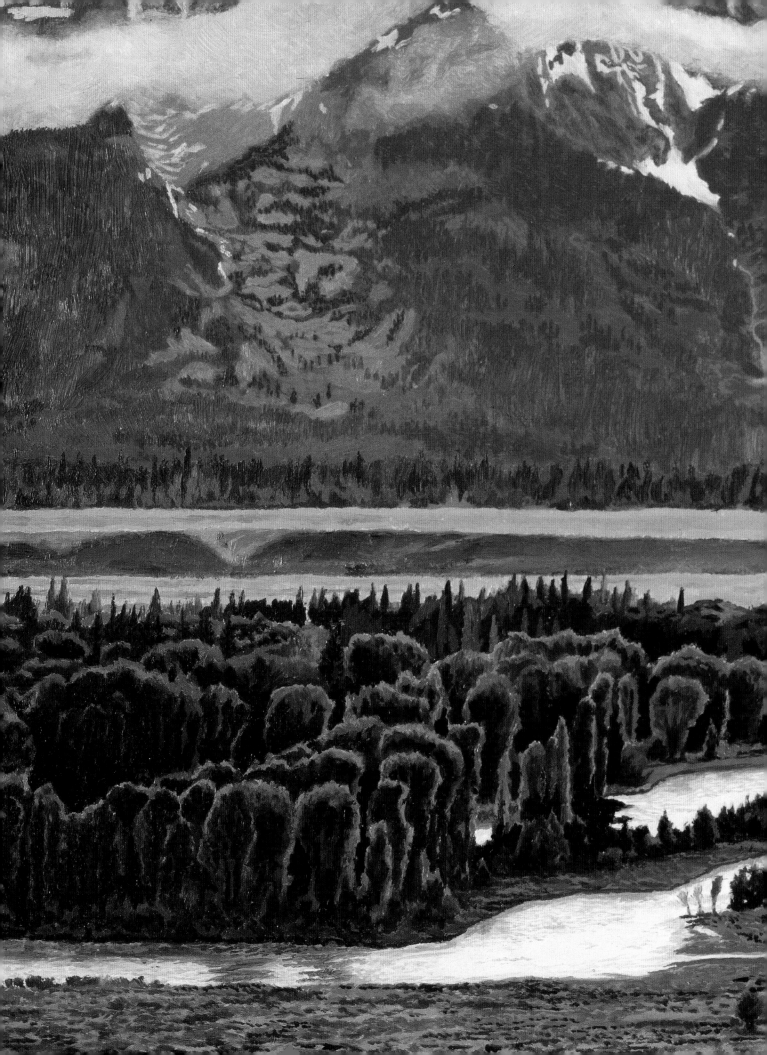

PART TWO
LAND BIRDS

The families of land birds have evolved to utilize almost every food source and habitat across North America. The birds' physical characteristics and habitat preferences reflect their main sources of food. This section takes you through various species of Birds of Prey, Ground Walkers and a general grouping I'll refer to as Backyard Birds.

Snake River BART RULON Watercolor 9" x 12" (23cm x 30cm) Private collection.

BIRDS OF PREY

Birds of prey specialize in spotting and catching live animals. They have extraordinarily keen eyesight (and in some cases, as with the owl, very good hearing) and feet with talons (long pointed claws) for capturing and killing their prey. Remember: When using captive birds of prey as references, note that the hook on the beak and the talons often grow longer than they would in the wild. On wild birds the beak and talons are naturally worn down.

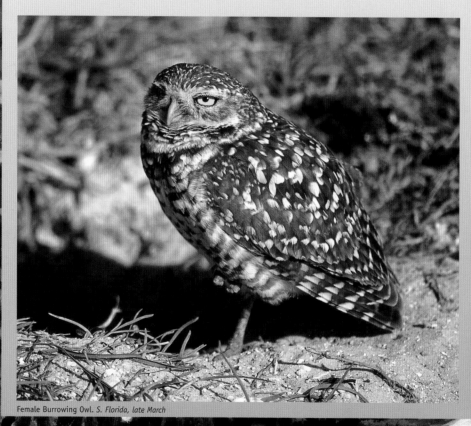

Female Burrowing Owl. *S. Florida, late March*

Burrowing Owl

Burrowing owls live primarily in the western United States and southward into Mexico, but they also inhabit Florida. This owl prefers open country including grassy fields, prairies, deserts and even golf courses and airports. Burrowing owls nest and roost in burrows abandoned by other animals, but may also dig their own burrows. Sometimes several pairs live close together in colonies, especially in the West where they use prairie-dog burrows. Burrowing owls are regularly visible and active during the day, especially at dawn and dusk.

During the day you can usually spot them standing on the ground near the entrance to their burrows or on a short perch nearby.

Burrowing owls feed on insects, rodents, other small mammals, lizards, snakes, amphibians and rarely, small birds. They normally start feeding in early evening and continue through the night. They typically fly close to the ground and sometimes hover while hunting.

Males and females look alike except males are slightly heavier than females and have longer wings. Burrowing owls have ten primary feathers, thirteen secondary feathers on the trailing edge and twelve tail feathers.

A Notice where the nostrils are placed on the owl's beak. *S. Florida, late March*

B Notice the big yellow eyes and the tiny leg feathers that look like hairs on this male burrowing owl. *S. Florida, late March*

C Burrowing owls, like this female, spend lots of time during the day standing outside their burrows. *S. Florida, late March*

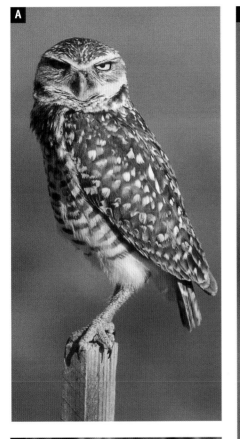

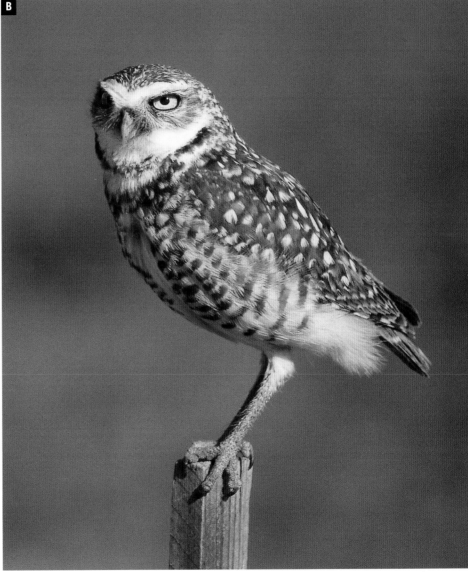

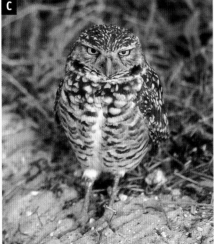

Burrowing Owl

A Owls' eyes are fixed in their sockets, but their extremely flexible head rotation helps them compensate for this. *S. Florida, late March*

B This female owl gives us a good view of her brown back with white spots. Notice how the pupil is dilated on the eye shaded from the sun. *S. Florida, late March*

C This female closes her eyes to shade them from the sinking sun. Take a good look at the details of the crown here. *S. Florida, late March*

D Ever alert, this owl spotted something in the sky. Notice the direction of feathers under the beak in this position. *S. Florida, late March*

E This male caught an insect then flew down to his burrow and offered it to his mate. *S. Florida, late March*

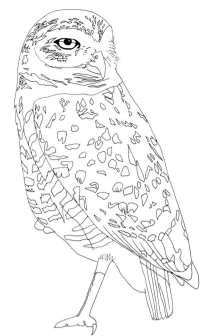

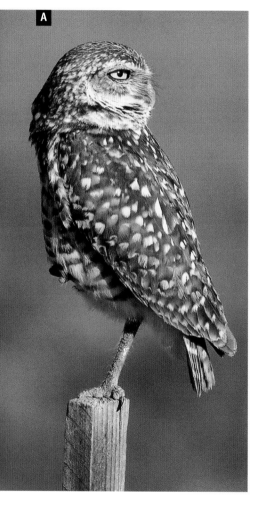

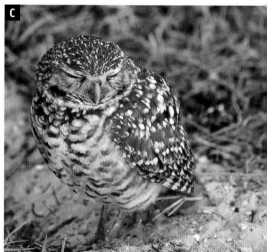

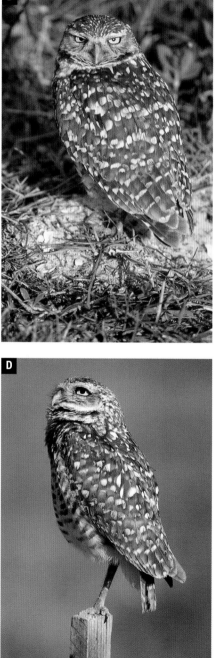

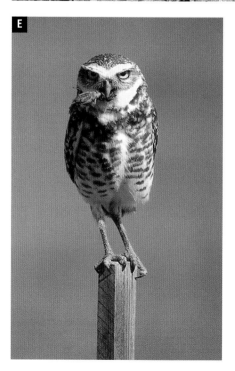

Peregrine Falcon

Peregrine falcons range over most of North America. They prefer open country near rocky cliffs or bluffs, such as freshwater or saltwater wetlands, or coastal areas with an abundance of birds. They also occupy cities and perch on tall buildings. Peregrines nest high on cliffs and on tall buildings in cities, but may also use other nest sights in trees and on the ground. Peregrines often return to the same nest site year after year.

These falcons prey chiefly on birds, especially ducks, shorebirds, seabirds and pigeons. Peregrines circle upward high into the sky, then dive down toward their target prey with jetlike speed, knocking their prey out of the sky with a quick blow from their feet.

Peregrines like to hunt in open areas because they are built more for speed than maneuverability. They can reach speeds up to 160 miles per hour on their hunting dives.

Three different subspecies of peregrine falcon inhabit North America. These subspecies have some plumage differences in their blue-gray upperparts and white underparts with black barring. Immature birds have brown upperparts and darkly streaked underparts. Males and females look similar, but females are larger than the males. Peregrine falcons have ten primary feathers, twelve secondary feathers on the trailing edge and twelve tail feathers.

A Study the layering of feathers on the back and wings of this female perched high on the top edge of a tall building. *Seattle, Washington, May*

B Peregrine falcons usually watch for prey from a high spot like a treetop, rocky cliff or telephone pole. *Washington, January*

C Notice how the brows overlap the eyes to provide shade and protection. This gives falcons a slightly "mean" look. Study the shape of the head. The yellow area on the base of the beak is the "cere" and is soft and fleshy. *Seattle, Washington, May*

D Notice the scales on the falcon's yellow feet. *Seattle, Washington, May*

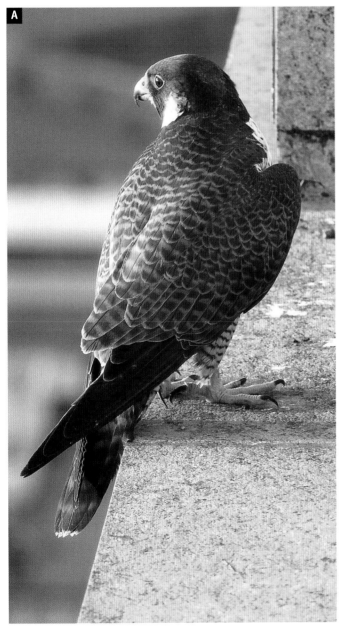

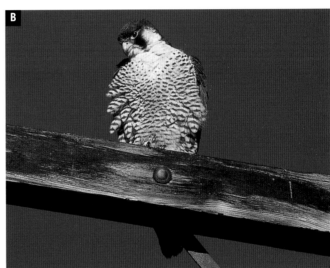

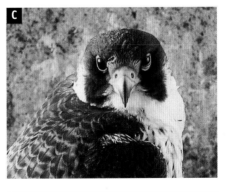

Peregrine Falcon

A Compare this male incubating eggs in a nest box high atop a tall building with the photo on the right (B) of his mate, the much larger female. *Seattle, Washington, May*

B In this photo of the female at nest you can see one of the unhatched eggs and a newly hatched chick. This falcon's lightly colored eyelid is covering her left eye. *Seattle, Washington, May*

C This female has heavy barring, especially on her upper belly. This varies between individuals and is not a difference between the sexes. Notice the warm buffy color of the belly. *Seattle, Washington, early June*

D Immature bird. *Seattle, Washington, early June*

E Study the groups of feathers and the barring on the front of this male. *Seattle, Washington, early June*

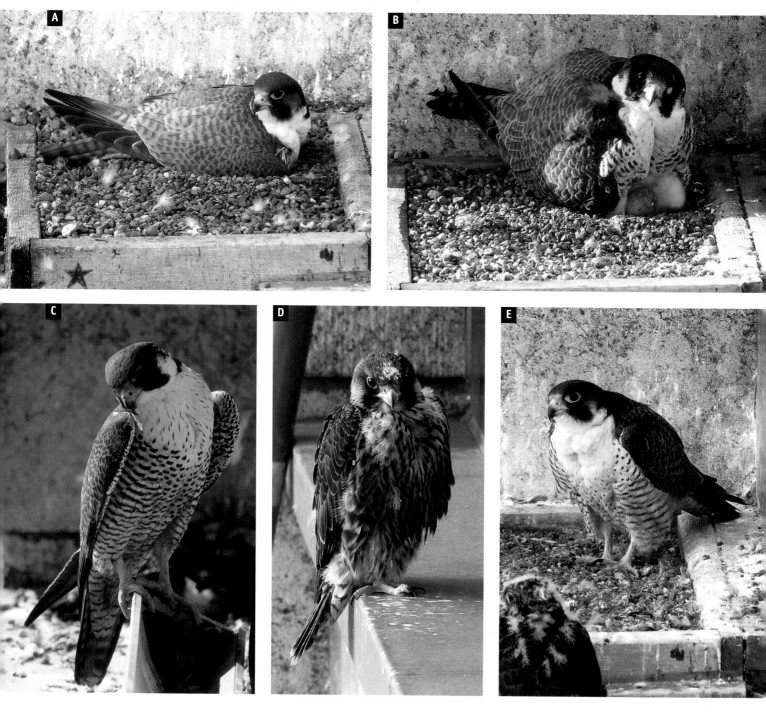

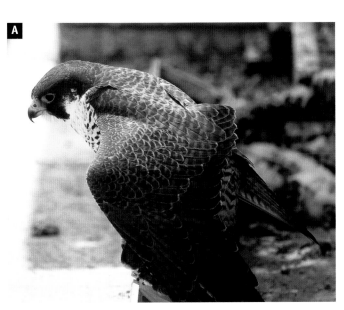

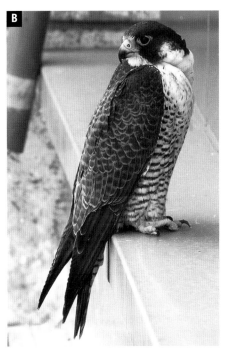

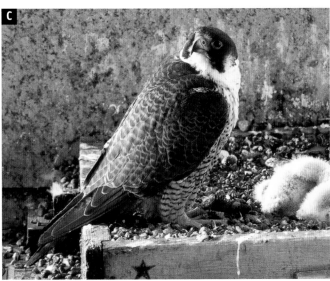

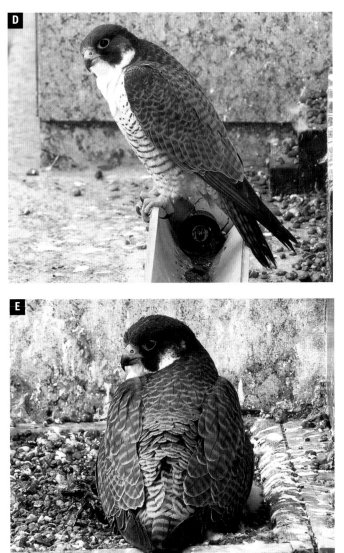

A Notice the very organized arrangement of feathers on the back and outstretched wing. The underlying body shape is very evident here and shows how the wing connects with the body. *Seattle, Washington, early June*

B The female is shown here in a typical perching pose. Notice the parting of feathers on the breast as the head turns. The bony knob in the middle of the nostril is thought to help falcons breathe when they are making their ultrahigh-speed dives. *Seattle, Washington, May*

C The reflection of light from the wall puts a highlight in the female's eye and creates warm reflected light on her belly. *Seattle, Washington, May*

D This male is in a typical resting pose. *Seattle, Washington, May*

E Study the feathers on the back of this female. *Seattle, Washington, May*

Peregrine Falcon

A Here the male has just flown in and greets his mate like peregrines typically do with noisy calls and head bobbing. *Seattle, Washington, early June*

B This female caught a pigeon and has plucked the feathers before bringing the prey up to the nest. She is shown here in a typical stance for a falcon with captured prey, with one foot clasped to her prize. *Seattle, Washington, May*

C Notice the enlarged crop (enlargement of the esophagus in the neck primarily used to store food) on the chick in front. Also notice the notch on the cutting edge of the adult's upper beak; it's called the tomial tooth. *Seattle, Washington, May*

D At the nest the adults pick off small pieces of meat to feed the hungry chicks. Both the male and female share duties with the young. While one adult is protecting the chicks, the other is usually out hunting to provide food for the others. *Seattle, Washington, May*

E As the female lowers her wings keeping the chicks protected and warm, notice the separation of the feathers on her breast. *Seattle, Washington, May*

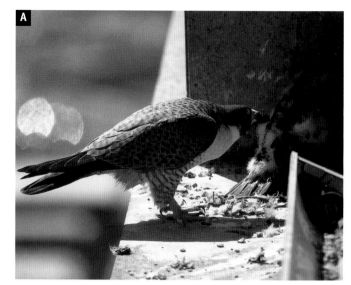

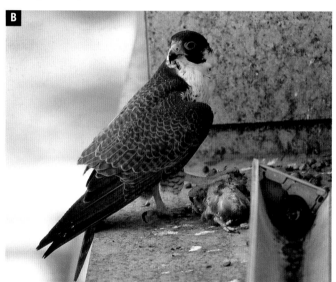

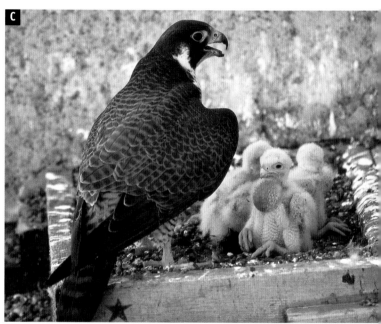

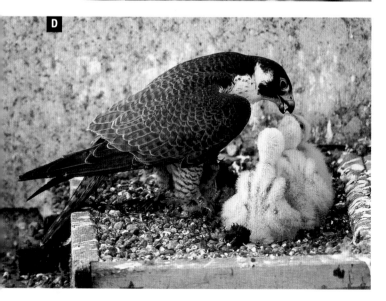

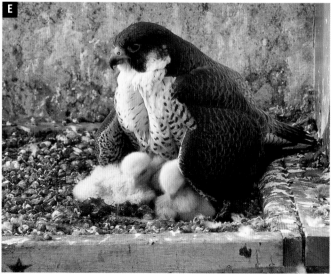

Red-Tailed Hawk

Red-tailed hawks are the most commonly seen hawks, ranging over the greater part of North America. You can see them year-round in most of the lower forty-eight states, and in the summer, look for them further north into the middle northern states, Canada and Alaska. The only places they don't inhabit are the upper reaches of Alaska and Canada. Red-tailed hawks utilize a wide range of habitats, but prefer open country interspersed with trees, fence posts and other high perches. They perch on the edge of woodlands, hunting in the open areas rather than perching in the dense trees.

Red-tailed hawks hunt from a stationary perch or while soaring in the air. Their main prey are rodents, especially mice, snatched from the ground. They are opportunistic feeders and also feed on other small mammals, birds, snakes, amphibians, lizards and insects among others. I once watched a red-tailed hawk steal a shorebird that a peregrine falcon had just caught.

Males and females look the same except that females are larger on average. The red-tailed hawk's plumage varies widely across North America. Light morph hawks are most commonly seen and have a brown back, brown head, light breast, streaked belly band, yellow legs and feet and a brick red tail. You may also see darker morphs that lack the light underparts. Certain morphs or variations are common in different regions. Check a bird field guide to study these variations. Red-tailed hawks have ten primary feathers, thirteen secondary feathers on the trailing edge and twelve tail feathers.

A This is the typical on-the-ground pose, with the body leaning forward after an attempt to catch prey. *W. Washington, February*

B Western form adult red-tailed hawk. *W. Washington, mid-January*

Red-Tailed Hawk

A This adult's eye is still the light yellow of an immature bird. The eyes of adults are usually dark brown, but on occasion abnormalities occur; possibly the hawk's captive diet may have an effect. The hook on the beak of this hawk was filed down because it had grown too long. *Captive bird*

B Study the heavily scaled toes of this adult. The talons are different lengths. The rear talon is the longest, and of the three front toes, the innermost toe has the next longest talon. *Captive bird*

C Immature bird. *W. Washington, January*

D This is a less common rufous morph adult hawk. Notice the deep Burnt Sienna and Chocolate Brown colors on the head and under-parts. *W. Washington, mid-January*

E This light morph variety is most common, having a dark brown back and wings with some lighter buff patches, and brick red tail. *W. Washington, mid-January*

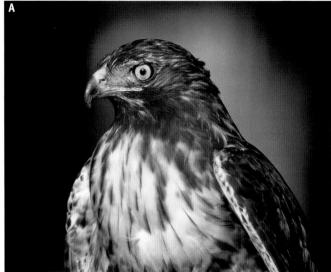

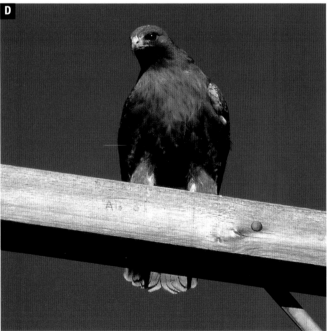

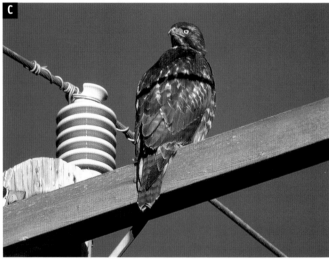

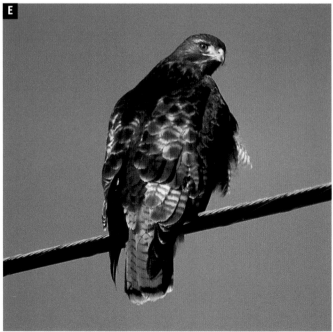

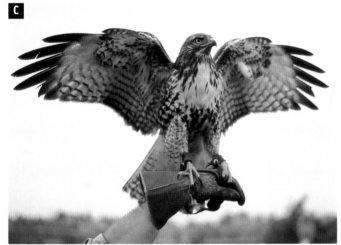

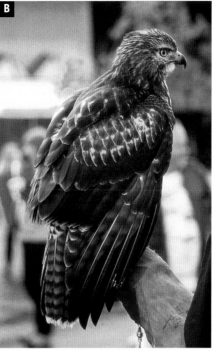

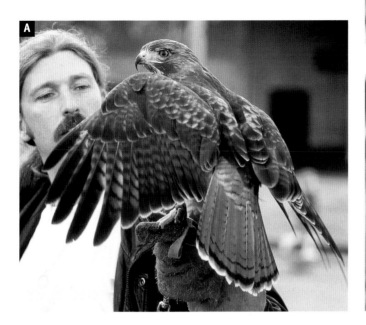

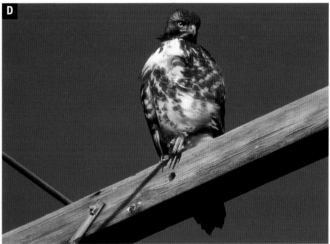

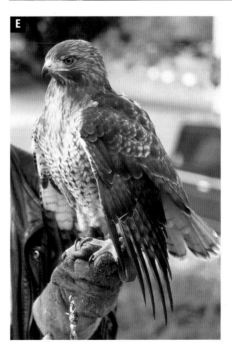

A This photo gives you a good look at the adult's brick red tail. The wide black band nearest the end of the tail feathers (subterminal band) tends to be wider in western birds than in eastern birds. Western birds, like this one, also tend to have other, less distinct bands above the subterminal band. Eastern birds usually lack these extra bands above the subterminal band. *Captive bird*

B Notice the buff patterns on the back (on the scapulars) and wing coverts on this immature hawk. *Captive bird*

C This immature hawk gives you a great opportunity to study the complex patterns on the undersides of the wings. Notice the group of feathers on the upper legs that come out from under the belly feathers. *Captive bird*

D This immature hawk scans the ground for any movement that might be prey like a mouse or vole. *W. Washington, February*

E Notice the pale pink and faint dark bands on the tail's underside. *Captive bird*

Snowy Owl

This large owl of the north ranges over most of Canada and Alaska. In the winter, snowy owls often move south into the northern United States. In years when lemming populations in the north are declining, owls move further south than normal in search of food. In the far north this owl lives on the open tundra, perching and nesting on the ground. Further south, snowy owls are seen in open areas around coasts, marshes, lakes, grassy fields and airports. They rarely perch in trees, preferring instead to perch on the ground, fence posts, wood stumps, roofs of buildings or even on farm machinery.

Snowy owls prey mostly on lemmings and mice in their northern habitat. They also feed on other small fur-bearing mammals, such as squirrels and rabbits and birds, especially waterfowl. They hunt during the night and day.

The snowy owl is a white bird with yellow eyes and dark bars on its body. Adult female owls are generally more heavily barred with black than adult males, and immature owls usually have heavier black barring than adults. Immature females tend to be the darkest. Some old males may be almost all white. Snowy owls have ten primary feathers, sixteen secondary feathers on the trailing edge and twelve tail feathers

A Notice the feathers directed forward over the sides of the beak. *W. Washington, late February*

B Notice the feather splits where the vanes of the feather separate on the feather's edge. *W. Washington, late February*

C A high population of cottontails and ducks nearby probably provided food for this owl on an island in Puget Sound. *W. Washington, mid-November*

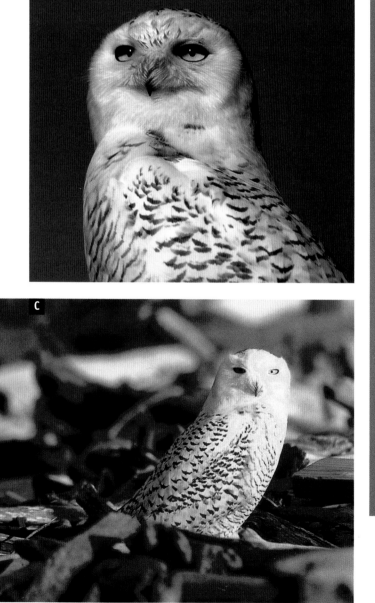

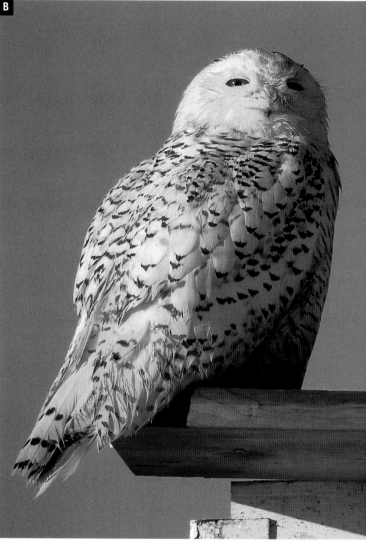

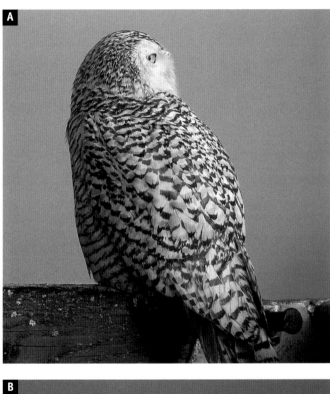

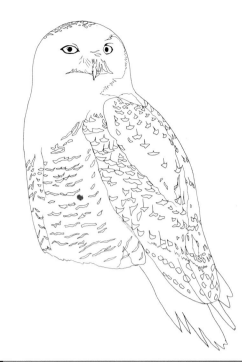

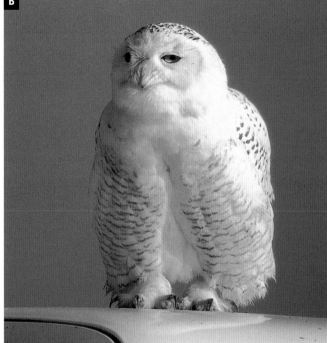

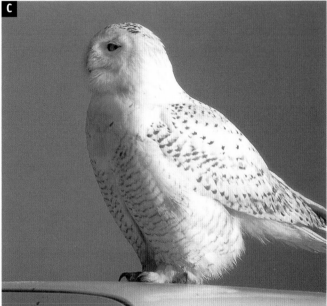

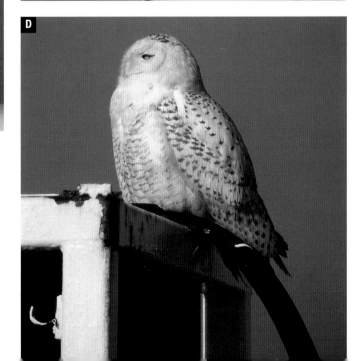

A Immature bird. *W. Washington, late February*

B Notice the brown barring on the belly of this owl, and how the groups of feathers are separated from left to right. *W. Washington, late February*

C Notice how the side and flank feathers come down and cover up the legs. *W. Washington, late February*

D Snowy owls often perch on farm machinery. *W. Washington, late February*

Snowy Owl

A Study the markings on the top of the head of this preening owl. *W. Washington, late February*

B To cool down on hot days, snowy owls often pant with their mouth wide open, pulsing the skin of their throat in and out (gular fluttering). *W. Washington, late February*

C The brow over the eye shades the eye at such an angle that their is no highlight from the sun. *W. Washington, late February*

D A yawn shows the wide gape of an owl's mouth. Notice the owl's squinted eyes. *W. Washington, late February*

E Something in the distance caught the eye of this very alert owl. *W. Washington, late February*

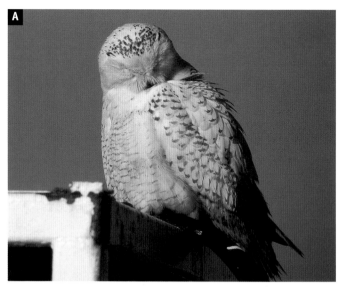

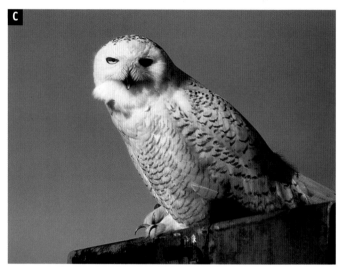

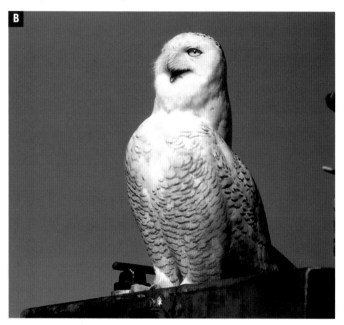

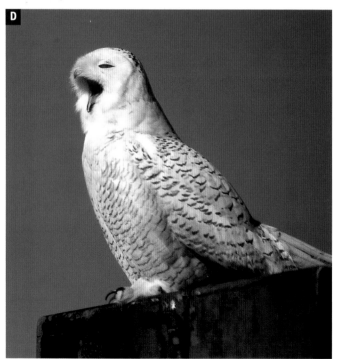

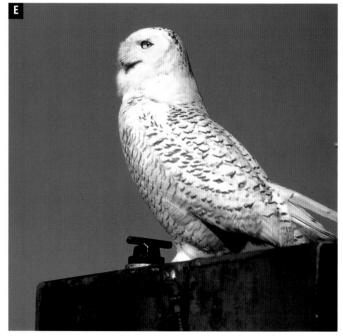

A The markings on the back are arranged roughly in rows. Most of these marks have thin points on their leading edge, where the feather barb, or central shaft, is located. *W. Washington, late February*

B The feathers of the side usually overlap part of the folded wing. *W. Washington, late February*

C The bars on a snowy owl's belly are usually longer, lighter, thinner and straighter than the markings on the back. *W. Washington, late February*

D Female upperwing.

E Upperwing (unknown sex). The amount of black barring on a snowy owl is variable, and males generally have less than females do.

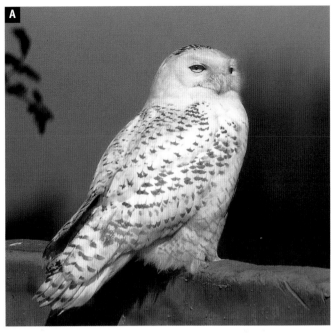

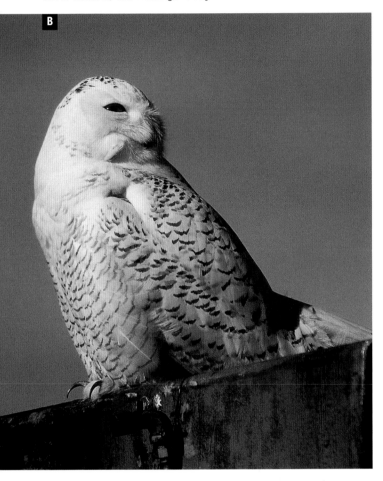

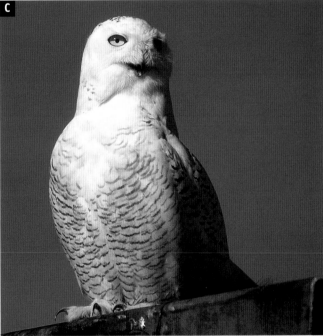

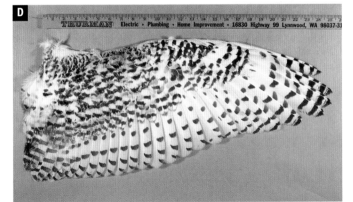

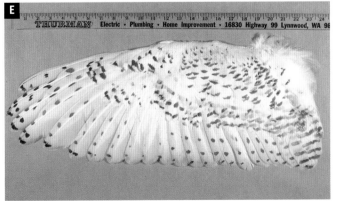

Snowy Owl in Watercolor

Materials

Paper:

Arches 140-lb. hot-press watercolor paper

Palette:

Winsor & Newton Watercolors— French Ultramarine, Cerulean Blue, Raw Umber, Burnt Umber, Raw Sienna, Burnt Sienna, Yellow Ochre, Lemon Yellow Hue, Cadmium Orange, Alizarin Crimson, Sap Green, Neutral Tint.

Brushes:

round no. 00, no. 2, no. 3, no. 4, no. 12, no. 14

Other:

Masonite board
Masking tape
Incredible White Mask Liquid Frisket

During a winter abundant with snowy owls, I found one hanging out on a driftwood-strewn shoreline close to my home. I took many pictures of this owl and its driftwood habitat at different times of the day. I also found and photographed other owls in areas nearby. In planning this painting I picked out the most interesting driftwood photo and owl photographs, from all the birds I followed, that would fit the scene. The idea was to draw from all my references to sum up my favorite moments with the first owl in the warmth of the evening sun but with a better composition than what I actually saw.

Habitat reference photo

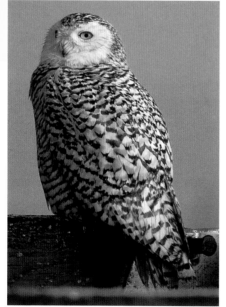

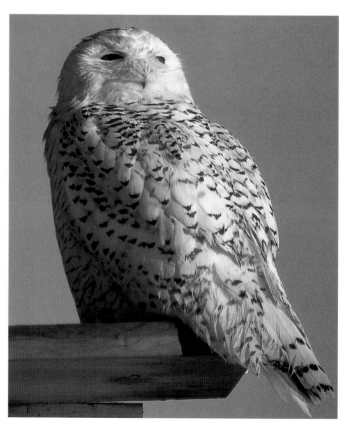

1. Choose Reference Photos

Find a good landscape photograph of an area inhabited by snowy owls. Then pick out a few photographs of snowy owl poses that would fit into that scene.

2. Construct the Composition

Plan possible compositions by drawing various thumbnail sketches of the scene with different owl poses.

3. Start Painting

After completing a detailed drawing of the habitat on watercolor paper, make a paper cutout of your owl sketch and fine-tune the owl's position in the composition, sketching it in when it looks right.

Lightly paint in the darkest markings on the owl, wood and grass, using no. 2 and no. 3 round brushes with a Neutral Tint/Burnt Umber/Raw Umber mixture. This helps you find your place when referring back to the reference photographs. Add warm washes of Raw Sienna to the wood and grass using no.12 and no.14 round brushes. Paint in purple shadows and crevices in the wood with a French Ultramarine/Alizarin Crimson mix.

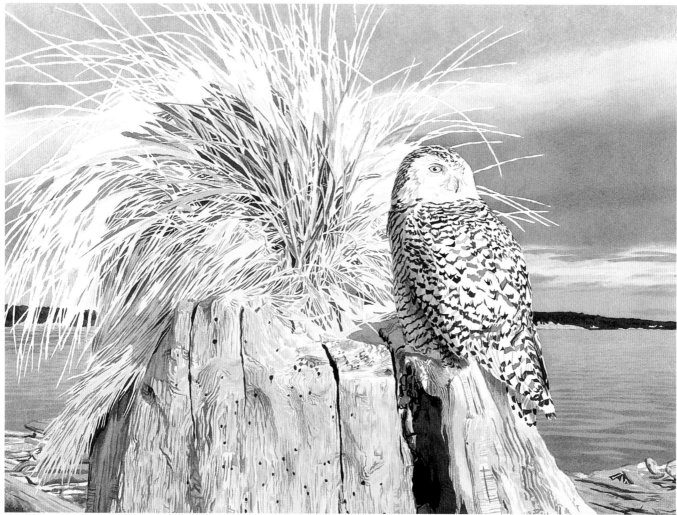

4. Work All Over the Painting

Continue to develop the grass using the same colors as before, and add a Sap Green/Raw Sienna (or Burnt Sienna) mix with a no. 2 round brush to give it some green coloring. Add more crevices to the wood with a Raw Sienna/Burnt Umber mix, painting a mix of Raw Sienna, Burnt Sienna and Cadmium Orange with a no. 4 round brush over areas of the wood with the most warmth from the sun.

Build the owl's shadow areas with a no. 4 round brush using a French Ultramarine/Alizarin Crimson mix. Adding a wash of Raw Sienna on the edge of these areas helps represent the warm reflection from the sunlit grasses. Darken the owl's markings using the same colors as in step three. Block in the owl's eye with a Lemon Yellow Hue/Cadmium Orange mix; then paint in the dark areas of the eye with a no. 00 round brush, leaving the white of the paper as a highlight.

To start work on the background, mask the grass's edges with liquid frisket using a small, old brush. Mix Cerulean Blue/French Ultramarine for the top of the sky, French Ultramarine/Alizarin Crimson for the clouds and water, and Alizarin Crimson with a touch of French Ultramarine for the pinkish highlights in the clouds. Wash these mixtures onto the background with no. 12 and no. 14 round brushes. It may take several layers of washes before reaching your desired intensity. Add ripples on the surface of the water with a stronger mix of French Ultramarine/Alizarin Crimson and a pinker mix of Alizarin Crimson with a touch of French Ultramarine.

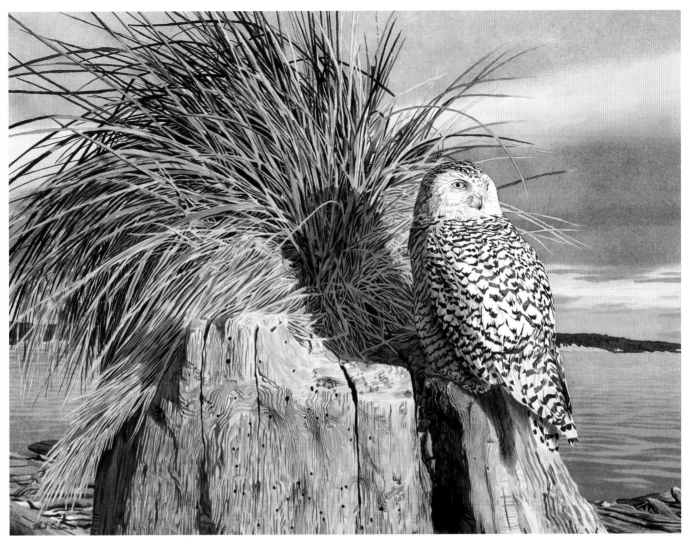

5. Add Final Details

Deepen the colors in the grass and wood using their previous mixtures of color plus Yellow Ochre. Add the darkest and thinnest details in the wood and grasses with a no. 2 round brush to maintain their crispness.

Finish the owl's facial details using a no.2 round brush with a Raw Sienna/Burnt Umber mix, and a French Ultramarine/Alizarin Crimson mix. Paint several thin washes of Raw Sienna on the back, wings and tail to indicate the warmth of the sun. Deepen the shadow on the owl and the barring on the owl using their previous mixtures of color.

Sunset View—Snowy Owl, BART RULON, Watercolor, 18" X 24" *(46cm X 61cm)*

Create the Owl's Shadow

Make several drawings of how you imagine the shadow, color them with black marker, cut them out and place them on the painting for comparison. Once you find a believable shape, lightly draw the shadow on your painting. Paint the shadow with two washes of a French Ultramarine/Alizarin Crimson mix, making the edges uneven as they are when a shadow is cast on a scattered subject like grass.

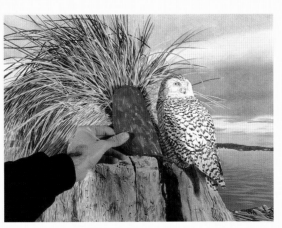

GROUND WALKERS

The ground-walking (gallinaceous) birds covered in this book include grouse, ptarmigan and quail. They have plump bodies with strong legs, short rounded wings, stout beaks and muscular breasts. They spend most of their time on the ground, flying from danger only as a last resort, as they prefer to escape on foot or go unnoticed.

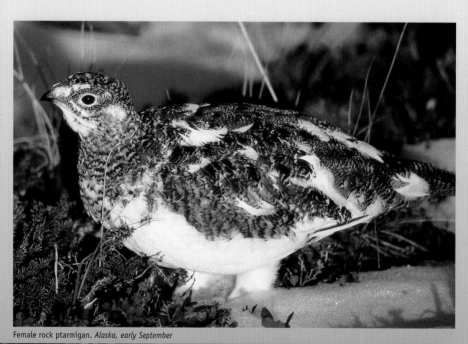

Female rock ptarmigan. *Alaska, early September*

California Quail

The California quail inhabits Washington, Oregon, California, Idaho, Nevada and Utah, also ranging into Baja California. Their habitat consists mostly of woodland edges or brushy areas that open up into weeds and grass with a nearby water source. You can see them around farms, ranches, suburbs and gardens. California quail are very gregarious and gather in large coveys in the fall and winter. In the spring, couples pair off to raise young on their own.

While feeding in coveys one bird, from a high perch or the ground, usually acts as a sentinel, looking for danger. Quail eat seeds, leaves, buds, grasses, berries and insects. They scratch the ground with their feet to expose seed. A covey of quail often visits the same feeding areas day after day, feeding most actively in the morning and evening.

Males and females differ in appearance. The male is very colorful and has elaborate markings on his head, belly and sides, with a large teardrop-shaped group of plume feathers projecting from his head. The female has a shorter tuft of plume feathers pointing off her head, and she is not as boldly marked as the male. California quail have ten primary feathers, one short secondary feather next to the primaries, then nine secondary feathers that reach the trailing edge and twelve tail feathers.

A Male. *Washington, July*

B Female. *Washington, August*

C Small quail chicks are mottled brown to help camouflage them. Soon after hatching, quail chicks can walk and feed for themselves. *Washington, July*

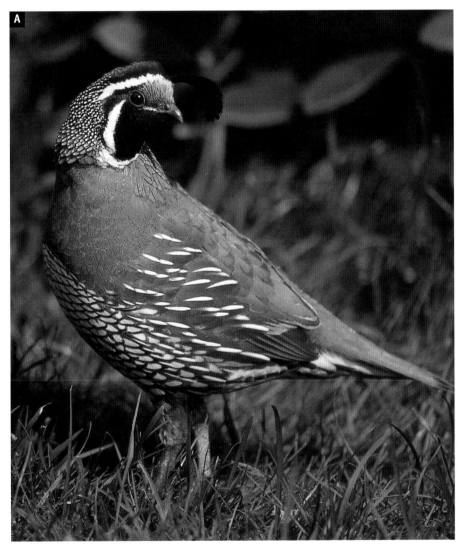

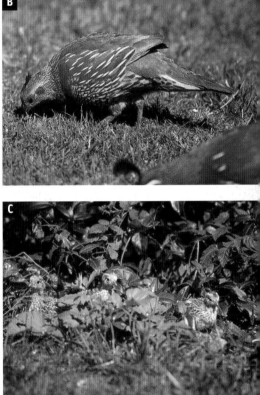

California Quail

A When in danger, quail burst into flight and land away from threat on the ground, in trees or bushes as this male did. Notice the reddish brown patch in the middle of the belly. *Washington, July*

B This male acts as sentinel, watching for danger as the female and chicks feed. *Washington, July*

C A pair together allows you to see the differences between male and female coloring and feather plumes. The females blend more into their habitat than the males. *Washington, July*

D This typical feeding pose gives you a great view of the white streaks on the side of the quail. *Washington, August*

E The head plumes can also be projected backwards from the head. *Washington, August*

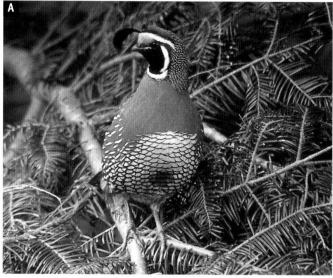

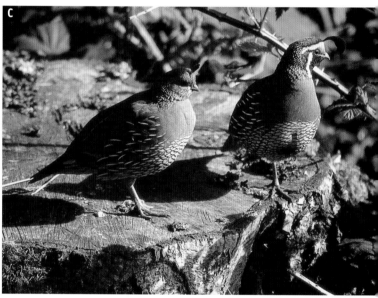

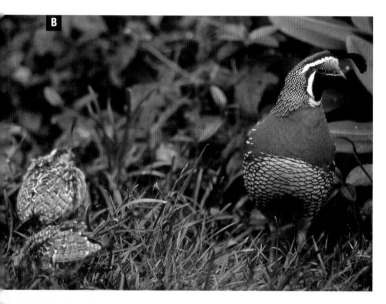

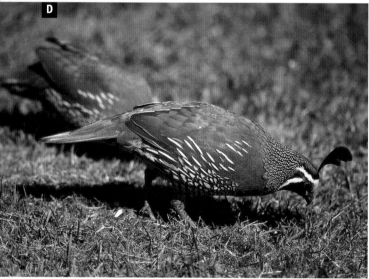

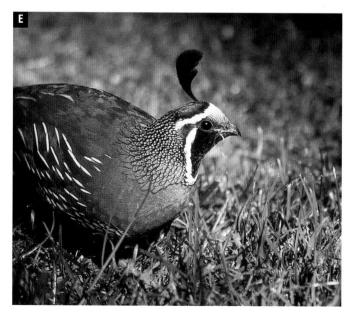

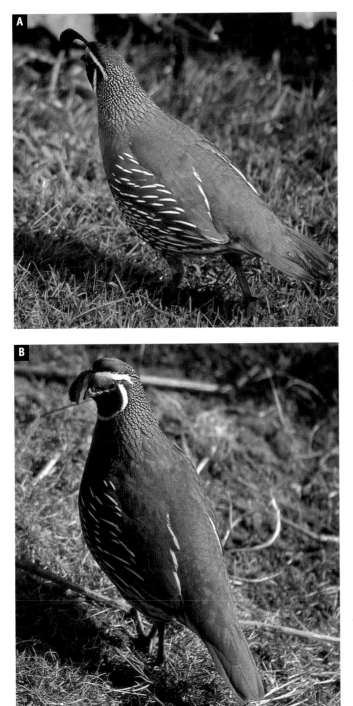

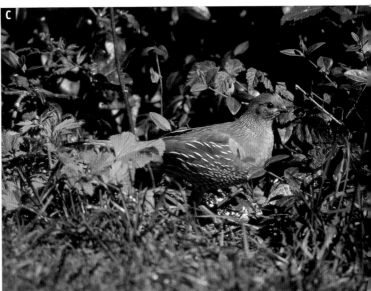

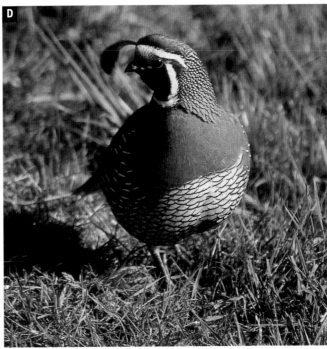

A From this angle you can study the rusty crown and the distinct feathers on the neck of a male. *Washington, July*

B The black plume feathers projecting from the quail's head have a scoop-like shape. *Washington, July*

C Females also have wedge-shaped feathers on their necks. *Washington, July*

D The small feathers of the neck separate from the breast feathers when this quail turns his head. *Washington, July*

Rock Ptarmigan

Rock ptarmigan range from Alaska in the west and across the upper reaches of Canada to the east. Their southernmost range is generally the middle of Canada. They live on mountaintops, rocky slopes and in tundra. They eat leaves, flower buds, twigs, seeds, berries and some insects.

In summer, both the male and female have brown plumage with black markings, white wings, white legs and black tails. The male's summer plumage is darker and grayer than the female's. In winter, both the male and female have virtually all-white plumage except for the black on their tails, and a red comb of bare skin above the eyes. Males in winter have a black line of feathers on their lores, running from the beak to the eyes. The legs and toes of the ptarmigan are feathered. The toes become heavily feathered in the winter. While the birds are molting from winter to summer plumage or vice versa, they have patchy areas of white and brown. Their plumage change allows them to be camouflaged in order to avoid predators; they often freeze and allow humans to approach closely before flying or running away. Rock ptarmigan have ten primary feathers, one short secondary feather next to the primaries, then twelve secondary feathers that reach the trailing edge. They have sixteen tail feathers.

A Notice the rounded cheeks. *Alaska, early September*

B Study the complexity of patterns on the back and sides of this female. *Alaska, early September*

C Rock ptarmigan live high in the mountains, on rocky slopes and in the tundra. This female is well camouflaged. *Alaska, early September*

D Summer plumage. *Alaska, early September*

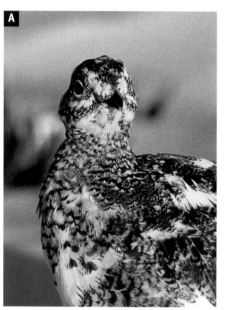

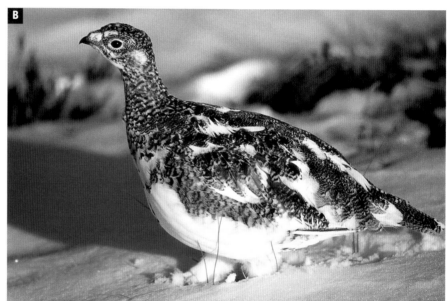

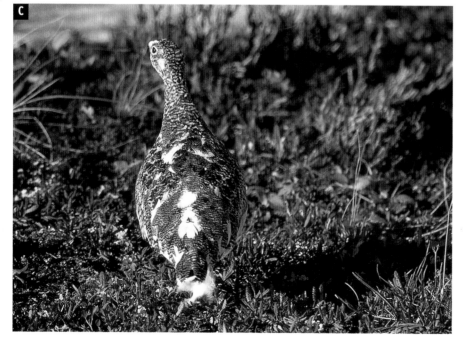

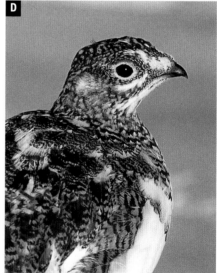

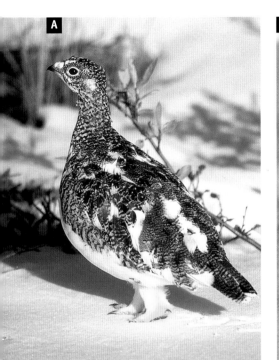

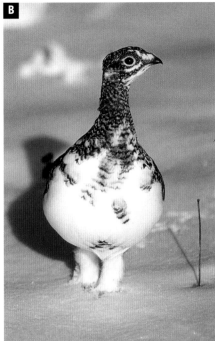

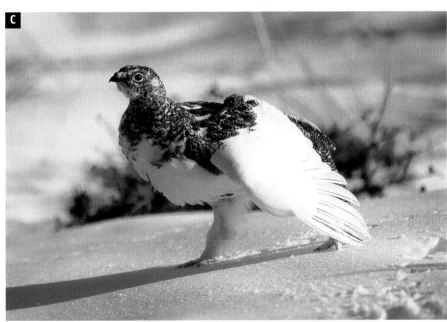

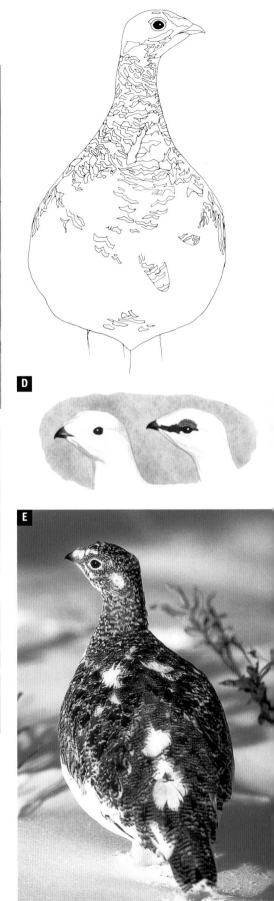

A Rock ptarmigan's feathered feet and toes keep them warm and help them walk on snow. *Alaska, early September*

B This photo shows how plump ptarmigan are, and how the white belly blends into the brown breast and neck of a female. *Alaska, early September*

C Wings remain white through the year, although some of the feathers on the inner wings change color. *Alaska, early September*

D Male (right) and female(left) in winter.

E This photo of a female gives you a view of the shape of the body from directly behind. *Alaska, early September*

Spruce Grouse

Spruce grouse range over most of Alaska and Canada. They inhabit some of the northern United States in the northwest, northeast and around the Great Lakes. This approachable bird prefers evergreen forest habitat. You can see spruce grouse in trees (especially in winter) as well as on the ground, and they frequent gravel roads. They travel singly or in small coveys.

In the trees, spruce grouse eat buds of fir, larch, pine and spruce. They also eat berries, weeds, seeds, leaves, mushrooms, ferns and some insects.

Male spruce grouse are more striking and larger than females. The male has a black neck and breast with white feathers on the side, large red combs above the eyes, a gray back and a dark tail with a tan edge. The undertail coverts are black with white tips. The female is brown or gray with black barring on the back, and black-and-white barring on the belly with a tail similar to the male's. The females lack the large red area of skin above the eye that the males have. Spruce grouse have ten primary feathers, one short secondary feather next to the primaries, then eleven secondary feathers that reach the trailing edge. They have sixteen tail feathers.

A Male. *Alaska, early September*

B Female. *Alaska, late August*

C Notice the variety of feather markings on the neck of this young male grouse. *Alaska, early September*

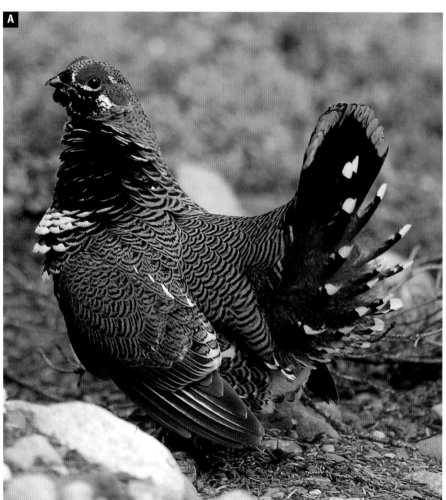

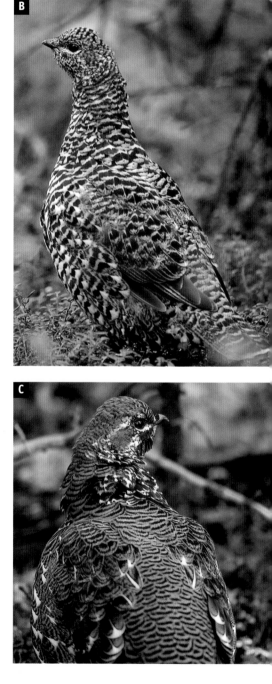

A The female's belly is heavily barred with black and white. *Alaska, late August*

B This view of a displaying male shows the black undertail coverts with white tips surrounded near the skin by soft downy feathers. *Alaska, early September*

C In a view from the front you can see how the black breast feathers ruff up on the male when he displays. *Alaska, early September*

D Notice how the undertail coverts cover up the soft downy feathers when the male is not displaying. *Alaska, early September*

E Displaying male. *Alaska, early September*

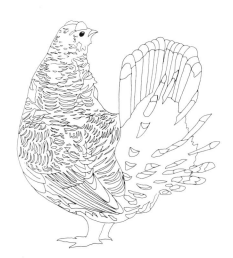

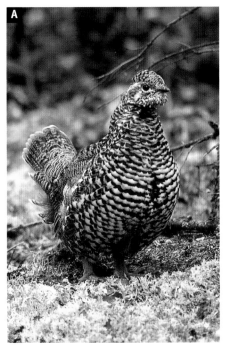

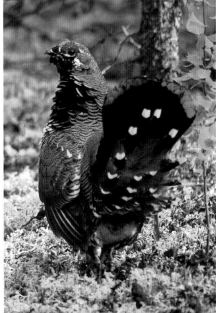

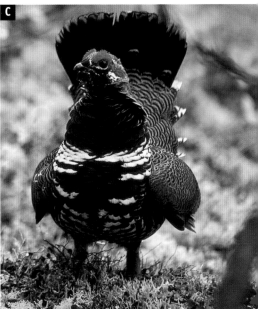

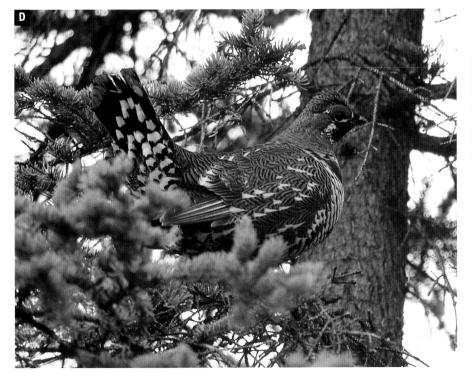

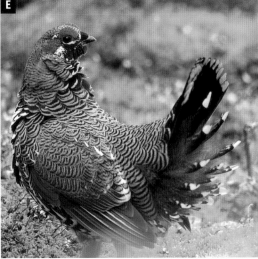

Willow Ptarmigan

The willow ptarmigan ranges from Alaska across the top of Canada to Newfoundland, and through much of British Columbia. This ptarmigan is common on brushy tundra especially in the thickets of willow and alder and is commonly seen in flocks or coveys.

In the summer, ptarmigan feed mainly on the flower buds and leaves of alder, birch and willow; berries such as blueberry, kinnikinnick and cranberry; and insects. In the winter they eat twigs and buds of trees and bushes such as willow and dwarf birches.

Like other ptarmigan, the willow ptarmigan has different winter and summer plumage. In winter both male and female birds are all white with a black tail and red combs of bare skin over the eyes. In summer, the male keeps his white wings (some of the feathers on the inner wings change color), white legs and black tail, but the rest of his body turns a chestnut color. In summer the female keeps her white wings (some of the feathers on the inner wings change color), white legs and black tail but the rest of her body turns brown with black barring, similar to the female rock ptarmigan.

Female willow and rock ptarmigan are difficult to tell apart, but willow ptarmigan average larger with larger beaks that are wider at the base. The legs and toes of both sexes are feathered. Willow ptarmigan have ten primary feathers, one small secondary feather next to the primaries, then twelve secondary feathers that reach the trailing edge, and fourteen tail feathers.

A Study the back and tail in this photo. *Alaska, late August*

B The red comb above the eye of this male enlarges in the spring during mating season. *Alaska, late August*

C These willow ptarmigan are actively feeding in the ground cover on the edge of a dirt road. Notice an adult male standing upright on the right side. *Alaska, late August*

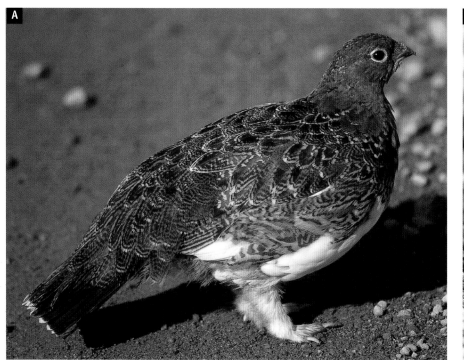

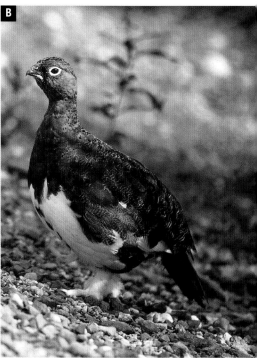

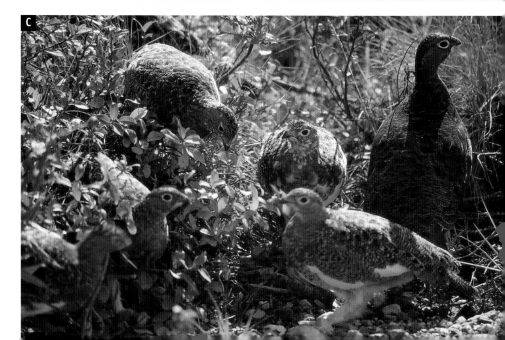

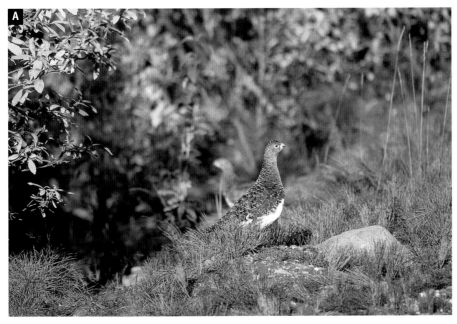

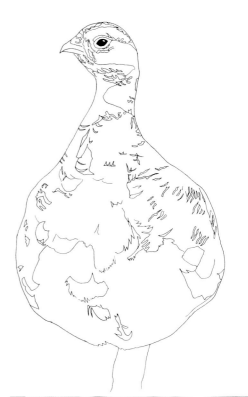

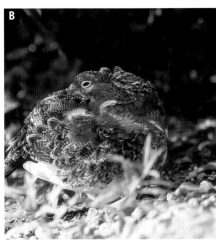

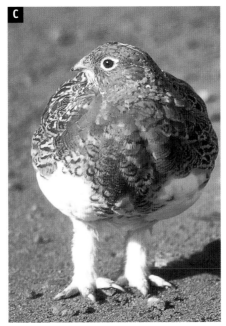

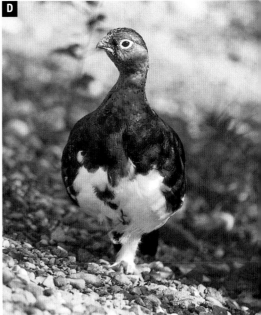

A This ptarmigan is shown in typical fall habitat. *Alaska, early September*

B This preening willow ptarmigan gives you a great view of the back and wing feathers. *Alaska, late August*

C You can really see how plump ptarmigan are in this pose. *Alaska, late August*

D Adult male in fall. *Alaska, late August*

E Winter plumage.

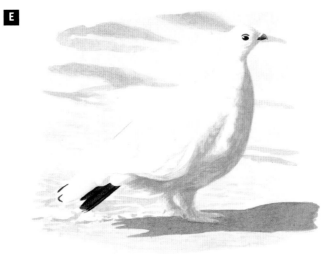

BACKYARD BIRDS

The birds in this section include songbirds, hummingbirds and woodpeckers. Many of these species are seen in yards around rural areas and suburbs, and most will come to backyard feeders of one kind or another.

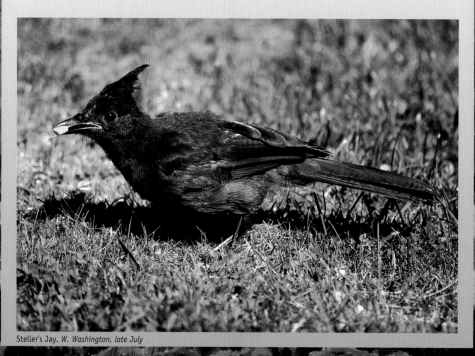

Steller's Jay. W. Washington, late July

Cardinal

Cardinals range throughout the eastern United States. Their nonmigratory range extends westward to the Dakotas, Nebraska, Kansas, Oklahoma, Texas, New Mexico, Arizona and Mexico. Most areas west and north of those areas do not have cardinals. Cardinals can be seen in many habitats such as forest borders, thickets, backyards, hedgerows, streamsides, gardens, parks and swamps. They are regulars at birdfeeders. Cardinals are normally seen singly or in pairs.

Cardinals feed on the ground, in shrubs and in trees. They eat mostly insects, seeds and the fruits of trees, shrubs and vines.

Males and females differ in plumage. The male is red with a black mask on his face bordering the base of his orange beak. The female also has an orange beak and a face mask, but her mask is not as dark as the male's. The female is not as colorful as the male. She is olive brown and gray with a red crest and reddish wings. Cardinals have nine primary feathers, nine secondary feathers, and twelve tail feathers.

A Male. *Central Kentucky, late December*

B Female. *Central Kentucky, late December*

C Note the scale details of the toes and notice that the middle toe is the longest toe on each foot. *Central Kentucky, late December*

D The beak and head shape of the female is the same as in the male, but with different colors. *Central Kentucky, late December*

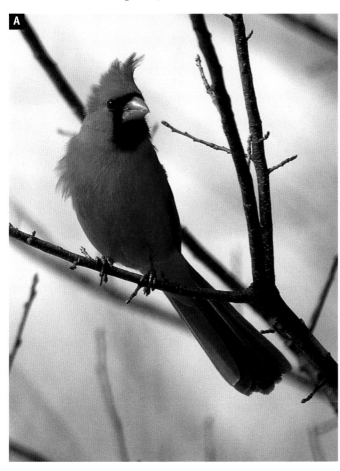

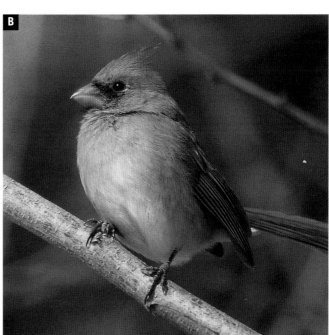

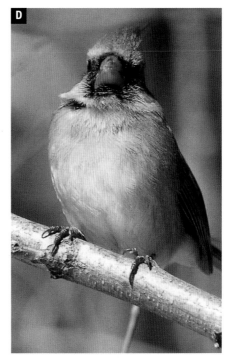

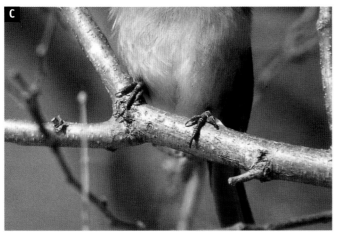

Cardinal

A The back of the neck of the males is grayer and not as brilliant red as the front of the cardinal. *Central Kentucky, late December*

B The crest can be raised or lowered like it is here. *Central Kentucky, late December*

C The male has grayish red back and wings. *Central Kentucky, late December*

D This view shows the gray edges of the male's back feathers. *Central Kentucky, late December*

E This photo shows the female's grayish back and dusky red wings and tail. *Central Kentucky, late December*

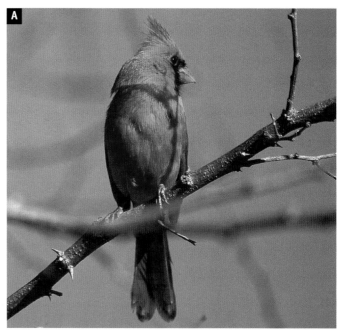

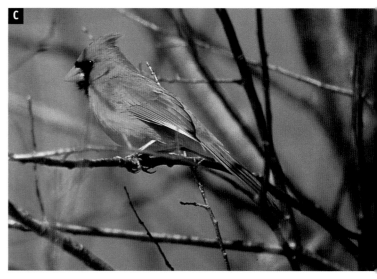

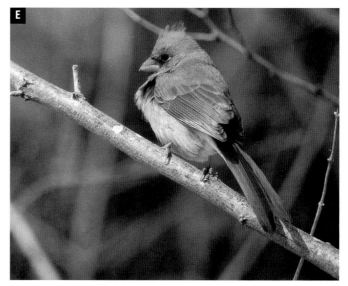

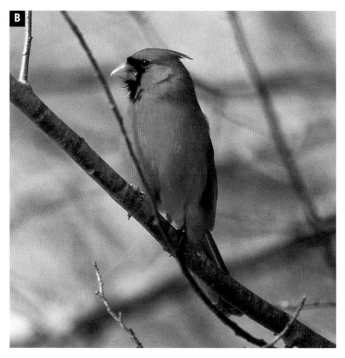

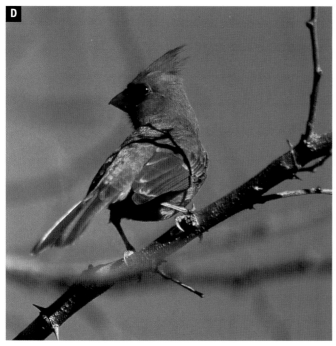

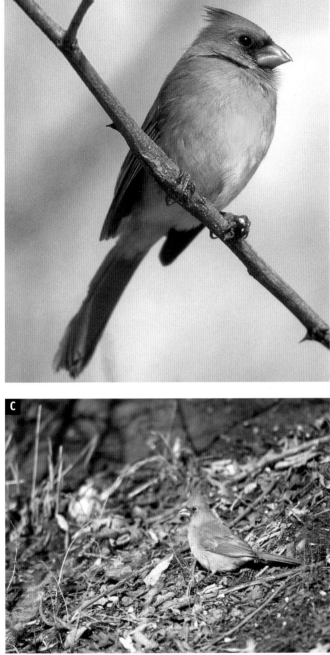

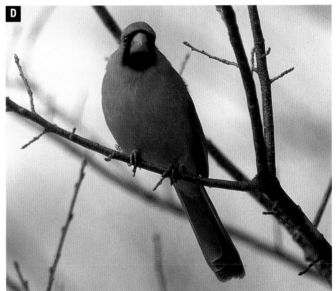

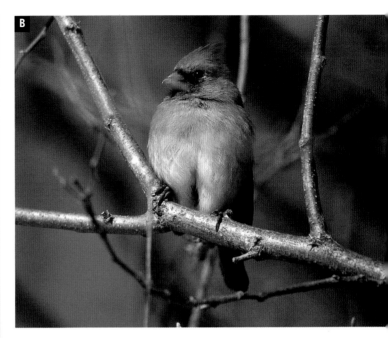

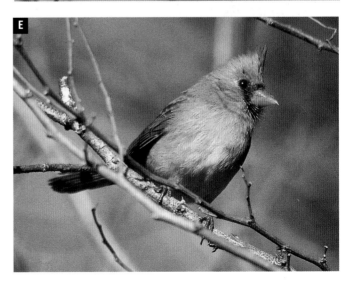

A Note the loose grip of the feet, the highlights on the beak and chocolate brown eyes. *Central Kentucky, late December*

B The white highlight in the eye brings this female to life. Notice the parting of the feathers in the lower belly. This female's beak is extremely orange. *Central Kentucky, late December*

C Cardinals spend a lot of time feeding on the ground like this female. *Central Kentucky, late December*

D In a frontal view notice the male cardinal's thick bill and the shape of the head and mask. *Central Kentucky, late December*

E The upper mandible of the beak is slightly longer at the tip than the lower mandible. *Central Kentucky, late December*

Carolina Chickadee

Carolina chickadees are common in the southeastern United States. The northern border of their range runs across southern New Jersey; southeastern Pennsylvania; Maryland; West Virginia; southern Ohio, Indiana, Illinois and Missouri; and southeastern Kansas. The western limit of their range runs from southeastern Kansas down through the eastern half of Oklahoma and eastern Texas. Carolina chickadees inhabit all the states to the south and east of those mentioned above.

Carolina chickadees are common in most types of forest and forest edges, woodland clearings, foothills, coastal plains, suburbs and parks. They are frequently seen in flocks moving actively from tree to tree feeding, and often associate with other birds such as tufted titmice and downy woodpeckers.

They feed mostly from the branches of trees and bushes looking for insects. They also eat spiders and seeds of ragweed, redbud, pine and mulberry, and they visit backyard seed and suet feeders.

Males and females have the same plumage. Carolina chickadees have ten primary feathers with the last, outermost primary being much smaller than the others; nine secondary feathers; and twelve tail feathers.

A A Carolina chickadee's most notable characteristics are the black cap, white cheeks and black throat, usually called a bib. *Kentucky, early January*

B Study the shape of the black cap, black bib and the white cheeks from the front. Notice how all these marks point in towards the beak. *Kentucky, early January*

C In mid-song. *Kentucky, early January*

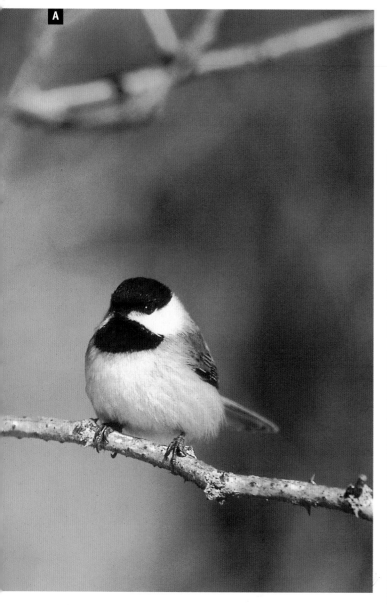

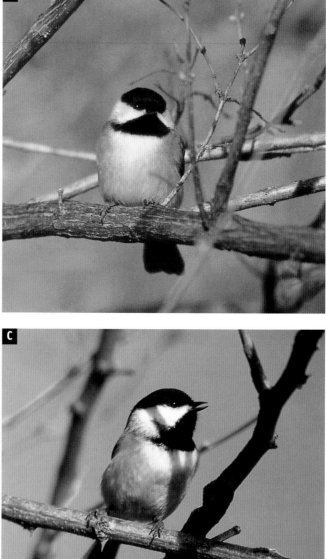

A Carolina chickadees have short, thin beaks and white bellies with light tan sides. *Kentucky, early January*

B Chickadees are extremely active birds and spend most of their time flitting from branch to branch. *Kentucky, early January*

C Study the angle of the body and spacing of the legs on this chickadee perched on a vertical branch. *Kentucky, early January*

D Capturing the highlight in a chickadee's eye helps distinguish the black eye from the surrounding black feathers of the cap. *Kentucky, early January*

E The back and wings of the chickadee are gray. *Kentucky, early January*

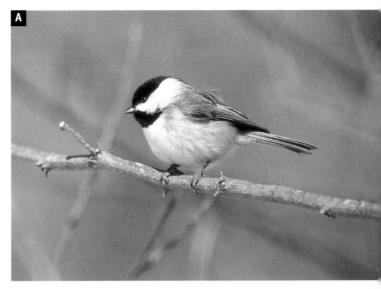

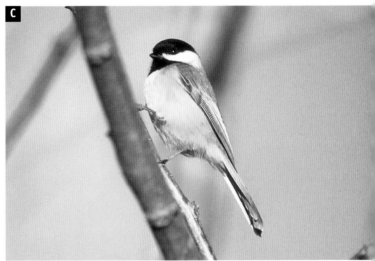

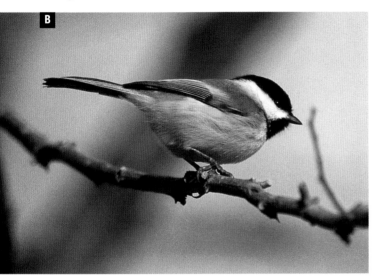

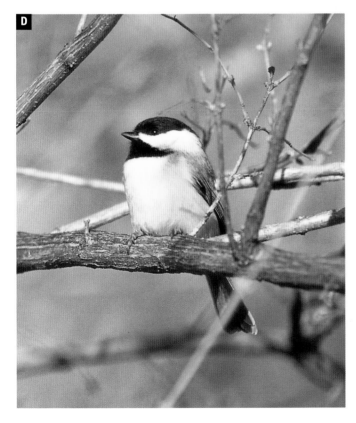

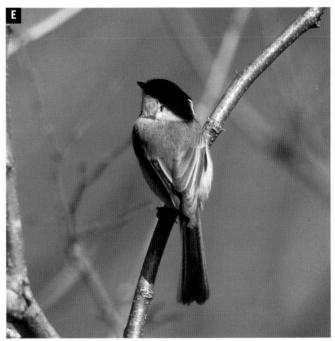

Downy Woodpecker

Downy woodpeckers are widespread year-round over most of North America except the upper reaches of Canada and Alaska. They are also absent from some of the southern portions of California, Arizona, New Mexico and Texas. These woodpeckers inhabit open forests of mixed growth and forest edges, and they visit trees in backyards, parks and orchards. They are regulars at suet and seed birdfeeders.

Downy woodpeckers are usually seen singly or in pairs, and sometimes join flocks of other birds such as chickadees and titmice. They feed mostly from tree trunks and branches eating wood-boring and other insects, insect eggs, cocoons, seeds, nuts, fruit, crop grains and other vegetative matter. On trees, downy woodpeckers move in jerky hops, sometimes backwards as well as forward, while they look for food.

Males and females basically look the same with black-and-white plumage, but the male has a red spot of feathers on the back of his head which is lacking in the females. Downy woodpeckers have ten primary feathers, but the last, outermost one is much smaller than the others. They have eight secondary feathers on the trailing edge and ten tail feathers.

A Female. *Kentucky, late December*

B Male. *Kentucky, late December*

C To tell the difference between male and female downy woodpeckers, look at the back of the head. A male has a red patch on the back of his head. *Kentucky, late December*

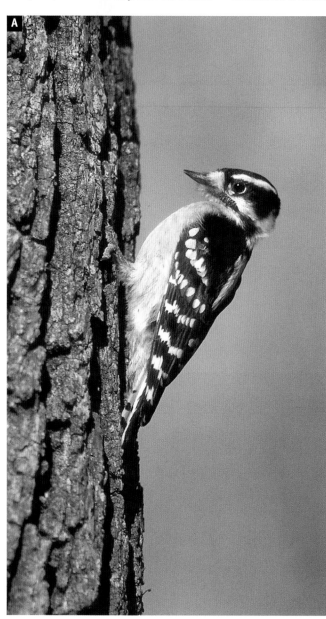

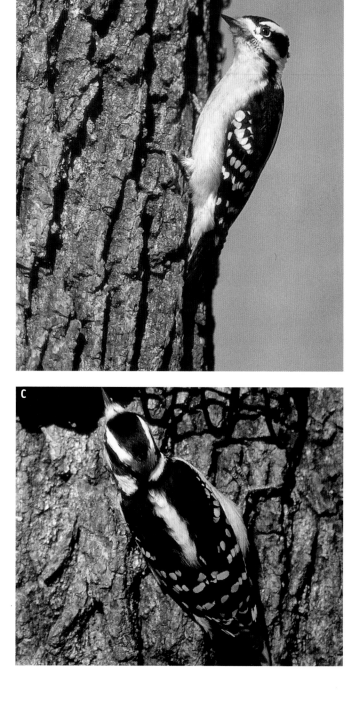

A Study the rows of white bars on the black wings of this female. *Kentucky, late December*

B Birds in some areas of the West tend to have the darker brownish gray underparts, while eastern birds have whiter underparts. *Kentucky, late December*

C This female gives you a good look at the light yellow lore area in front of the eyes which is present on both sexes. *Kentucky, late December*

D This female shows a typical trunk-clinging pose. *Kentucky, late December*

E This view gives you a good look at the back of a female's head. Both sexes have a white back and white outer tail feathers with a few black bars. *Kentucky, late December*

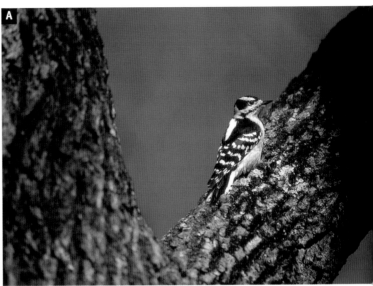

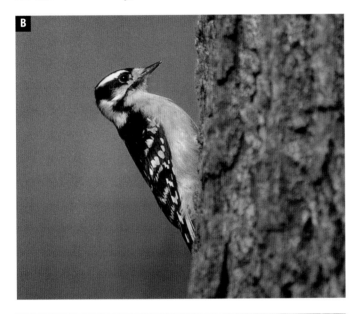

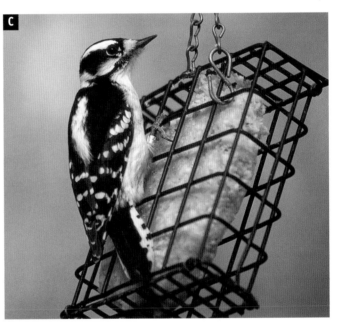

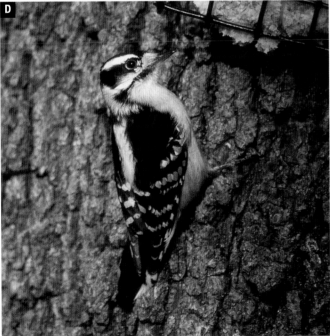

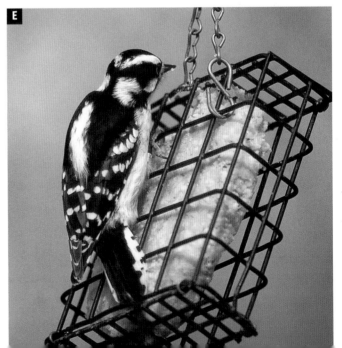

Mourning Dove

Mourning doves range throughout the United States and into Mexico. To the north in Canada they range into the southern provinces of British Columbia, Alberta, Saskatchewan, Manitoba and Ontario. Most doves use only the northern parts of their range in the summer. Mourning doves prefer open areas such as farms, fields and yards with scattered trees and shrubs. They are common in suburbs, gardens and parks and frequently visit backyard birdfeeders.

Mourning doves swallow grit from road-sides and other gravelly areas to help digest their food. These doves are gregarious and are often seen in large flocks. Mourning doves feed mostly on the ground and especially in farmers' crop fields. They eat seeds and grains of weeds, grasses and crops.

The sexes are similar in appearance except the females are generally smaller and duller than the males. Mourning doves have ten primary feathers, eight to nine secondary feathers on the trailing edge and fourteen tail feathers.

A Typical pose. *Central Kentucky, December*

B Doves spend much of the midday resting on a perch like a tree or on an electric wire. *Central Kentucky, December*

C Study the shape of the head from the front. *Central Kentucky, December*

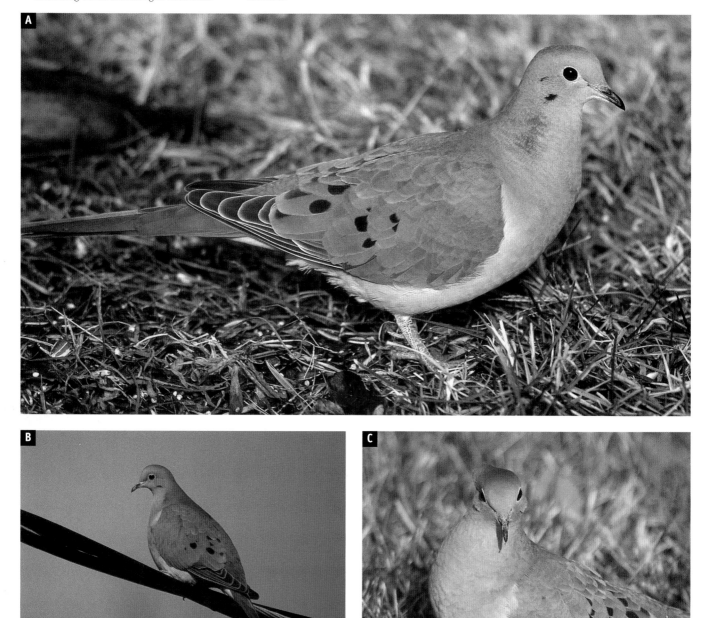

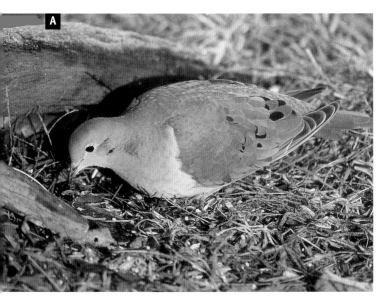

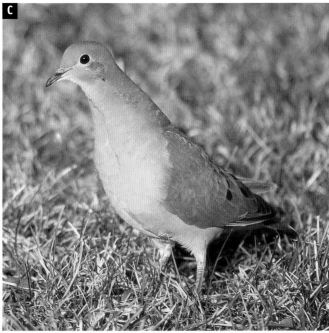

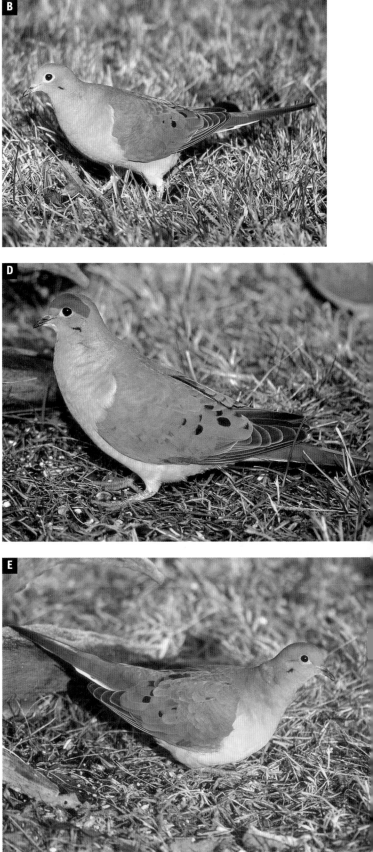

A Mourning doves feed primarily on the ground, eating seeds. *Central Kentucky, December*

B Mourning doves have a black spot below their eyes on the underside of their cheeks. Notice the dove's characteristic pointy tail with white tips on the outer feathers. *Central Kentucky, December*

C This alarmed dove gives you a good look at the small patch of iridescent feathers on the neck. Males have more iridescence than females. Also notice the powder blue eye ring. *Central Kentucky, December*

D Mourning doves have pinkish red legs and feet with black nails. *Central Kentucky, December*

E Study the layout of the wing feathers in this early morning photograph. Notice a couple of iridescent feathers on the neck. *Central Kentucky, December*

Pileated Woodpecker

Pileated woodpeckers range from the eastern half of the United States up into eastern Canada, westward across the lower provinces of Canada, and down into the United States again in the northwestern states. This is the biggest woodpecker commonly seen in North America. Their habitat preference is mature forests, but they utilize second-growth forests and forest edges. You can see them in wooded parks and campgrounds. This is one species you will commonly see deep inside forests as well as along the edges. You can usually spot them flying from tree trunk to tree trunk, or on the ground near the base of trees or old stumps.

Pileated woodpeckers use their powerful beak to hammer away at the bark and wood of live and dead trees in search of insects. They specialize in eating carpenter ants and other wood-boring insects. Pileated woodpeckers also spend time on the ground working away at tree trunks or dead logs. Besides insects they also eat plant matter such as fruits, acorns and beechnuts.

Males and females look the same except for two differences. The male has a red crest and forehead on the top of his head, while the female has a partial red crest with black on her forehead. Also, the male has a red streak, or mustache, running from the base of his

beak to the middle of his cheek. The female has this mustache, but it is black. Pileated woodpeckers have ten primary feathers, eight secondary feathers on the trailing edge and ten tail feathers.

A Male. *S. Florida, late March*

B Female. The stain of yellow near the base of the beak is present in both males and females. *S. Florida, late March*

C Besides eating insects from trees, pileated woodpeckers will also feed on fruit such as apples. *W. Washington, October*

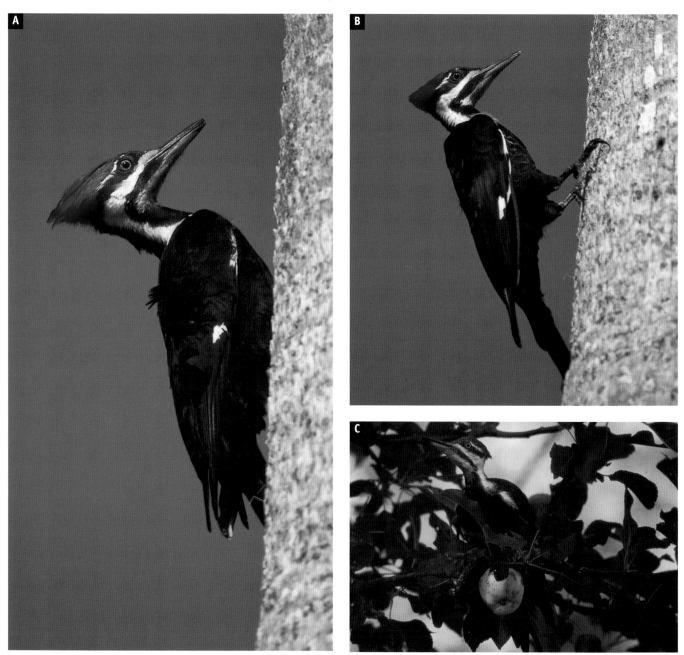

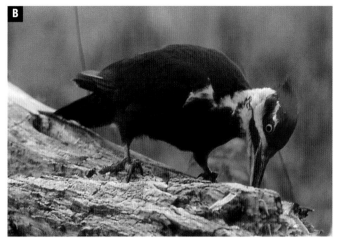

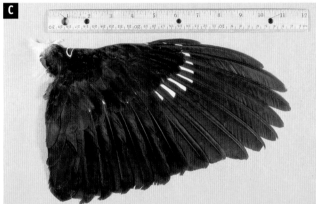

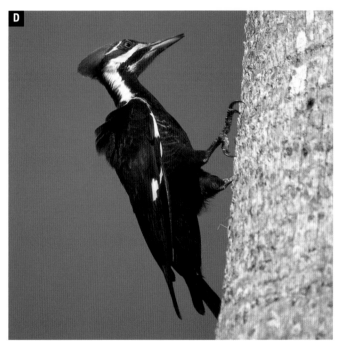

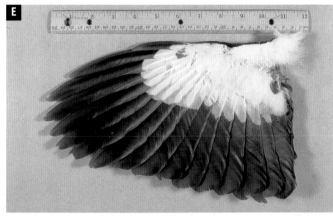

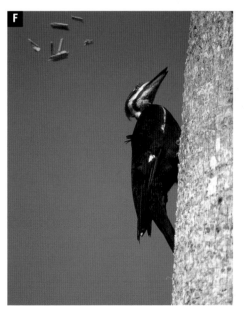

A Study the shape of the head and beak and eye placement of the woodpecker looking straight at you. *W. Washington, June*

B This male hammers away on an old stump in search of insects. *W. Washington, June*

C Upperwing.

D Pileated woodpeckers have two toes in front and two in back. The woodpecker's central tail feathers are stiff and press up against the tree for additional support. *S. Florida, late March*

E Underwing.

F Here the male throws out the wood he has hammered out of his nest hole. *S. Florida, late March*

Robin

Robins are members of the thrush family and are common throughout North America into Mexico. Those living in warm regions stay year-round, but those habitating colder areas migrate southward for the winter. They are abundant in backyards, parks, gardens and moist woodlands, and nest in bushes or trees. Their chief food is earthworms, but they also eat insects and berries. You can see them on the grass with their heads cocked looking for worms. They hunt only by sight, not by sound.

Robins have an orange breast and belly, a brownish gray back and head, white undertail coverts, a yellow beak, and a broken white eye ring around their eyes. Males differ from females in that they usually have a deeper orange belly than the females do. Immature birds have a pale orange belly with black speckles. Robins have ten primary feathers but the last outermost primary is extremely small. They have seven secondary feathers on the trailing edge, nine secondaries in all, and twelve tail feathers.

A Notice the broken white eye ring and the white throat on this robin caught in a typical pose. *Alaska, mid-September*

B Male. *W. Washington, late January*

C Female. A robin's lower belly is white, but this individual's white is more extensive than usual. *W. Washington, late January*

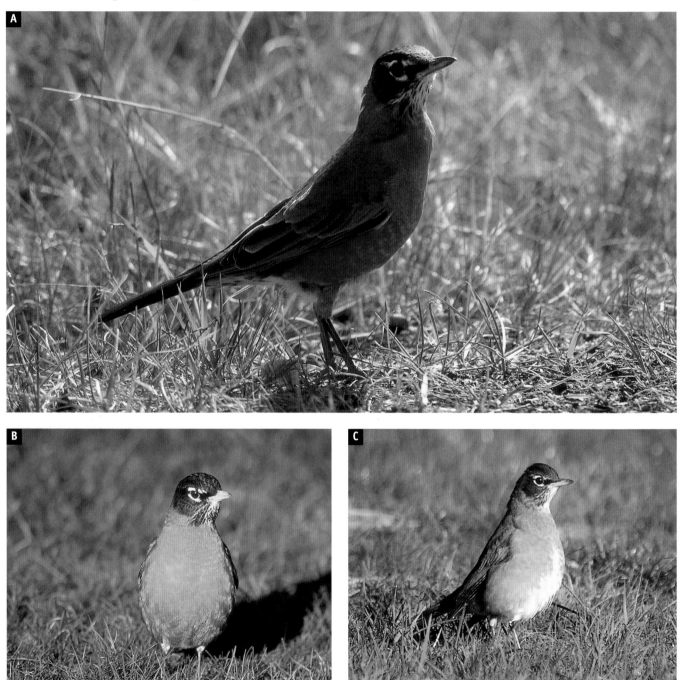

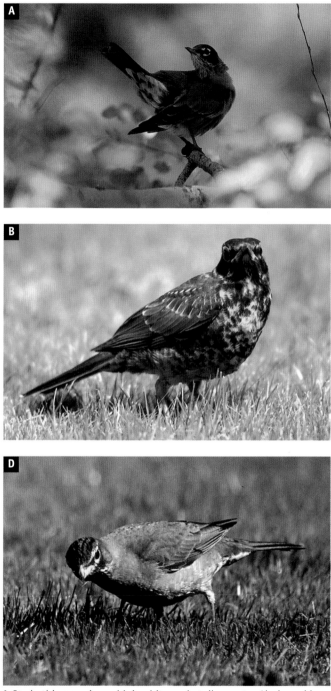

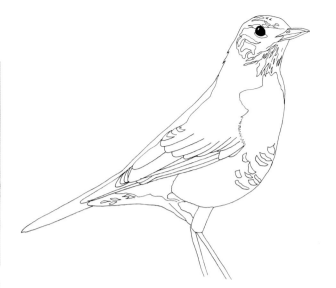

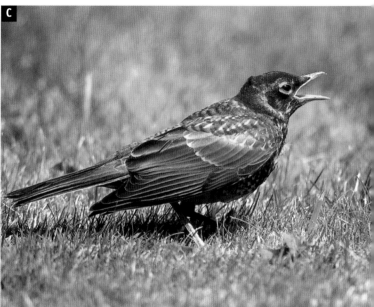

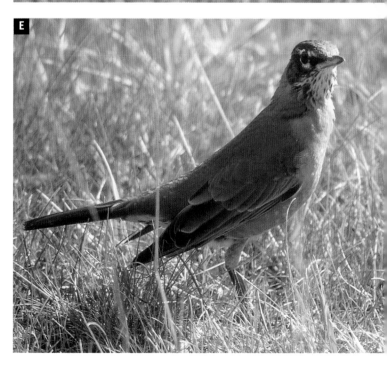

A Study this preening robin's white undertail coverts. *Alaska, mid-September*

B This view of an immature robin shows you the shape of the head and bill from straight on. Notice the pale orange belly with dark speckles. *W. Washington, July*

C The upperwing coverts of an immature robin are not as uniform as in the adults. Notice the light markings. *W. Washington, July*

D Even though it may look like robins listen to the ground for worms, they actually spot them with their eyes. *W. Washington, mid-April*

E Robins often hold their folded primary wing feathers lowered beneath the level of the tail. *Alaska, mid-September*

Rufous Hummingbird

In the summer, the rufous hummingbird ranges from Oregon, Idaho, western Montana and Washington northward into British Columbia and Alaska. During migration times these hummingbirds move through the previously mentioned states and the states west of and including Wyoming, Colorado and Texas, and down into Mexico. Males start northward on their spring migration before females do.

Both sexes are very aggressive in defense of their feeding and nesting territories. At busy hummingbird feeders, these hummingbirds often chase each other away, wildly fighting for the food. Rufous hummingbirds are especially attracted to red flowers, such as columbines, tiger lilies and paintbrushes. They also feed on flowers of different colors and on insects.

The male has a reddish brown back, tail and sides, an iridescent red throat and a green crown. His back may have some areas of green. The female has a green back and crown, rufous sides, white breast and belly, white throat with darker scale-like feathers, and a multicolored tail with green, reddish brown, black and white. Immature birds resemble the females. Rufous hummingbirds have ten primary feathers, six secondary feathers and ten tail feathers.

A Adult male. *W. Washington, June*

B Females and immature birds look alike. The amount of reddish brown feathers mixed in with the green on the back and uppertail coverts can vary. *W. Washington, June*

C Hummingbirds are particularly attracted to red flowers, but also feed on flowers of other colors, like these delphiniums. *W. Washington, June*

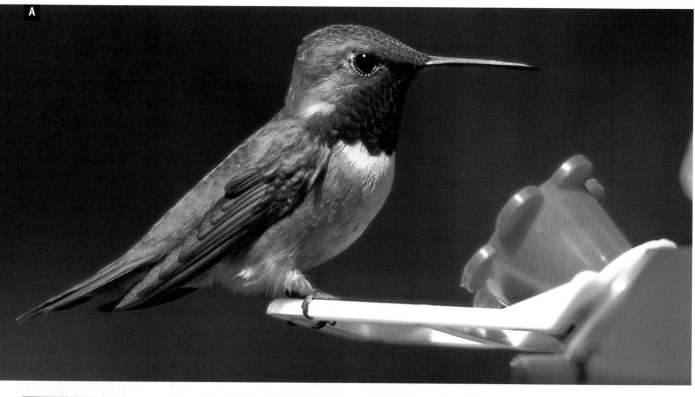

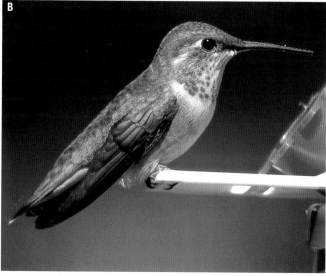

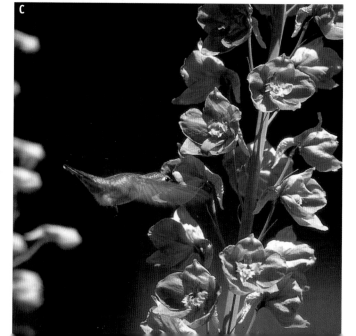

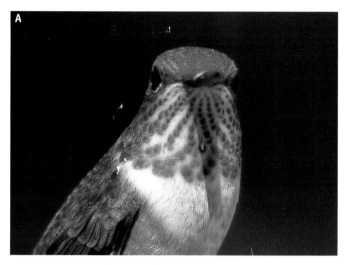

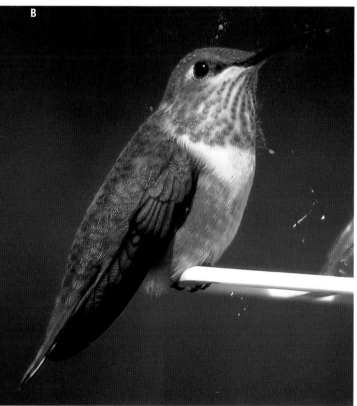

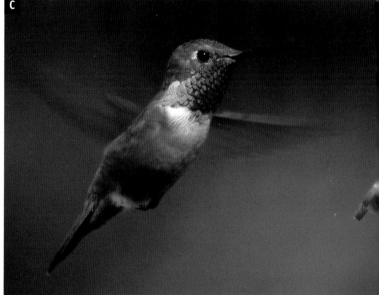

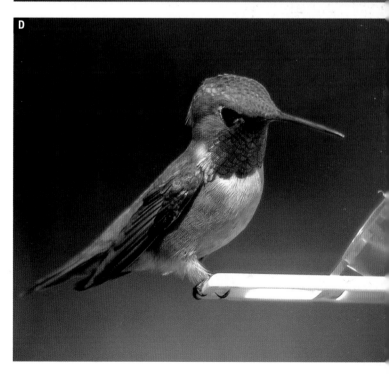

A Study the shape of the head from a frontal view and the rows of feathers on the chin and throat. *W. Washington, June*

B Study the layering of feathers on the wing, back and throat of this bird. Notice that the upperwing (in the shoulder area) is green. *W. Washington, June*

C Their iridescent throat or "gorget" is often dark when facing away from light, but shines a deep red or gold in direct light. *W. Washington, June*

D Study the layering of feathers on this male's crown. *W. Washington, June*

Rufous Hummingbird

A Study the details around the eyes, chin and face in this photograph. Notice the tiny toes and toenails. *W. Washington, June*

B Study the tail feathers. *W. Washington, June*

C Females and immatures have a metallic green back, neck and crown. *W. Washington, June*

D When using photos as reference for painting flying hummingbirds, keep in mind that painting the wings blurred gives a better impression of reality. *W. Washington, June*

E Hummingbirds sometimes use high perches to watch for other hummingbirds invading their feeding or nesting territory. *W. Washington, early July*

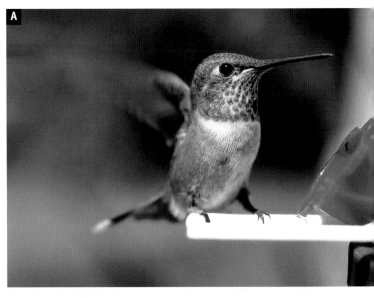

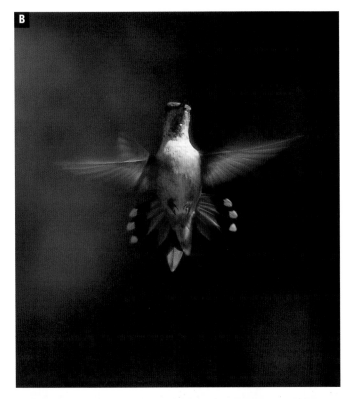

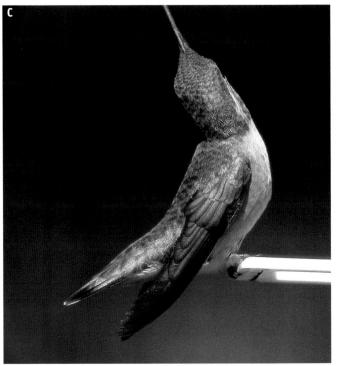

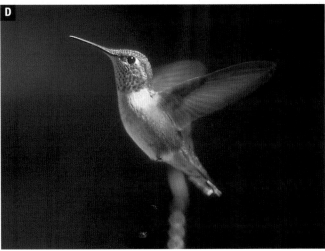

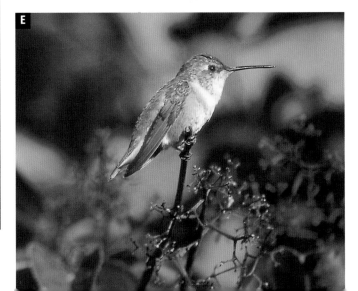

Steller's Jay

The Steller's jay ranges from the southern portion of Alaska down into British Columbia, and into the United States in the Rocky Mountains, most states west of the Rockies and southward into Mexico. These jays are found in evergreen forests in the northwest and pine and oak woods in the southwest. They inhabit mountains or lowlands, and you can see them hanging around campgrounds, boldly looking for food, or as regulars at birdfeeders. These jays are seen singly or in flocks of up to ten or more.

Steller's jays eat mainly acorns, pine seeds, fruit, insects, carrion, camp leftovers and some small animals such as frogs. They hoard food for winter consumption.

Both the male and female look alike, with dark blue wings, tail and belly, and black on the head, upper back and upper breast. They have inconspicuous white or light blue streaks on the forehead, above the eye and on the throat. This jay has a crest on the back of its crown. Steller's jays have ten primary feathers, seven secondary feathers on the trailing edge, nine secondaries in all, and twelve tail feathers.

A Notice the blue streaks on the forehead, the chocolate brown eye, and whiskerlike feathers at the base of the beak called rictal bristles. *W. Washington, mid-April*

B Steller's jays are common residents in coniferous forests. *California, early December*

C Immature bird. Notice the imperfect look of many of the feathers. *W. Washington, late July*

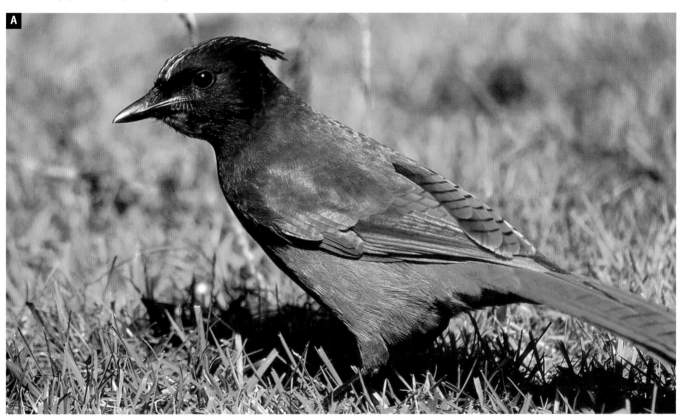

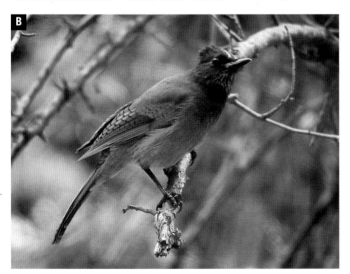

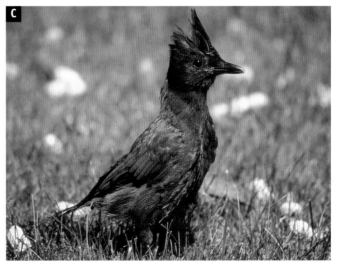

Steller's Jay

A The back of the jay shows the black ladder-like pattern on the wing and tail feathers. Steller's jays can raise their crests very high. *W. Washington, mid-April*

B This jay is looking for food with its head tilted and held high to see into the grass. *W. Washington, August*

C This is a typical feeding or drinking pose, with the jay lifting its head up after picking up the food or to swallow the water. *W. Washington, late July*

D Upperwing.

E Underwing.

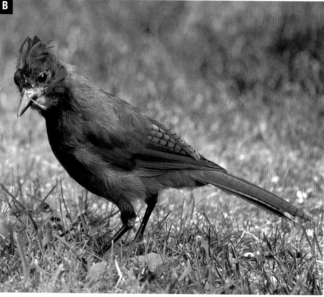

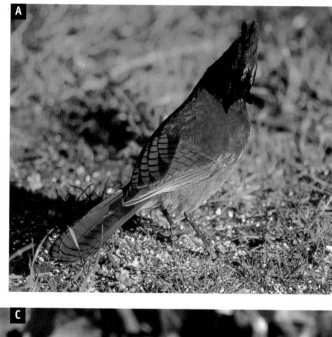

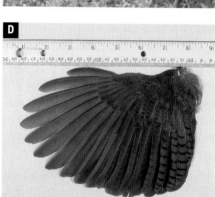

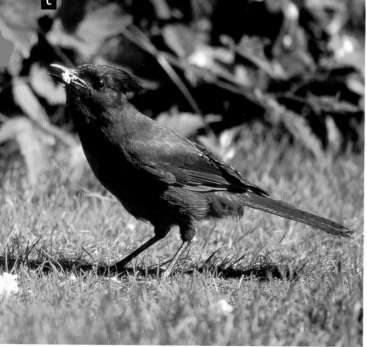

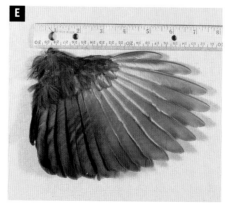

Varied Thrush

The varied thrush is a western bird ranging from Alaska and the Yukon down through British Columbia, Washington, Oregon, California, Idaho, Nevada and eastern Montana. This thrush spends summers in the northern to middle part of this range and winters in the southern to middle part, mostly in the United States. The varied thrush is a shy bird, common in moist forests, especially evergreen forests at high and low altitudes.

It feeds on the ground among rocks and moss and also in the trees. The varied thrush eats a variety of food including insects; earthworms; snails; berries of juniper, madrone, poison oak, pepperberry and buckthorn; raspberries; blackberries; snowberries; seeds and acorns.

In both sexes, the varied thrush has an orange throat, breast, belly and wing bars, and an orange streak above the eye. The female's orange is paler than the male's. The male has a bluish gray neck and back with a black breast band and black head markings. The female is duller and browner on the neck back and head, and her breast band is dull and often incomplete or lacking altogether. Varied thrushes have ten primary feathers, but the last, outermost primary is extremely small. They have seven secondary feathers on the trailing edge, nine secondaries in all, and twelve tail feathers.

A Male. *W. Washington, early January*

B Female. *W. Washington, early January*

C As the sun goes down, its rays deepen the orange colors of this male. *W. Washington, early January*

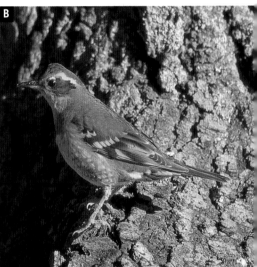

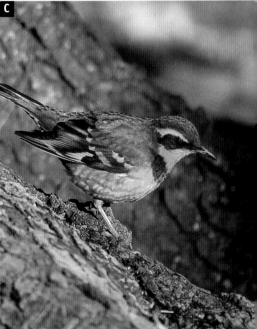

Varied Thrush

A This male ruffing up his feathers shows you the subtle feather edges on his back. *W. Washington, early January*

B Notice the gray feather edges on the sides of this male. Both males and females have this characteristic. *W. Washington, early January*

C This female clings vertically to a tree where she has been looking for insects. *W. Washington, early January*

D A view from the front shows the feather layering on the belly. Males generally have more complete breast bands than this one. *W. Washington, early January*

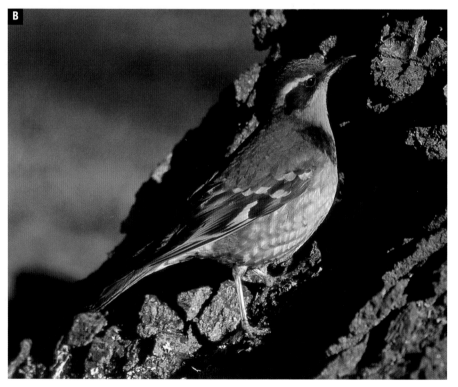

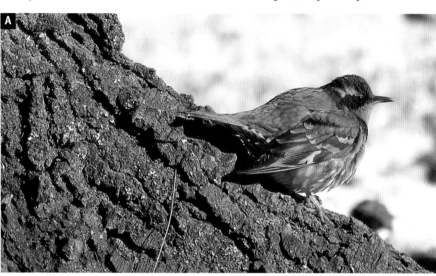

Western Tanager in Oil

by Sherry C. Nelson, MDA

Materials

Palette:

Oil Paints—Ivory Black, Titanium White, Raw Umber, Raw Sienna, Sap Green, Prussian Green, Cadmium Scarlet, Winsor Red, Burnt Sienna, Yellow Ochre, Cadmium Lemon

Acrylic Paints—Accent Wicker, Accent Linen

Brushes:

Brights no. 2, no. 4, no. 6, no. 8
round no. 1

Other:

Odorless thinner, cobalt siccative (optional), palette knife, paper towels, disposable palette for oils, graphite paper, tracing paper, ballpoint pen, hardboard (Masonite panel), sponge roller, #220 wet/dry sandpaper, Krylon Matte Finish-#1311

G ood reference photographs, field sketches and observations are invaluable for Nelson's decorative artwork. For this painting she wants viewers to look twice to find the bird, just as they would have to in a natural setting.

Prepare the Surface

Apply a base coat of Accent Linen to the Masonite panel with a small sponge roller. Once dry, sand the surface and apply another coat. While still wet, drizzle a little Accent Wicker and drag the sponge roller around to get a splotchy mix of the colors. When this dries, spray on the matte finish to prevent the oils from absorbing too much.

Bird photo reference
Photo by Terry Steele

Apple photo reference
Photo by Deborah A. Galloway

Bird photo reference
Photo by Terry Steele

137

1. Transfer the Sketch

After completing a preliminary drawing, place a piece of graphite paper down on your Masonite and lay the drawing on top of it. Cover the drawing with tracing paper for protection, and with a ballpoint pen, transfer the drawing onto the Masonite. Be careful to trace each detail of the bird.

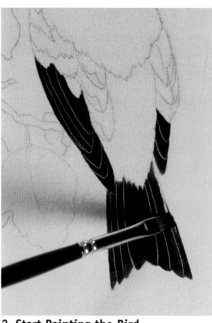

2. Start Painting the Bird

Mix Ivory Black and Raw Umber and apply the base coat for the tail and both areas of primary wing feathers. Sketch the edges of feathers back in the wet paint to help you remember where to paint them later.

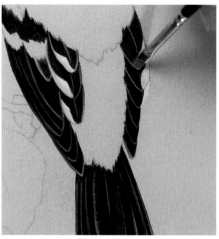

3. Develop Tail and Wings

Paint in the feather edges on the tail and primaries using a no. 4 bright brush, and a mixture of Titanium White with a little Raw Sienna and a touch of Sap Green. Use the same color mixture to paint in some faint lines to represent highlights on the feather barbs.

Paint in detailed areas on the secondary wing feathers and wing coverts with Titanium White and a no. 2 bright brush. Use Ivory Black mixed with Raw Umber to paint in the remaining wing feathers, using the same technique as in step 2 to create feather edges.

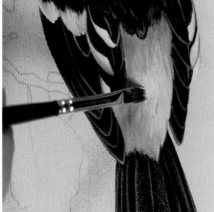
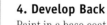

4. Develop Back

Paint in a base coat of the Ivory Black/Raw Umber mixture for the darker feathers of the back. Define two or three soft rows of feathers with a dirty white and a no. 4 bright brush.

Paint a base coat of Titanium White on the white wing bar with a no. 4 bright brush. Then, block in all the lower back and rump using the no. 4 bright and a mixture of Cadmium Lemon and Yellow Ochre, adding some Raw Sienna to dull. Paint on highlights with a mix of Cadmium Lemon and Titanium White.

6. Finish Bird Details

Shade the lower mandible of the beak with Raw Umber and the upper mandible with a Raw Sienna/Raw Umber using the no. 2 brush, adding highlights with Titanium White. Add a highlight in the bird's eye with pure Titanium White using the no. 1 round.

Then sparsely paint Winsor Red over the areas on the head that you previously coated with Raw Sienna, following the direction of the feathers. Add a few small red feathers over the yellow on the nape and the throat. On the crown and cheek, deepen the red with a bit of Cadmium Scarlet. Then add some shading on the base of the beak, the chin and crest with Raw Umber.

Start the toes with a base of Raw Umber and Titanium White, then add highlights with the same mixture but with more white added. Use black to paint the toenails and dark lines between the scales on the toes.

5. Develop Head and Neck

Block in the yellow wing bar and neck with a Cadmium Lemon and Yellow Ochre mix, adding some Raw Sienna. Paint on highlights with the mix used for highlights in step 4.

Paint in the eye ring using a no.1 round brush with a Cadmium Lemon/Yellow Ochre mix. Fill in the eye with Ivory Black and paint the remainder of the head with Raw Sienna.

For the beak apply a base coat of Raw Sienna and Titanium White on the upper mandible, Raw Sienna and Raw Umber on the lower mandible.

7. Block in the Elements

Apply sparse base coats of Raw Sienna and Sap Green randomly on the leaves with a no. 6 bright, blending as needed. Block in the apples with Cadmium Lemon and Yellow Ochre in the lightest areas and Raw Sienna in the natural shadow areas. Lay Sap Green dirtied with a little Raw Sienna down one side of the branches and Raw Umber and Raw Sienna down the shadow side, blending colors together by pulling the chisel edge of a small brush across the branch to give the look of gnarled, bumpy apple branches.

8. Develop Details

Add details to the leaves by shading one side of their vein structure with Prussian Green dulled with earth colors using a no. 4 brush. Shade the Raw Sienna area of the apples with Burnt Sienna, and paint a mix of Sap Green, Raw Sienna and Raw Umber on other areas of the apples using a no. 6 brush. Add some odorless thinner to this same dirty green mix, using a no. 1 round. Add paint speckles on the skin of the apples.

9. Finish Element Details

Add vein structure in the leaves by lifting out color with a damp no. 4 bright or by adding veins in with a light value mix. Add touches of Burnt Sienna on the edges of the leaves to emphasize imperfections. Highlight some of the leaves with a Sap Green/Titanium White mix and the rest of the leaves with a Cadmium Lemon/Sap Green/Titanium White mix.

Stengthen the shadows of the Burnt Sienna areas of the apples with Winsor Red.

10. Final Touch

After the painting is dry, glaze a little Raw Umber over the apples and leaves to help control the brightness of those colors.

Western Tanager
SHERRY C. NELSON, MDA
Oil
12" X 16" (30cm X 41cm)

Contributor

Sherry C. Nelson, MDA

Sherry Nelson has been painting and teaching wildlife art for nearly twenty-five years and has, in the past fourteen, settled into birds as a specialty. Capturing birds in art as realistically as possible and placing them in a setting characteristic of their natural habitat holds a special challenge for her. She does extensive field work to give her subjects the "form and feeling" of that particular species.

Sherry lives and paints on thirty-seven acres of spectacular wilderness in the Chiricahua Mountains of Arizona. Eight species of hummingbirds frequent the feeders and animals abound.

Sherry has been active in the Society of Decorative Painters since its inception, serving as president of that organization and receiving the Master Decorative Artist award (the highest level of certification) in 1976. She also received the prestigious Silver Palette Award in 1987, given for outstanding work within and beyond the field of decorative painting.

Sherry has produced sixteen instructional publications for the wildlife painter with innovative worksheets and step-by-steps geared for painters of all skill levels. She believes that anyone can try painting wildlife art and produces her books with that goal in mind.

Western Tanager *detail*.

Bibliography

Griggs, Jack L. *All the Birds of North America*. New York: HarperCollins Publishers, 1997.

Scholz, Floyd. *Birds of Prey*. Edited by Judith Schnell. Mechanicsburg, Pennsylvania: Stackpole Books, 1993.

Scott, Shirley L., ed. *Field Guide to the Birds of North America*. Washington, D.C.: The National Geographic Society, 1987.

Terres, John K. *The Audubon Society Encyclopedia of North American Birds*. Avenel, New Jersey: Wings Books, 1991.

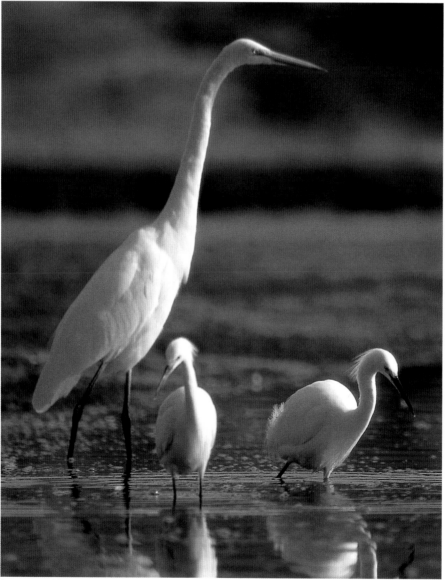

A great egret with two snowy egrets. *Corkscrew Swamp, Florida, late March*

Index

Index